GENERATION

25 Years of
Contemporary Art
in Scotland

Edited by
Moira Jeffrey

GENERATION

25 Years of Contemporary Art in Scotland

GUIDE

National Galleries of Scotland
and Glasgow Life

Published by the Trustees of the National Galleries of Scotland and Glasgow Life to accompany the series of exhibitions, GENERATION: *25 Years of Contemporary Art in Scotland*, held throughout Scotland during 2014.

ISBN 978 1 906270 71 1

Designed and typeset in Solitaire by Dalrymple
Cover and map designed by The Leith Agency
Printed in Spain on GardaMatt 135gsm by Grafos

The proceeds from the sale of this book go towards supporting the GENERATION project
www.generationartscotland.org

Many exhibitions that form part of GENERATION have been made possible with the assistance of the Government Indemnity Scheme provided by the Scottish Government.

Glasgow Life is the operating name of Culture and Sport Glasgow. Culture and Sport Glasgow is a company limited by guarantee and is registered as a charity (no. SC037844) with the Office of the Scottish Charity Regulator.

National Galleries of Scotland is a charity registered in Scotland (no.SC003728)

This publication has been made possible thanks to the support of British Council Scotland

Contents

MANAGED AND FUNDED BY

NATIONAL GALLERIES SCOTLAND · Glasgow life · LOTTERY FUNDED

CULTURE 2014
XX COMMONWEALTH GAMES

SUPPORTED BY

EventScotland · BRITISH COUNCIL Scotland

IN PARTNERSHIP WITH

Museums Galleries Scotland · Visit Scotland · BBC Scotland · Education Scotland Foghlam Alba · Children in Scotland every child · every childhood · Young Scot

generationartscotland.org

@genartscot

#genartscot

Partners' Foreword

GENERATION is a landmark event and one of the most ambitious celebrations of contemporary art ever held by a single nation. It has been inspired by the energy and vision of the artists who have lived and worked here over the last twenty-five years – a period which has seen Scotland develop an international reputation as a distinguished centre for contemporary art, produce a disproportionately high number of award-winning artists, host a number of ground-breaking exhibitions and foster an infrastructure which has enabled contemporary art to flourish.

At the heart of GENERATION is a desire to increase public engagement with contemporary art. Our aim is for more of the very best art to reach more people in more places across the country. We want to ensure that over the summer of 2014 anybody living in, or visiting, Scotland will be able to enjoy a unique and inspiring programme of exhibitions and events.

GENERATION presents an exceptional range of work – with more than 100 artists and sixty venues, it really will provide something for everyone. And we are particularly motivated to use GENERATION to inspire future generations. Harnessing the knowledge and expertise of the participating galleries, we have established an innovative programme focused on children and young people. Our ambition is to foster their creative abilities and to enable their voices to feature throughout.

GENERATION is a celebration of all of Scotland's many great achievements in the field of contemporary art. As a truly national project, it highlights the strength and diversity of the many organisations who work – year round – to

produce and present work of the highest quality. We aim for this project to help forge new partnerships and collaborations that will sustain well beyond 2014, paving the way for future success.

An event of this scale and ambition could only happen through partnership. This project has been made possible as the result of a unique relationship established between the National Galleries of Scotland and Glasgow Life. These organisations established an early vision for the project that was fuelled by their desire to share the wealth of their collections as well as the significant knowledge and expertise of their staff. The ambition demonstrated by these organisations attracted substantial interest and support from Creative Scotland. This, in turn, has enabled a real breadth of programme and reach that will attract both national and international attention.

GENERATION demonstrates a deep confidence in the strength of our past achievements and the extent of our future potential. We hope that it not only lights up the summer of 2014 but also helps us to find new ways to work together to inspire and engage people in the longer term.

Special thanks need to be extended to the artists, without whom this project would not have been possible. A specially convened Curatorial Board comprised of representatives of the partner organisations along with an Associate Curator, Katrina Brown, has formed the overall shape of the project, its specific manifestation across the partner organisations' venues and the extension of the programme nationwide to include many other galleries and organisations across Scotland. Thanks are due to Jenny Crowe whose excellent project management has made it all possible, to Chloe Shipman who has brought substantial digital expertise and to Iona McCann for co-ordinating the significant public engagement programmes. Additional thanks are extended to key staff in the National Galleries of Scotland, Glasgow Life, Creative Scotland and those many galleries and organisations who have brought the project to life across Scotland. Likewise to our Advisory Board members and supporters including VisitScotland and EventScotland; British Council Scotland; Museums Galleries Scotland; Education Scotland; Young Scot; Children in Scotland and the BBC.

For more information please visit www.generationartscotland.org.

COUNCILLOR ARCHIE GRAHAM
Depute Leader, Glasgow City Council
Chair of Glasgow Life

BEN THOMSON
Chairman, Board of Trustees of the National Galleries of Scotland

SIR SANDY CROMBIE
Chair, Creative Scotland Board

Welcome

I am delighted to welcome you to GENERATION, a unique and inspirational programme of exhibitions that celebrate twenty-five years of contemporary art in Scotland.

Presented as part of the Cultural Programme for the 2014 Glasgow Commonwealth Games, the project aims to increase access to and participation in the arts.

With exhibitions taking place in over sixty galleries and venues the length and breadth of the country, GENERATION will take art into communities and enable people across Scotland to enjoy and participate in the richness of our culture.

This is one of the most ambitious celebrations of contemporary art ever held by a single nation, and I am pleased that there is such a strong focus on engaging and inspiring our young people. GENERATION is a fantastic opportunity to introduce them to the great art created in this country during their lifetime, and to explore its relevance to the ideas and issues of today. I would like to pay tribute to all the wonderful artists whose work is making up GENERATION and congratulate them on their achievements.

The year 2014 is when Scotland takes centre stage as we welcome the world to join us in the celebration of the second year of Homecoming, and as the host of the Commonwealth Games and the Ryder Cup. With the eyes of the world upon us, GENERATION provides a significant opportunity to showcase the very best of Scottish culture and creativity to the world.

Scotland's culture is one of our most enduring and powerful national assets. We are a creative nation and we value the artists who live and work here and whose job it is to generate new ideas, fresh insights and alternative perspectives. They help us to see ourselves in new ways and to present Scotland in its many dimensions to the wider world.

Such an ambitious programme on the scale of GENERATION wouldn't be possible without the distinctive infrastructure that has supported the development of contemporary art in Scotland over the last twenty-five years. We value the work of all the organisations that have made this project possible and who are committed to ensuring that people from across all of Scotland's communities can enjoy and benefit from the incredible range of art and exhibitions on offer.

I believe that culture and heritage is of us all and for us all. I hope that you will enjoy and be inspired by the works included in this celebration of art in Scotland, and that throughout 2014 you will be encouraged to explore more of the fantastic array of activities available as part of the Cultural Programme for the Commonwealth Games.

FIONA HYSLOP MSP
*Cabinet Secretary for Culture
and External Affairs*

Introduction

This book serves as an introduction to the art and artists to be found in GENERATION exhibitions across Scotland during the summer of 2014. With texts about individual artists and details of group shows and other projects, it also includes a map and a list of the galleries, museums and other spaces across the country taking part in this unique chance to view and re-view so much art from one country in that country.

GENERATION is a major nationwide programme of exhibitions showcasing some of the best and most significant art to have emerged from Scotland over a period of twenty-five years. Coinciding with Glasgow's hosting of the Commonwealth Games in the summer of 2014, GENERATION offers access to world-class art on an unparalleled scale. It looks at the generation of ideas, of experiences, of stories, and of some outstanding art. It tells a story about our culture now and how our art and artists continue to thrive.

Across the range of exhibitions, GENERATION traces something of the remarkable developments in contemporary art as they have happened in Scotland since 1989. It does this through the work of artists whose careers have grown from Scotland during that period, a time that has seen dramatic changes in our cultural lives, including unprecedented interest in, and acclaim for, our artists.

The exhibitions feature works by artists who came to attention practising in Scotland, whether Scottish by birth and education, or some of the many artists from elsewhere who have come to study and chosen to remain,

helping to create the buoyant and vibrant setting for contemporary art that exists today.

This inbound flow of talent has been one of the defining characteristics of the period, unlike previous times in which artists would leave to seek careers elsewhere. A number of factors made it possible for artists to live and work outside of the established, traditional centres for art, such as Paris, Berlin or New York. These included, for example, cheap air travel and the enormous changes in communications, including faxes, mobile phones and the Internet, which allowed artists to live and work in one place while being part of a larger, international network.

It is not one style or dominant trend that characterises the art that has emerged from Scotland during this period, but rather its diversity. In the field of painting alone, the spectrum includes the robust figuration of the late Steven Campbell, whose 1990 exhibition *On Form and Fiction* is re-created as part of GENERATION, to the striking abstraction of Callum Innes and the remarkably complex *in situ* wall paintings of Richard Wright. Similarly, artists working in sculpture have ranged from the crafted abstraction of Claire Barclay to the more expressive and at times autobiographical work of Cathy Wilkes. While others, such as Karla Black and Sara Barker, can be seen to be working in both painting and sculpture, using traditional materials in new ways.

Alongside this, there has been a significant growth in the range of artists working with film and video, an area in which many artists practising in Scotland have achieved international recognition: from Douglas Gordon's hugely influential *24 Hour Psycho* (1993), through artists like Luke Fowler and Duncan Campbell who have

used documentary filmmaking, to the lush and fantastical work of Rachel Maclean. Artists have worked together in collaborative pairs (Joanne Tatham and Tom O'Sullivan, Dalziel + Scullion) and larger groups (GANGHUT, Henry VIII's Wives). Performances and live events have becoming increasingly important features of contemporary art.

New works commissioned for GENERATION, by Jacqueline Donachie and Nicolas Party, exist beyond any gallery and reflect something of the importance of working outside conventional spaces that has been such a vital characteristic of contemporary art both in general and in Scotland during this period.

The diversity of forms and types of work to be seen is matched by that in the range of locations in which it is to be found, from the Pier Arts Centre in Orkney to Mount Stuart on the Isle of Bute, via the neoclassical grandeur of the RSA in Edinburgh and the post-industrial grit of Tramway in Glasgow, the latter a space that first came into use as a venue for visual art in 1989.

This *Guide* is accompanied by a second publication, a *Reader* that includes new writing by acclaimed authors Louise Welsh and Nicola White, leading critic and curator Sarah Lowndes, art historian and curator Andrew Patrizio, curators Francis McKee and Juliana Engberg, and artist Jenny Richards, as well as a selection of writings from the period by and about artists and the ideas and discussions that have been triggered by their work. The *Reader* provides a picture of the times and the places in which the work featured in GENERATION has come into being, through the voices of many of those who have been witness to it.

With this publication as your guide, we hope that GENERATION will help you to reconsider things that you know, but also to find the new – whether artists, ideas or places. Through this diverse array of art experiences, from the intimate to the collective, GENERATION offers a unique opportunity to see art that is innovative, thought-provoking, imaginative, at times beautiful, at others challenging, but always inspiring.

CURATORIAL BOARD, GENERATION

Further information about terms used in this book can be found in the Glossary on pages 203–7.

Entries on artists, group exhibitions and other projects show the relevant GENERATION location of works and exhibitions.

Charles Avery

In 2004 Charles Avery embarked on a project called *The Islanders,* which was conceived as a way to explore, consolidate and give direction to his art and ideas. *The Islanders* is a painstakingly detailed and diverse description of a fictional island in drawing and painting, sculpture and texts.

Untitled (View of the Port at Onomatopoeia) (2009–10) shows the full might of Avery's imagination and drawing skills. Measuring over five metres wide, this drawing immerses the viewer in a scene of the bustling port of Onomatopoeia, the main town on the island. With the edges of the composition less detailed, attention is focused on the centre of the paper, which shows a diverse group of mysterious island inhabitants and their wares, alongside visitors who have arrived by boat.

Avery's drawings are made entirely from his imagination. He improvises as he goes. Once a narrative emerges he develops it in several directions and uses different ways to tell the story.

The island's natives are known as the If'en and have their own specific customs, gods and favourite foods. They live in a geometric landscape of vast plains and towns with cultural buildings and municipal parks.

It is important to consider the differences between Avery's drawings and his sculptures. In essence, the drawings are narrative whilst the sculptures, such as hats, trees and animals, can be understood as items which have been sold as souvenirs to the island's tourists. Therefore they have been removed from their original island context and are now situated in reality – creating a direct connection between the two. Avery extends this link through the inclusion of the protagonist, the Hunter, who has travelled to the island and documents what he experiences from an outsider's perspective.

Avery prefers to exhibit a broad selection of works together so as to pose questions concerning the likes of mathematics, philosophy and time, whilst also offering the viewer a more in-depth experience of the island's topology and cosmology. If *The Islanders* is ever completed, Avery hopes for it to be consolidated in a large, leather-bound encyclopaedic book, accessible to anyone interested in it. **ShC**

GENERATION LOCATIONS
Edinburgh: City Art Centre; Scottish National Gallery of Modern Art.

BIOGRAPHY
Charles Avery (born 1973 in Oban) moved to London in 1993 where he completed a foundation course at Chelsea School of Art. Apart from this he remains largely self-taught as an artist. In 1996, Avery jointly set up an artist-led space where he exhibited, before holding his first solo show at Entwistle Gallery, London, in 1998. In 2008 *The Islanders: An Introduction* opened at Parasol Unit, London, before touring to the Scottish National Gallery of Modern Art, Edinburgh, and Museum Boijmans Van Beuningen, Rotterdam. In 2007 Avery participated in *Scotland + Venice* at the 52nd Venice Biennale. He lives and works in London.

FURTHER READING
Charles Avery, *Onomatopoeia: The Port*, Koenig Books, London, 2010

Charles Avery, *The Islanders: An Introduction*, Koenig Books, London, 2008

Untitled (View of the Port at Onomatopoeia) (detail), 2009–10
Graphite, ink and gouache on paper, 240 × 510 cm
Tate, London

→ Claire Barclay

Claire Barclay works mainly in sculpture and printmaking. Although the forms she produces are abstract, they are informed by a deep interest in the material world we live in. Her prints typically feature strongly defined two-dimensional forms that overlap or interrelate. They can suggest the physical processes involved in printing itself. Her sculptural installations often combine small machine-tooled elements or pieces made using craft techniques with larger structures.

Barclay usually composes her installations within the gallery itself, improvising with materials as well as using pieces created in the studio. She has suggested that they could be thought of as 'pauses' between their making and dismantling. This is a useful way to understand the sense in which these artworks are at once full of life and poised or stilled. Her way of working also means that they are carefully related to the spaces they occupy. Like the people who visit the gallery, her works can inhabit space with different degrees of comfortableness or belonging.

The artist notes that a crucial moment in her early artistic development came when she realised that using readymade elements, like found objects, brought too many clear-cut meanings into her work. She began to use objects she made or commissioned for herself. But in making this shift, Barclay has not abandoned the real world. The works often suggest tactile relationships to the things that surround us. They remind us of what it's like to touch the substances we use to construct or furnish the places we live in. They use materials that clothe and adorn our bodies. Sometimes they look *almost* like familiar objects, or like the tools that we use in various kinds of crafting or making.

We know – or think we do – what wood, clay, brick or straw look and feel like. We know how fabric or leather drapes or folds over another material. But in Barclay's art, we never get the sense that we are dealing simply with the domestic, the familiar or the useful. The works suggest instead that we often relate to our material world in ways that are strange, psychological, and perhaps dysfunctional. Claire Barclay's art invites us to think about what places and objects feel like, and to ask how well we really know them. **DP**

GENERATION LOCATIONS
Arbroath: Hospitalfield Arts.
Edinburgh: Scottish National Gallery of Modern Art.

BIOGRAPHY
Claire Barclay (born 1968 in Paisley) studied BA Environmental Art and MFA at The Glasgow School of Art. Solo exhibitions include: *Shadow Spans*, Whitechapel Gallery, London (2010); *Overlap*, Glasgow Print Studio (2010); *Pale Heights*, MUDAM, Luxembourg (2009); *Openwide*, The Fruitmarket Gallery, Edinburgh (2009); *Shifting Ground*, Camden Arts Centre, London (2008); *Fault on the Right Side*, Kunstverein Braunschweig, Brunswick (2007); *Half-Light*, Art Now, Tate Britain, London (2004); *Ideal Pursuits*, Dundee Contemporary Arts (2003); *Homemaking*, Moderna Museet, Stockholm (2000); *Out of the Woods*, CCA, Glasgow (1997). She lives and works in Glasgow.

FURTHER READING
Kirsty Ogg (ed.), *Claire Barclay: Shadow Spans*, Whitechapel Gallery, London, 2010

Fiona Bradley (ed.), *Claire Barclay: Openwide*, The Fruitmarket Gallery, Edinburgh, 2009

Flat Peach (detail), 2010
Machined aluminium, sheet aluminium, sewn printed fabric

Sara Barker

Sara Barker's elegant sculptures are light and spare in appearance. At first glance they are simple, but on closer inspection they reveal themselves to be full of incident, movement and intricate detail.

They are formed through an intuitive working process that uses a wide range of materials: from metals such as steel, brass or aluminium, to Jesmonite®, glass or cement. Barker sometimes begins a sculpture by using paint to make improvised marks on sheets of aluminium. Strips of metal are then cut and worked into three-dimensional structures. Canvas or other materials might be added to these structural elements.

Barker's works have an obvious sculptural presence, but they often take up the space of the wall as well as the floor. They are characterised by line rather than mass or heaviness – so much so that they have often been described as being drawings or paintings in space. There is a rich tradition of sculpture as 'drawing in space' in twentieth-century art, but Barker's approach is individual to her. In pieces such as *Matters* (2013) the artist investigates and refines a sculptural language that has emerged from her own working process.

The delicate lines that make up Barker's pieces can resemble interwoven frames. In art the frame is usually the threshold between the artwork and the world outside it, and is intended to keep the two spaces separate. Barker is interested in what happens when such boundaries are less clear. This is important because it means that her works inhabit the real places in which they are displayed rather than remaining purely in a world of their own.

Literature is an important source of inspiration for Barker, and especially the writings of figures such as Virginia Woolf, Emily Dickinson and Doris Lessing. They were interested in how we invest spaces with meaning, and with how private 'moments of being' that occur, exist within public spaces and situations.

Included in Barker's 2013 exhibition *THE THINGS THAT ARE SOLID, ABSORBED AND STILL* was a work entitled *The things that are fluid, changeable and unpredictable* (2013). Most artworks are either solid or fluid, still or unpredictable. Barker's works subtly combine these two ways of being a thing, and being in space. **DP**

GENERATION LOCATION
Glasgow: Gallery of Modern Art.

BIOGRAPHY
Sara Barker (born 1980 in Manchester) studied BA Painting at The Glasgow School of Art. Solo exhibitions include: *Sara Barker and Ryder Architecture*, BALTIC, Gateshead (2013); *THE THINGS THAT ARE SOLID, ABSORBED AND STILL*, Mary Mary, Glasgow (2013); *Woman at a Window*, Stuart Shave/Modern Art, London (2012); *Hanging A Way Of Dressing*, Project Room, Glasgow (2008); *New Work Scotland*, Collective, Edinburgh (2006). Group exhibitions include: *New Order: British Art Today*, Saatchi Gallery, London (2013); *Drawing: Sculpture*, Leeds Art Gallery, Leeds (2012); *Frauenzimmer*, Museum Morsbroich, Leverkusen, Germany (2011); *Group Show*, doggerfisher, Edinburgh (2008). She lives and works in Glasgow.

FURTHER READING
Anna Lovatt, 'Drawing across and between media', in Sarah Brown, Kate MacFarlane and Sophie Raikes (eds), *Drawing: Sculpture*, Leeds Art Gallery, 2012

Stephanie Kreuzer (ed.), *Frauenzimmer*, Kerber, Bielefeld, 2012

Matters, 2013
Plywood, aluminium, various paints, filler, brass rod
Installation view: THE THINGS THAT ARE SOLID, ABSORBED AND STILL, Mary Mary, Glasgow, 2013

Beagles & Ramsay

John Beagles and Graham Ramsay have worked together as a collaborative duo since 1996. Their work ranges from sculpture, photography and painting to video and performance. They often use aspects of self-portraiture to delve into a range of contemporary cultural, social and political anxieties, most notably political disenfranchisement, the culture of consumerism and the cult of celebrity.

They also owe a great deal to older traditions within art, specifically the counter tradition of the carnivalesque – a term used in literature to describe the use of humour and absurdity as a tactic to overturn conventional authority or everyday assumptions. Beagles & Ramsay used this approach to explore issues around consumerism in works such as *Burgerheaven* (2001) and *Good Teeth* (2009).

Historical artists, from the painters Brueghel, Tiepolo and Goya, to more acerbic satirists such as Daumier and Hogarth (as well as novelists such as Swift, Rabelais and Chaucer) have also exerted a profound influence. An influential aspect of these artists' work has been their ability to combine their visual or literary aesthetic with political allegories and satirical content.

We Are The People – Suck on This (2000) is Beagles & Ramsay's most explicit work on the subject of political disenfranchisement. It features Graham Ramsay in the Robert De Niro role of Travis Bickle from Martin Scorsese's film *Taxi Driver*. The video charts Ramsay's walk through central London, and ends with him handing in a petition to Tony Blair, at 10 Downing Street. The petition reads 'We Are The People – Suck on This' and was signed only by the two artists.

The artists' presence within their own work is not straightforward. They often use doppelgangers, such as puppets, disguises or assumed identities. These tactics allow them the freedom to explore aspects of contemporary culture, without the restrictions of a singular, authoritative voice. *Ventriloquist Dummies Double Self-Portrait* (2003) shows the artists as hapless dummies, reflecting their interest in the way we can easily be manipulated. The dummies appear again in the video *New Meat* (2004), where the sinister dialogue and fragmented soundtrack convey a deep sense of unease. **MJ**

GENERATION LOCATION
Glasgow: People's Palace.

BIOGRAPHY
John Beagles (born 1970) and Graham Ramsay (born 1968) are based in Glasgow. Their first solo exhibition *Goodnight Goodnight* was at Collective, Edinburgh in 1997. Their work has been exhibited internationally at venues including the Venice Biennale; MoMA PS1, New York; the Migros Museum, Zurich; the New Museum of Contemporary Art, New York; the ICA, London; and the Rotterdam International Film Festival. They have also curated a number of exhibitions and written for magazines including *Art Monthly*, *Variant* and *Sight and Sound*. Ramsay teaches on the MFA programme at The Glasgow School of Art and Beagles teaches at Edinburgh College of Art as lecturer in Visual Culture.

FURTHER READING
Francis McKee and Moira Jeffrey, *Beagles and Ramsay*, Gasworks Gallery, London and Collective, Edinburgh, 2003

Ventriloquist Dummies Double Self-Portrait, 2003
Mixed media
Collection of Glasgow City Council, Glasgow Life (Glasgow Museums)

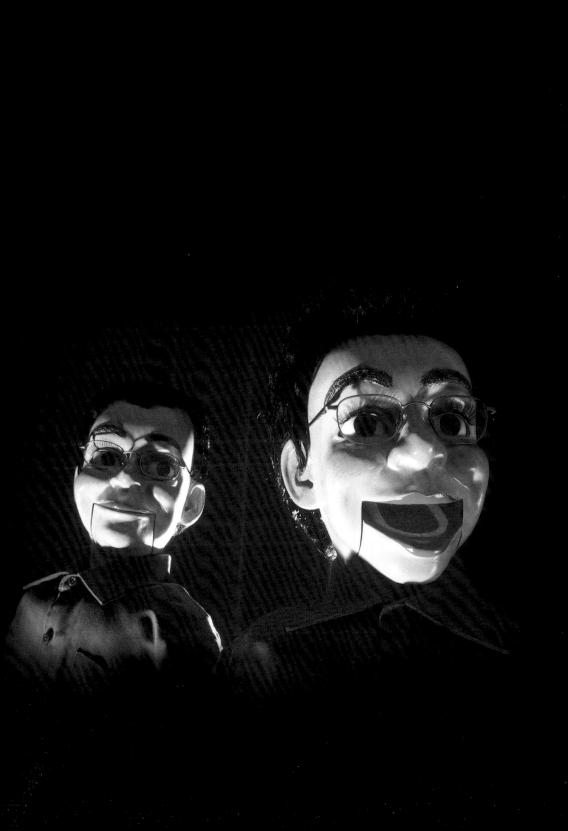

Karla Black

Karla Black's abstract sculptures explore material and physical experience as a way of communicating and understanding the world around us. She is interested in ideas of play and early childhood learning as well as the raw creative moment when art comes into being. She explores the capabilities of materials as well as the limits of what sculpture can be.

Usually made in response to the space where they will be shown, and often created with ephemeral materials, her works have ranged from delicate cellophane, paper and polythene hanging pieces suspended with ribbon or tape to large-scale floor-based sculptures made from plaster, chalk powder and soil.

Black skillfully draws out and plays with the physical properties of everyday materials such as soap, eye shadow, cotton wool, petroleum jelly, toothpaste and lip-gloss. She uses these in combination with traditional art supplies to invite us to understand them in a new and different way. Although many of the materials used may serve as a reminder of the intimate, daily acts that are commonly associated with women, such as applying make-up and domestic chores, Black does not select them for this reason. Instead her concern is with the physical merits of matter: its texture, colour and feel, rather than any cultural connotations. Similarly the artist's regular use of pale pastel colours, in particular her fondness for baby blues and pinks, is not intended as a comment on gender.

Many of Black's sculptures have the appearance of hovering on the border between existence and collapse. Sometimes they seem as though on the point of breakdown, or conversely, as if they are floating unaided. This is true of her 2010 hanging work *There Can Be No Arguments*. A dusting of baby-pink plaster powder clings to the surface of a large polythene sheet, transformed from its original state into a delicately draped, elongated knotted form. Suspended from invisible thread, the work appears weightless and drifting, but as with all of Black's works *There Can Be No Arguments* has a commanding authority despite the apparent fragility of the materials used. Its ambiguous title, a seemingly definitive statement, invites us to consider the relationship between the use of language as a means of communicating and our understanding of the world through physical experience. **J-AD**

GENERATION LOCATION
Edinburgh: Scottish National Gallery.

BIOGRAPHY
Karla Black (born 1972 in Alexandria, Dunbartonshire) studied Sculpture at The Glasgow School of Art from 1995 to 1999. She gained an MPhil in Art in Organisational Contexts (1999–2000), and her MFA in 2002–4. Solo exhibitions have been staged at the Institute of Contemporary Art, Philadelphia (2013), the Gallery of Modern Art, Glasgow (2012), and the Migros Museum, Zurich (2009), among others. Her works are held within many prestigious collections including the Scottish National Gallery of Modern Art, The Hammer Museum, LA, and Tate. In 2011 she represented Scotland at the 54th Venice Biennale, and she was nominated for the Turner Prize in the same year. She lives and works in Glasgow.

FURTHER READING
Karla Black, The Fruitmarket Gallery, Edinburgh, 2011

Heike Munder *et al.*, *Karla Black: It's Proof That Counts*, Zurich, 2010

Karla Black: Mistakes Made Away from Home, Mary Mary, Glasgow, 2008

Foreground to background:
Forgetting Isn't Trying, Don't Depend, At Base, Walk Away From Gilded Rooms, At Fault, Brains Are Really Everything, 2011
Installation view: *Scotland + Venice*, 2011
Commissioned by The Fruitmarket Gallery

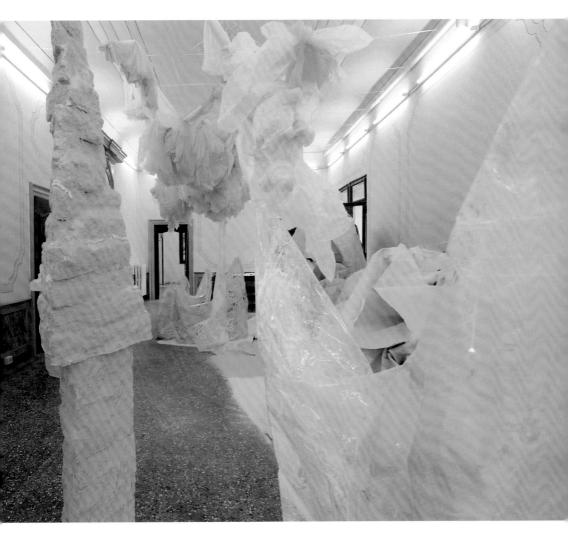

Christine Borland

Christine Borland is an artist who draws on the skills and expertise of other disciplines in her work, particularly from the field of science. Several early works referred to forensic science and the techniques used in solving crimes, made familiar through many a TV drama series. Other major works developed through direct collaborations and discussions with specialists in human genetics and other related areas of study.

A project entitled *From Life*, first shown at Tramway, Glasgow, in 1994, involved collaborating with a range of specialists, including medical artists and forensic anthropologists working on facial reconstruction, using both computer-generated imaging and portrait busts in plaster and clay. Borland's starting point was the purchase from a medical supplies company of a human skeleton, which she then set about studying with the various specialists. The exhibition included both the original skeleton and a classical, bronze portrait bust based on the facial reconstruction process. The process was an attempt to return the anonymous object of study to being understood as a specific, individual human.

A related work, *L'Homme Double* was first exhibited in 1997. Borland asked six different artists, all sculptors, to make a clay portrait bust of the notorious Nazi war criminal Josef Mengele (1911–1979), known as 'the Angel of Death'. Borland provided each of the six artists with exactly the same information on which they were to base their portraits: two grainy, black-and-white portrait photographs and some short descriptions of Mengele's physical appearance. The portrait busts are all different, each presented on a simple wooden frame as if straight from the artist's studio. Each is made of clay and left unfired, emphasising the overall lack of certainty and finality. When seen together, the six portraits do not provide a clear, recognisable, singular identity, but a number of possibilities.

With these and many other works, Borland has questioned how we identify truth, or objective, scientific fact and fused traditional, conventional forms and materials of art – such as the use of bronze or ceramics – with advanced, new technologies. Her work is always mindful of the fact that how we look affects what and how we understand. **KB**

GENERATION LOCATIONS
Ayr: Maclaurin Art Gallery.
Dumfries: Gracefield Arts
Centre. Edinburgh: City Art
Centre; Scottish National
Gallery. Kilmarnock: Dick
Institute.

BIOGRAPHY
Christine Borland (born 1965
in Darvel, Ayrshire) studied
at The Glasgow School of Art
and the University of Ulster,
Belfast. Borland's work has been
exhibited widely internationally,
including the *Aperto* exhibition
at the 45th Venice Biennale
(1993) and *Sculpture: Projects in
Münster* (1997), when she was
also shortlisted for the Turner
Prize. Recent solo shows have
included those at Glasgow
Sculpture Studios (2010) and
Camden Arts Centre, London
(2011), and a collaborative
project with Brody Condon for
Edinburgh Art Festival (2012).
The University of Glasgow
commissioned a permanent
installation in the grounds of the
Reading Room in 2001. Borland
is BALTIC Professor at the BxNU
Institute of Contemporary
Art. She lives and works in
Kilcreggan, Argyll.

FURTHER READING
Christine Borland: Preserves, The
Fruitmarket Gallery, Edinburgh,
2006

L'Homme Double (The Double)
1997
Clay, steel, wood, acrylic, documents
Installation view: Sammlung Migros
Museum für Gegenwartskunst

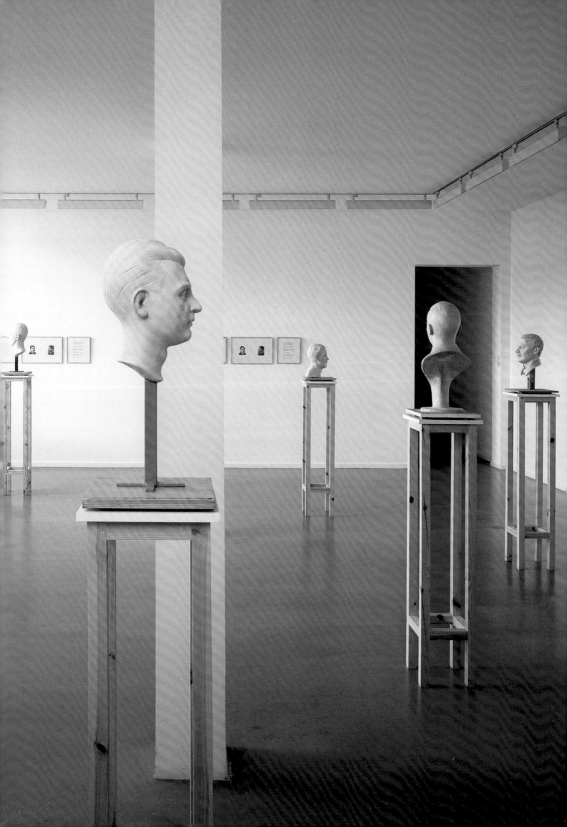

Martin Boyce

Martin Boyce works across a range of media including sculpture, installation and photography as well as wall paintings and fictional text. At the core of his work is an exploration of modernist design and specifically how time has affected our understanding of design objects.

Now I've got real worry (Mask and L-bar) from 1998–9 is an example of an early work in which Boyce has deconstructed two modernist objects by the iconic American designers Charles and Ray Eames, making the leg splint into a tribal mask and the L-bar into a spear. In works such as this, Boyce compares the culture in which the objects were originally produced, in this case the optimism surrounding the post-war boom in manufacturing, to their position today as collectable art objects.

Boyce's interest in modernist design was reinforced when he discovered a photograph of the concrete trees created by the sculptors Joël and Jan Martel for the 1925 Parisian Exhibition of Decorative Arts. This marks the departure point for his recent work. From the Martels' decidedly cubist-inspired interpretation of nature, Boyce devised his own grid-based vocabulary of geometric shapes that he has since used as a basis for all aspects of his art. He also created his own font of angular letters, which has allowed Boyce to develop his interest in language and narrative.

Installation plays a significant role in Boyce's art. His distinct awareness of space and its effect on the viewer was honed through his education's focus on art for the public realm. Recalling familiar public spaces such as playgrounds, pedestrian walkways and abandoned or disused sites, Boyce's installations often have a ghostly or somewhat disquieting atmosphere. His 2002 installation *Our Love is Like the Flowers, the Rain, the Sea and the Hours* at Tramway, Glasgow, transformed the gallery space into a darkened urban park, the only light emanating from trees constructed from tubular lamps. Such stage-sets create an imagined world where the past, present and future mix. Boyce merges the natural and the constructed, the populated and the uninhabited, the real and the imaginary, to create a melancholy interpretation of an unnamed landscape. **ShC**

GENERATION LOCATIONS
Edinburgh: City Art Centre;
Scottish National Gallery.

BIOGRAPHY
Martin Boyce (born 1967 in Hamilton) studied Environmental Art at The Glasgow School of Art from 1987 to 1990, before completing an MFA in 1997. Boyce has exhibited internationally in group shows such as *Modern British Sculpture* at the Royal Academy, London (2011) and *Nettverk Glasgow*, Oslo (1998). His solo shows include his critically acclaimed installation at Tramway, Glasgow (2002) and an exhibition at The Fruitmarket Gallery, Edinburgh (1999). In 2009 he represented Scotland at the 53rd Venice Biennale with *No Reflections* and in 2011 he was awarded the Turner Prize. He lives and works in Glasgow.

FURTHER READING
Martin Boyce: No Reflections, Dundee Contemporary Arts, 2009

Martin Boyce, JRP|Ringier, Zurich, 2009

Our Love is Like the Flowers, the Rain, the Sea and the Hours, 2002
Powder-coated steel, fluorescent light components, chain-link fencing, wood, DVD projection
Installation view: Tramway, Glasgow, 2002
Collection of Glasgow City Council, Glasgow Life (Glasgow Museums)

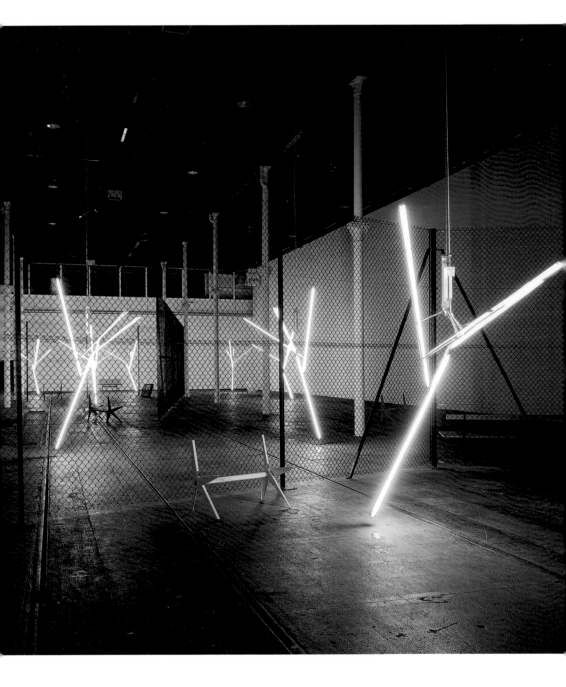

→ Roderick Buchanan

Roderick Buchanan focuses on what shapes our identity and to what extent we shape our own. He asks these questions by looking from the outside in, usually through making photographs, videos and sculptures. Sometimes he uses methods similar to portraiture to investigate whether sport, culture and clothes say something about who we are.

Buchanan looks at the groups or 'clans' we divide ourselves into, often using his native Scotland as an example. Sectarianism, and its links with football and music, has been a focal point of his art throughout his career. *I am Here* (2007) presents us with a Loyalist flute band playing on one screen and a Republican flute band on the other. There are religious and cultural tensions in Scotland between Protestants and Catholics, often linked to the Irish heritage that lies behind them. By placing these videos side by side, Buchanan compares the two cultures in a thoughtful and optimistic way.

In *Sodastream* (1995) he light-heartedly explored the smaller details of Scottish identity. Garvie's soft drinks were once a national alternative to the global giants. In this video, each candy-coloured flavour of these bottles smashes to the ground. In 1970s Scotland a bottle of soda was a symbol of status for a kid. In a mischievous kind of street game, each bottle leaves a fizzy, abstract mess in its wake. The video is both a cheery appreciation of the drink and a poignant reminder of the growth of larger, faceless corporations.

Gobstopper (1999) shows different children trying to hold their breath as they pass through Glasgow's Clyde Tunnel. Filmed in a campervan, it shows the fun of such a simple game. Buchanan remembers playing this game as a child and viewers may find themselves trying to take part in the 50-second challenge. The children are all united in their efforts to 'win'. Here, perhaps less obviously than in other works by the artist, the video contains both the competitive and social elements of sport. *Gobstopper* demonstrates the way in which games can join us together by evoking a memory of the game or a general nostalgia for childhood. Roderick Buchanan has the ability to bring viewers together with work that speaks both to those who have specialised knowledge of art and those who do not. **SMCG**

GENERATION LOCATION
Edinburgh: Scottish National Gallery of Modern Art.

BIOGRAPHY
Roderick Buchanan (born 1965 in Glasgow) was educated at The Glasgow School of Art (1984–9) and then the University of Ulster (1989–90). Over the years he has exhibited internationally, including solo shows in Europe, Asia and the United States. In 2000, he was awarded the first Beck's Futures Prize. He currently lives and works in Glasgow.

FURTHER READING
Jan Verwoert and Steven Bode, *Portraits,* Film and Video Umbrella, London, 2005

Ross Sinclair *et al., Players,* Dundee Contemporary Arts, 2000

Work in Progress (detail), 1995
39 photographs, mounted and laminated onto rigid PVC plus vinyl lettering
Scottish National Gallery of Modern Art, Edinburgh

Duncan Campbell

Filmmaker and artist Duncan Campbell works in many ways including constructing documentary-like narratives from archival footage. He often builds up profiles of significant public figures, while interspersing found film with material he shoots himself. In several of his films Campbell has investigated subjects and people closely associated with Northern Ireland and the country's social and political history, revealing a side to the subject not commonly portrayed in the mainstream media.

Campbell's film *Bernadette* (2008) portrays socialist and former Northern Irish MP Bernadette Devlin during the 1960s and 1970s. When elected at the age of twenty-one, Devlin became the youngest female Member of Parliament ever to have been elected to Westminster. Campbell's depiction of her reveals the dynamics of documentary filmmaking itself. He blurs fact and fiction and mixes archival and new footage to construct and unravel representations of his subject. Making use of the distance that the passage of time allows, he creates a portrait of Devlin that is free from the political partisanship that has surrounded many depictions of her. John DeLorean (1925–1975) – the maker of the DeLorean car, famous to most through its appearance in the 1985 film *Back to the Future* – is the subject of *Make It New John* (2009).

The starting point for Campbell's recent film *It for others* (2013) was the French filmmakers Chris Marker and Alain Resnais's early collaboration *Les Statues meurent aussi* (*Statues also Die*) from 1953. Marker and Resnais's black-and-white essay film captured the objectification and fetishisation of African artefacts and the impact of colonialism on African heritage. Similarly, *It for others* features an array of related artefacts and archival footage, examining the question of how artefacts and artworks are valued, exchanged, collected or displayed. A choreographed sequence composed in collaboration with dancers from the Michael Clark Company is captured from a bird's-eye view, and seeks to illustrate, in the manner of a moving diagram, how value is accumulated. Here, Campbell acknowledges old and new, while capturing the contemporary contexts in which his new film is born.

St C

GENERATION LOCATION
Glasgow: The Common Guild.

BIOGRAPHY
Duncan Campbell (born 1972 in Dublin) received a BA from the University of Ulster in 1996 and an MFA from The Glasgow School of Art in 1998. Recent solo exhibitions include the self-titled show at the Carnegie Museum of Art, Pittsburgh in 2012; *Arbeit* at Hotel, London in 2011; and *Make It New John*, which was staged in 2009–11 at London's Chisenhale Gallery, Glasgow's Tramway, Sligo's The Model, Belfast Exposed, and New York's Artists Space. In 2013 he participated in *Scotland + Venice* at the 55th Venice Biennale, Campbell also participated in the *British Art Show 7* (2010). He lives and works in Glasgow.

FURTHER READING
Martin Herbert and Melissa Gronlund, *Duncan Campbell*, Film and Video Umbrella, London and Tramway, Glasgow, 2010

It for others (still), 2013
16mm film transferred to digital video
Commissioned by The Common Guild
for *Scotland + Venice*, 2013

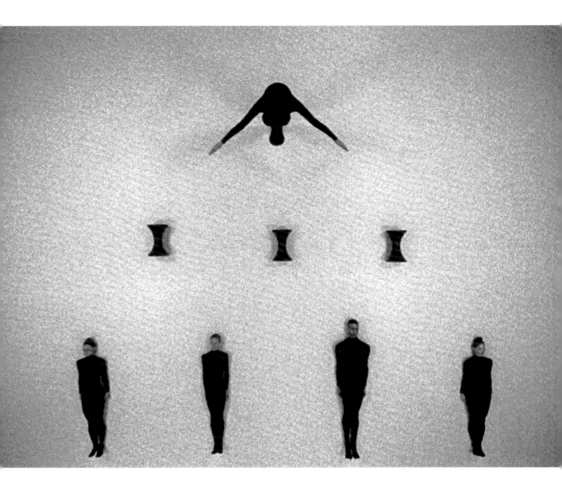

Steven Campbell

Steven Campbell was a painter of complex and often witty works that form a key link between the work of the preceding generation of artists in Scotland and what followed in the 1990s. Campbell insisted that his art had its roots in 1970s British Conceptual art such as the performance art of artists like Bruce McLean and Gilbert & George. Indeed, his paintings retain many of the features of the performances that he made as a student at The Glasgow School of Art: exaggerated gestures, a strong narrative structure and the use of historical events and characters (often from the 1920s and 1930s) to create a claustrophobic, fictional world of bizarre happenings.

In Campbell's paintings from the 1980s, solidly built, tweed-clad young men – scientists, philosophers, architects and artists – are engaged in a quest to find meaning and order in an Alice-in-Wonderland universe. In keeping with the post-modern mood of the times, where knowledge was seen as dependent on historical circumstances and hence changeable, the world that Campbell depicted made no rational sense, although it had a perverse logic, similar to that found in the surrealist paintings of René Magritte (1898–1967).

In his 1990 exhibition *On Form and Fiction*, at Glasgow's Third Eye Centre, Campbell took a compendium of artistic forms and styles and subjected them to absurd fictional plots. He created a museum-like setting, complete with benches borrowed from Kelvingrove Art Gallery and dramatic lighting. The walls were covered with a grid of sepia-ink drawings, framing twelve large acrylic paintings. In addition there was a tape recorder playing amongst other things the infamous 1969 love song by Serge Gainsbourg with Jane Birkin, *Je t'aime … moi non plus*, together with some words spoken by the artist. The show was a carefully staged installation, one might almost say the backdrop for a performance, which played with ideas in a sophisticated manner and, as such, had a big impact on a younger generation of artists in Scotland. In the 1990s and 2000s Campbell's art became darker and less playful in mood, as it reflected the horrors of some of the world's current conflicts. KH

GENERATION LOCATION
Edinburgh: Scottish National Gallery.

BIOGRAPHY
Steven Campbell (born 1953 in Glasgow) worked as an engineer in a steelworks from 1970 to 1977 before studying at The Glasgow School of Art from 1978 to 1982. In 1982 he was awarded a Fulbright Scholarship and studied at the Pratt Institute in New York. He had highly successful shows in New York in 1983, which led to exhibitions in London and Edinburgh in 1984–5. He moved back to Glasgow in 1986. He was included in the exhibition *The Vigorous Imagination: New Scottish Art* in Edinburgh in 1987. He was Artist-in-Residence at the Art Gallery of New South Wales, Sydney in 1990. He showed frequently in London, Glasgow and Edinburgh from 1987 to 2004. He died in 2007.

FURTHER READING
Duncan Macmillan, *The Paintings of Steven Campbell: The Story So Far*, Mainstream Publishing Company, Edinburgh, 1993

Steven Campbell, On Form and Fiction, Third Eye Centre, Glasgow, 1990

Steven Campbell, New Paintings, Riverside Studios, London and The Fruitmarket Gallery, Edinburgh, 1984

On Form and Fiction, 1990
Installation view: *On Form and Fiction*, The Third Eye Centre, Glasgow, 1990

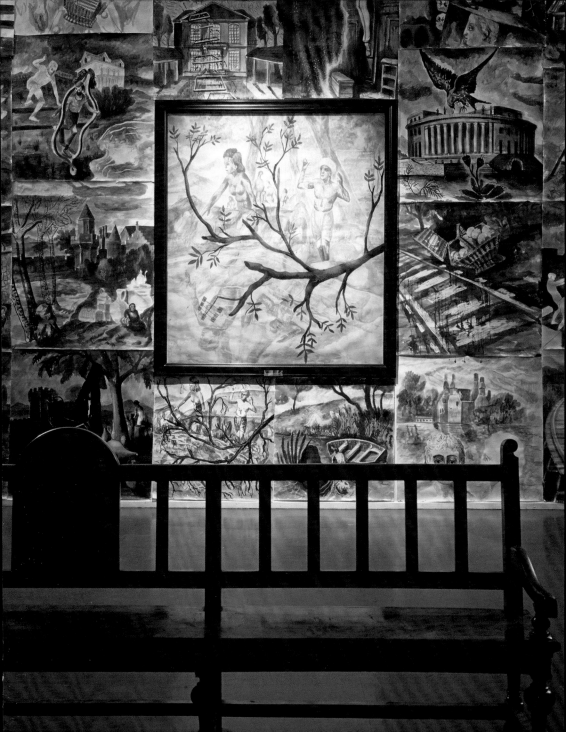

Paul Carter

Faith was an important concern for the artist Paul Carter, who was a key figure in the Scottish art scene and an influential teacher at Edinburgh College of Art. Being agnostic, or undecided about the existence of god, drove Carter to question faith and belief systems in general, including politics and our assumptions about the role of art. Carter's own art was full of visions and miracles, as well as ingeniously home-made contraptions, but at its heart lay a deep questioning of our expectations of both this world and the next.

For GENERATION the works on show at Edinburgh Sculpture Workshop have been drawn from two key exhibitions: *Icaro Menippus* at Chapter Gallery, Cardiff (2002) and *Edge of Darkness* at The Fruitmarket Gallery, Edinburgh (2003). Both dealt with questions of pioneering.

Daedalus (2002) is a floating allotment that draws on ideas of anarchist gardening and eco-activism, but also on the 1972 sci-fi movie *Silent Running* in which a rogue captain saves a spacecraft of botanical specimens after the extinction of plant life on Earth. The theme is developed in *Moses Basket* (2002), a clear balloon somewhat inadequately designed to transport its inhabitant into space.

Light and dark were strong features of Carter's exhibitions in practical terms and in their associations. In the work *13* (2002), set in a darkened gallery, light flooding out through a punctured wall gives peephole access to an ominous abandoned room – the scene of a crime or terrible accident. Stepping back from the work, the pattern of light coalesces into the image of a face, which might be that of Jesus or Che Guevara, as though created by the splatter effect of gunshot. Carter's interest in such figures was an examination of the power and economy of their images in popular culture.

In one of his best-known public projects, Carter worked with young people at Royston Youth Action, Glasgow setting up a transceiver on the Royston Spire in 2002. Messages from the local community were beamed into space. To date no response has been received. Carter's support for peers and young artists was generous and decisive. If many of his artworks suggest that the search for spiritual or artistic satisfaction was an individual, and at times futile, quest, they also remind us that the effort is worth it. **SM**

GENERATION LOCATION
Edinburgh: Edinburgh Sculpture Workshop.

BIOGRAPHY
Paul Carter (1970–2006) studied Sculpture at Edinburgh College of Art and completed his MFA at The Glasgow School of Art (1995). His solo exhibitions and projects included: *Edge of Darkness*, The Fruitmarket Gallery, Edinburgh (2003); *Icaro Menippus*, Chapter, Cardiff (2002); *Chapel Barbarossa*, Deveron Arts, Huntly, Aberdeenshire; and shows at Embassy, Collective and the Travelling Gallery, Edinburgh and Transmission Gallery, Glasgow. His many group exhibitions included the *Yugoslav Biennial* (2004), *Angst* at the Künstlerhaus Dortmund (2002) and *Art in The Home* in Yamaguchi (2001). He taught at Edinburgh College of Art from 1997 to 2006.

FURTHER READING
Edge of Darkness, The Fruitmarket Gallery, Edinburgh, 2003

1 Second Revolution, 2004
Performance to camera

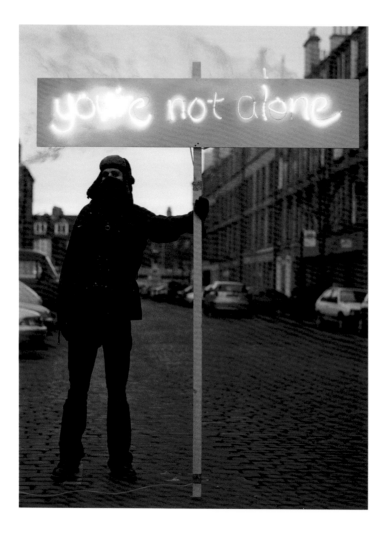

Rob Churm

Whether working on a white sheet of paper or the stage of a darkened nightclub, Rob Churm fills empty space with experiment and fluid improvisation. Churm studied fine art and makes drawings, prints and wall-drawings, but his current career as an artist developed in tandem with his long-term involvement in Glasgow's independent music scene. He sings and plays guitar with his current band Gummy Stumps. Creating posters and artwork for bands helped Churm develop his bold mark-making, his keen sense of graphic technique, and his use of everyday materials such as biro, Tipp-Ex®, felt-tip pen and photocopy toner. The informal world of music, with its culture of fanzines and do-it-yourself publishing, has also supported his fascination with outdated formats from the flexi disc to the old-fashioned printed newspaper. For GENERATION he has produced a series of works on paper, using drawing and printmaking techniques. His work appears unruly, but it is often set within rigid boundaries.

Churm's art calls on such diverse sources as punk rock visuals, comics, Japanese prints, occult illustrations and surrealist periodicals. His monochrome drawings meld areas of dense grids or cross-hatched marks with fluid lines and empty spaces. His more recent works in colour draw on a long tradition of printmaking that includes figures like William Blake (1757–1827). But a work like the coloured etching Angel Reading (2011) is both modern – there is more than a hint of the psychedelic in the rainbow pattern that surrounds his angel, and more prosaic – she is ascending heavenward powered by what might be a cartoonish fart.

Churm is responsible for programming at The Old Hairdressers, a small Glasgow venue that is as much an independent art centre as a club. Along with the artists Tony Swain and Raydale Dower he curated Le Drapeau Noir, an artists' café and cabaret instigated there by Dower in 2010 for the Glasgow International Festival. At the next festival, in 2012, Churm worked with artists Rebecca Wilcox, Ben Ashton and Oliver Pitt to produce a daily edition entitled Prawn's Pee. The title is an anagram of 'newspaper' and contributors were encouraged to re-imagine their work, to play with formats and to help create a space for new ideas. MJ

GENERATION LOCATION
Dundee: Dundee Contemporary Arts.

BIOGRAPHY
Rob Churm (born 1979 in Leighton Buzzard) graduated from The Glasgow School of Art in 2001. Recent solo exhibitions include The Glasgow Weekend at BQ, Berlin (2013), Exhaustion Hook at Sorcha Dallas, Glasgow (2011) and Ethanol Buzzgrid at the Gallery of Modern Art, Glasgow (2009). Group shows and projects include: Prawn's Pee, Glasgow International festival (2012); Le Drapeau Noir, Glasgow (2010); Singing Yoghurt, Log, Bergamo, Italy (2009); and If Not Now, Broadway 1602, New York (2006). He undertook a residency at Cove Park on the west coast of Scotland in 2013.

FURTHER READING
Rob Churm and Sorcha Dallas (eds), Rob Churm Under Key Seventeen, Argobooks, Berlin, 2008

Angel (Reading), 2011
Etching on paper

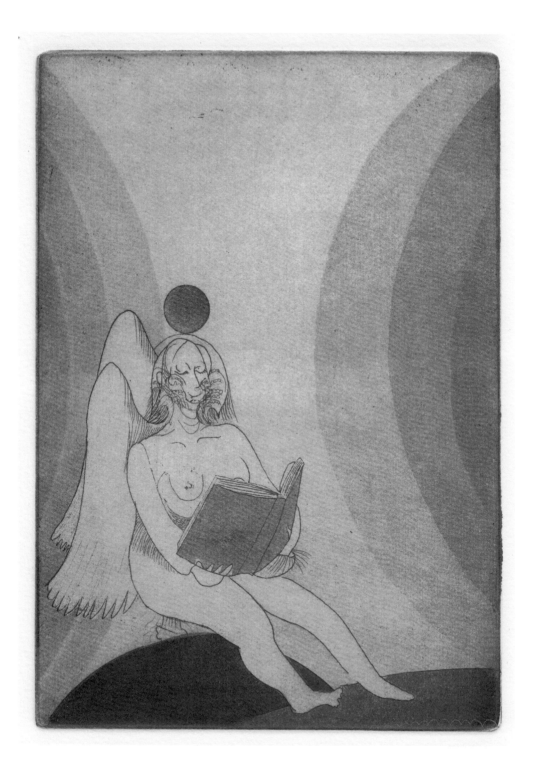

→ Nathan Coley

Throughout his work, Nathan Coley expresses curiosity about how we relate to public spaces and architecture. He is also interested in what we believe. His research informs drawings, photographs, sculptures and videos that often contain words or phrases.

His work *There Will Be No Miracles Here* (2006) explores belief. The phrase is spelled out in lit bulbs on bare metal scaffolding. The brightness and size of *There Will Be No Miracles Here* make it a spectacle, while the gaps in its frame include its chosen backdrop as part of the work. The factor of surprise in this piece, like much of the artist's work, also expresses an element of humour. The words seem like a regulation – Coley adopted them from a sign that was once erected in a village in seventeenth-century France by order of the King.

The Lamp of Sacrifice, 286 Places of Worship, Edinburgh 2004 is an installation of sculptures made up of all 286 religious and spiritual buildings that were listed in the 2004 Edinburgh *Yellow Pages* directory under 'places of worship'. A mammoth task, Coley had previously undertaken a similar work with *The Lamp of Sacrifice, 161 Places of Worship, Birmingham 2000*. In Birmingham, Coley made the models over the course of seven weeks in front of visitors to the Ikon Gallery.

Coley adopted the idea of an architectural 'Lamp of Sacrifice' from the Victorian artist and critic John Ruskin (1819–1900), who wrote in his famed 1849 essay *The Seven Lamps of Architecture*: 'It is not the church we want, but the sacrifice ….' Coley explores Ruskin's idea that buildings and architecture are two separate things – one being functional and the other art. Coley strips all religious insignia from the buildings and reconstructs them to scale in simple brown cardboard. He unites the buildings as one group or community. As fewer people go to church and the diversity of different areas shifts, the cardboard models offer a playful and abstract perspective on the buildings. Physically they represent buildings but emotionally they are religious architecture and in equal measure baffle and enlighten people. Nathan Coley doesn't provide answers, but he does inspire those who see his work to ask questions. **SMcG**

GENERATION LOCATIONS
Edinburgh: City Art Centre.
Glasgow: Gallery of Modern Art.

BIOGRAPHY
Nathan Coley (born 1967 in Glasgow) studied at The Glasgow School of Art from 1985 to 1989. From 1998 to 2005 he lived and worked in Dundee. In 2007 he was shortlisted for the Turner Prize. His work is represented in many international public and private collections. He currently lives and works in Glasgow.

FURTHER READING
Lisa Le Feuvre, *Nathan Coley*, Hatje Cantz, Berlin, 2014

Andrea Schlieker and Andrew McLean, *Nathan Coley*, The Mount Stuart Trust, Isle of Bute, 2006

The Lamp of Sacrifice, 286 Places of Worship, Edinburgh, 2004,
2004
286 cardboard models;
2 photocopied and annotated pages from *Yellow Pages* (Edinburgh)
Scottish National Gallery of Modern Art, Edinburgh
A Fruitmarket Gallery / Bloomberg Commission: purchased with funds from the Cecil and Mary Gibson Bequest 2004

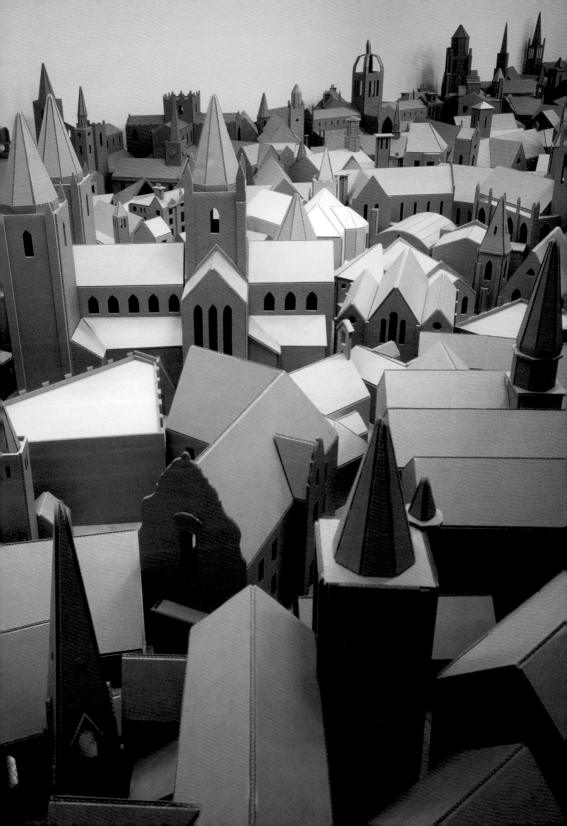

Henry Coombes

Henry Coombes explores hierarchy and power in the family and in wider society. He is particularly interested in the experience of the artist and how he must deal with the machinations of the art world. His work includes painting, collage, drawing and sculpture, but he is best known for his short films – character portraits for which he creates intricate sets that allow him to explore historical themes.

The Bedfords (2009) is a brooding re-imagining of the relationship between the celebrated Victorian painter Edwin Landseer (1802–1873) and the Duke and Duchess of Bedford. Landseer, a prodigious artist known for his landscapes and animal portraits, had a long-standing love affair with the Scottish Highlands. It is in this landscape that we see Landseer's romantic affair with the Duchess of Bedford and his subsequent psychological breakdown. Coombes's most recent film, *Two Discs and a Zed* (2013), filmed partly within the National Galleries of Scotland, continues his focus on the work of Landseer and is part of an ongoing project to complete a feature film about the latter artist.

There is a fluid relationship between Coombes's films and his work in painting and sculpture. He uses materials such as delicate watercolour, rough wood and bare plaster to create objects and images that slip between the naturalistic and the surreal. This unsettles our understanding of their function and role in the world – a sense that is heightened by the fact that the artist uses them in his film productions. Coombes has a peculiarly dark wit, seen throughout his work but perhaps best illustrated in his short, no-budget films, which are made on hand-held cameras. Every aspect of production is controlled by the artist and we see Coombes at his most caustic and self-deprecating. These short films act as sketches: vignettes that communicate subversive alternatives to the mundane and everyday. Often filmed from a window, commenting on action happening on the street below or within a domestic interior, they position the persona of the artist as at once commander of the landscape around him and at the same time as isolated eccentric, troubled by his own inability to navigate the world outside of the studio. LY

GENERATION LOCATION
Edinburgh: Scottish National Gallery of Modern Art.

BIOGRAPHY
Henry Coombes (born 1977 in London) studied at the London International Film School and Central Saint Martins before completing his BA at The Glasgow School of Art in 2002. Solo exhibitions include: a presentation at the Sydney Biennale (2014); *Man of the Year*, CCA, Glasgow (2013); *Henry Coombes*, Hammer Museum, Los Angeles (2008); *Solo Show*, Suzie Q Project Space, Zurich (2008); *Black Button*, Cooper Gallery, Dundee (2007); and *Solo Show*, Anna Helwing, Los Angeles (2006). He represented Scotland at the 52nd Venice Biennale in 2007. He was nominated for the Jarman Film Award in 2014. He lives and works in Glasgow.

FURTHER READING
Open Frequency: Henry Coombes, archived Scottish Arts Council website (www.scottisharts.org.uk)

Jac Mantle, 'Henry Coombes – The Twilight Zone', *The Skinny*, 1 February 2013

Alexander Kennedy, 'Visual art: Henry Coombes', *The List*, 20 July 2006

The Bedfords (still), 2009
16mm film
Written and directed by Henry Coombes, produced by Ciara Barry. Brocken Spectre Production, 2009

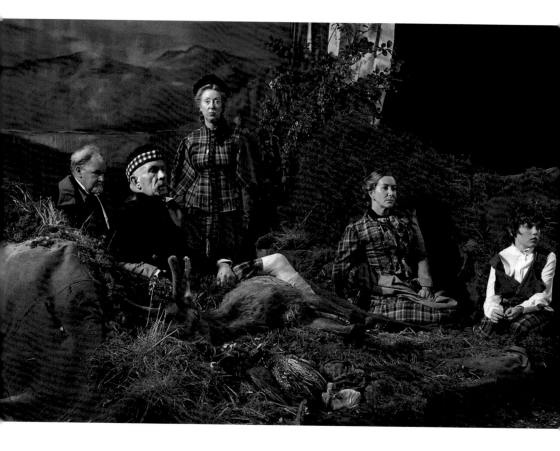

Craig Coulthard

Craig Coulthard is interested in the way that, despite our expectations, tradition never actually stays still. It is invented and reinvented as times change. Coulthard is an artist and musician who works with ideas and events as well as film and objects. From folk music to football, he tweaks traditional forms or familiar occasions to play with our ideas of memory, history, conflict and belonging.

His best-known work to date is *Forest Pitch*, commissioned by the Cultural Olympiad in 2012, a brand new football pitch in the heart of a forest in the Scottish Borders. Only two matches were ever played there and the pitch has since deliberately been left untended. The players were amateurs living in Scotland, most of whom had recently become British citizens or been granted 'exceptional leave to remain' in the UK. They thus reflected the way that national identity, and our assumptions about what it might mean to be Scottish or British, can be fluid rather than fixed. The rural setting questioned our ideas of nature. By clearing an area of unnatural commercial forestry, it actually prepared the way for the gradual return of a natural habitat.

Born to an air force family, Coulthard is also fascinated by our attitudes to military traditions. His work *An Exchange of Value (1)* (2013) is one of a series of carpets made for the artist in Afghanistan. Fascinated by the way that traditional carpet-making had been adapted to include images of recent armed conflict, he commissioned a series of rugs from different makers each featuring the same retirement portrait of his father in his RAF uniform.

The Drummer and The Drone, Coulthard's film commissioned for the Edinburgh Art Festival, draws on a simple association to explore a complex idea. The word 'drone' in music means a sustained sound. In bagpipes, pipes known as drones can sustain a long note without the need for the player's attention. In recent years the word has become associated with unmanned aerial vehicles. Drones have massive potential. But armed drones are controversially used by the United States and the UK in combat missions. Coulthard's film draws on the ambiguities of our relationship with machines, using the musical rhythms of both military music and the distinctive sound of the pibroch – a type of solo lament played on the Highland bagpipe. **MJ**

GENERATION LOCATIONS
Edinburgh: Edinburgh Art Festival Commission.
Various: Travelling Gallery.

BIOGRAPHY
Craig Coulthard (born 1981 in Rinteln, West Germany) completed his BA (Hons) (2002) and MFA (2006) at Edinburgh College of Art. He took part in Bloomberg New Contemporaries in 2005 and the Athens Biennale in 2006. His major public work *Forest Pitch* was the Scottish commission for Artists Taking the Lead, part of the London 2012 Festival & Cultural Olympiad. Recent solo shows include *Know Yr Grammar, Billboard for Edinburgh*, at the Ingleby Gallery, Edinburgh in 2012; *Selected Works 2004–2010*, Outbye Gallery, Pittenweem (2010); and *Der Die Das*, Atelier Höherweg, Düsseldorf (2008). He lives and works in London.

FURTHER READING
Forest Pitch, Second Century Press, Edinburgh, 2013

An Exchange of Value (1), 2013
Hand-knotted woollen rug

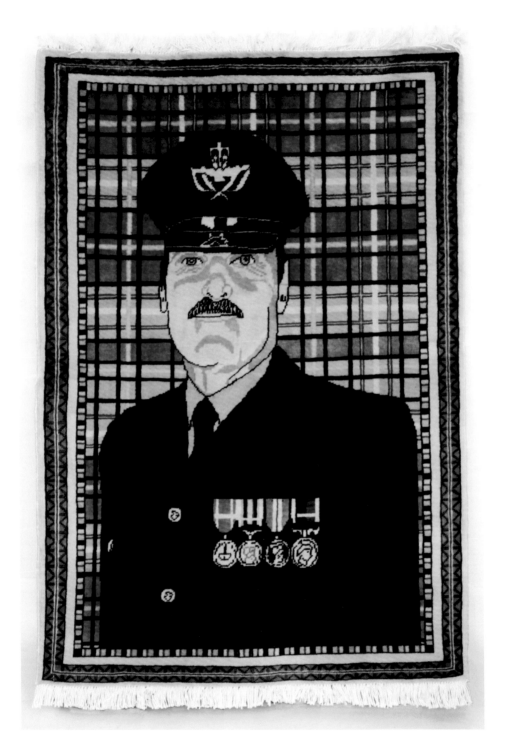

Alan Currall

Many of Alan Currall's inexpensively shot videos feature the artist himself. Their low-tech nature contrasts with the complexity of the ideas behind them. Although his works are full of humour, they often contain an element of tragicomedy. Currall playfully explores serious themes including morality, belief and ignorance.

Currall is the narrator in *Word Processing* (1995). A hand stabs fingers at the table and pompously instructs a tiny microchip to do as he bids. Like much of Currall's work, this video takes the form of a monologue. Here he tells the small and unresponsive object to form letters and numbers on a screen that we cannot see. We all expect computers to interact with us instantly. When they don't, our frustration with them sometimes seems like a one-sided conversation. The microchip looks remarkably like an insect. Rather than contrasting the worlds of technology and nature, here they are intermingled. *Word Processing* suggests both a comic theory of how technology might work by human coaxing and suggestion, and a more deep-seated exposure of our ignorance of the science behind computers.

Jetsam (1995) presents us with a deadpan Currall acting as an alien being. His mothership has crashed on the shores of Scotland and he has taken on human appearance. The alien Currall has decided to become an artist and has got a job at art school. The silliness of the scenario is entertaining. Yet day-to-day we all adopt roles and titles. Why do we decide to become certain people? Currall's work reminds us that the word 'alien' comes from the Latin for 'foreign' or 'other'. We can all relate to being aliens at some point. *Jetsam* reflects the insecurities and humour that come with acting up to our own adopted identities. Currall's work uses simple technology and simple scenarios to expose the limits on our ability to understand and communicate information and the lengths to which we will sometimes go to disguise that. SMCG

GENERATION LOCATION
Glasgow: Riverside Museum.

BIOGRAPHY
Alan Currall (born 1964 in Stoke-on-Trent) completed his MFA at The Glasgow School of Art. He now teaches there and at Edinburgh College of Art. His work has been shown at venues including the Museum of Modern Art, New York; Institute of Contemporary Art, London; Tramway and Gallery of Modern Art, both Glasgow; Kiasma, Helsinki; Stavanger Kulturhus, Stavanger, Norway; and Musée Cantonal des Beaux-Arts, Lausanne, Switzerland. He won the Richard Hough Bursary in 1998. In 2001 he was the Scottish Arts Council Artist-in-Residence at the Australian National University, Canberra. In 2003 he was shortlisted for the Beck's Futures Prize. He lives and works in Wanlockhead, Dumfries and Galloway.

FURTHER READING
Ben Judd, 'Alan Currall', *Art Monthly*, October 2002

Claire Doherty and Sean Cubitt, *Encyclopædia and Other Works*, Film and Video Umbrella, London, 2000

Jetsam (still), 1995
SVHS
Collections of Arts Council of England and Glasgow City Council, Glasgow Life (Glasgow Museums)

Dalziel + Scullion

Matthew Dalziel and Louise Scullion's art explores the complex, and at times strained, relationship between mankind and the natural world. Working together in a broad range of media including photography, video, sound and installation, they produce artworks that offer us the opportunity to think about the various habitats and species we live with. Whilst some of their works bring aspects of nature into the art gallery, others, such as *The Horn* (1997), beside the M8 motorway, *Gold Leaf* (2011) or their recent work *Rosnes Bench* (2013), are installed in the landscape.

The artists' interest in particular landscapes stems from when they lived in the small village of St Combs in the north-east of Scotland and developed following research trips to Norway. Their film *Water Falls Down* (2001), which shows three adults being baptised in the North Sea, reflects the artists' understanding of different involvements in the landscape – in this case a traditional community's respect for and faith in nature. Works such as *Source* (2007) and *Genus* (2003) explore ideas of living in the landscape and human impact upon it. Dealing with questions of freedom and control, Dalziel + Scullion's art often features wildlife, but the animals they portray are sometimes separated from their natural habitat. The opening image of *In The Open Sea* (2002), for example, features a shoal of herring swimming in circles in an aquarium.

Tumadh: Immersion (2014), which has been specially commissioned by An Lanntair in Stornoway and Dovecot Studios in Edinburgh, continues to investigate this idea but contrasts two very different forms of environment – the city of Edinburgh and the Outer Hebrides. In this ambitious work, Dalziel + Scullion explore the way city living disrupts our relationship with nature in comparison with lifestyles that are more in tune with it. In paying particular attention to the specifics of these places, their work encourages us to examine ideas of belief, pilgrimage, cleansing and transformation so as to reawaken our sense of our place in the world. **ShC**

Water Falls Down, 2001
DVD
Scottish National Gallery of Modern Art, Edinburgh

GENERATION LOCATIONS
Ayr: Maclaurin Art Gallery. Dumfries: Gracefield Arts Centre. Edinburgh: Dovecot Studios. Kilmarnock: Dick Institute. Stornoway: An Lanntair.

BIOGRAPHY
Matthew Dalziel and Louise Scullion have collaborated together since 1993. Dalziel (born 1957 in Irvine) studied sculpture at Duncan of Jordanstone College of Art & Design, Dundee (1981–5), Documentary Photography at Newport College, Gwent (1985–7) and Sculpture and Fine Art Photography at The Glasgow School of Art (1987–8). Scullion (born 1966 in Helensburgh) studied Environmental Art at The Glasgow School of Art (1984–8). They have exhibited widely in the UK and internationally, including *General Release: Young British Artists* at the 46th Venice Biennale in 1995. Much of their work involves site-specific commissions. They live and work in Dundee.

FURTHER READING
More Than Us: Dalziel + Scullion, Scottish Natural Heritage, Inverness, 2008

Some Distance from the Sun: Dalziel + Scullion, Peacock Visual Arts, Aberdeen, 2007

Keith Hartley *et al.*, *Home: Dalziel + Scullion*, The Fruitmarket Gallery, Edinburgh, 2001

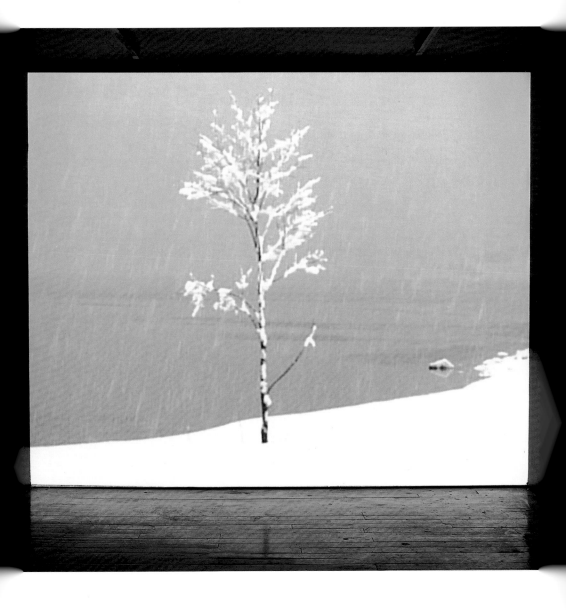

Kate Davis

Kate Davis's work frequently presents imagery and objects that have political, historical or social significance. Her interests are diverse, ranging from how the art of the past can be read in the present, to systems of education and economy and the role of historical events in our lives. Drawing is key for Davis but she also makes sculptures, films and photographs, sometimes combining found objects in her works. Her works often refer to the body in some way: through visual representation, an underlying idea or the way they are made.

Davis has a deep interest in feminism and the way women have been depicted in society and art. In the three drawings that make up the series *Who is a Woman Now?* (2008) she presents images of crumpled postcards that show paintings of female figures by the Dutch/American painter Willem de Kooning. As one of the major figures of the post-war period, de Kooning can be seen to represent the highly masculine approach to painting that dominated Western avant-garde art in the 1950s. Relegating his paintings to a pencil drawing of a cheap reproduction, Davis poses a critical question about the representation and circulation of images of women.

For her exhibition *Eight Blocks or a Field* (2013), Davis investigated the teaching methods of Maria Montessori (1870–1952) and Friedrich Froebel (1782–1852), both of whom believed that touch, play and creativity are central to learning. Davis made drawings, sculptures and a video that all draw attention to the ways objects are used and valued in play. The video, *Denkmal*, shows a child's hands examining domestic items, such as a deck of cards and a camera, which are increasingly being made redundant by new technology. Davis's acutely observed portrait drawings of 'emergent' dolls, made by children living in deprived areas of London in the 1890s from discarded shoes, bone and fabrics, are made in the style of nineteenth-century French artist Jean-Auguste-Dominique Ingres. They reflect on the instinctive impulse to play and create and the notion of how objects are deemed obsolete. **LA**

GENERATION LOCATIONS
Edinburgh: Scottish National Gallery of Modern Art. Glasgow: Glasgow Women's Library.

BIOGRAPHY
Kate Davis (born 1977 in New Zealand) studied at The Glasgow School of Art where she completed a BA in Fine Art (1997–2000) and an MPhil (2000–1). Selected solo exhibitions include those at: Temporary Gallery, Cologne (2013); The Drawing Room, London (2012); CCA, Glasgow (with Faith Wilding) (2010); Tate Britain, London (2007); Galerie Kamm, Berlin (2007 and 2011); Kunsthalle Basel (2006); and Sorcha Dallas, Glasgow (2004 and 2008). Group exhibitions include those at: Art Stations Foundation, Poznan, Poland; Tate Britain, London; Museo Tamayo, Mexico City (all 2013); and *eva International 2012*, Limerick, Ireland (2012). Davis is a lecturer at The Glasgow School of Art. She lives and works in Glasgow.

FURTHER READING
Eight Blocks or a Field: Kate Davis, Temporary Gallery, Cologne, 2013

Dr Dominic Paterson, *Not Just the Perfect Moments,* The Drawing Room, London, 2012

Kate Davis: Role Forward, CCA, Glasgow and Sorcha Dallas, Glasgow, 2010

Who is a Woman Now? (2), 2008
Pencil and screenprint on paper, 170 × 130 cm
Gaby and Wilhelm Schürmann, Germany

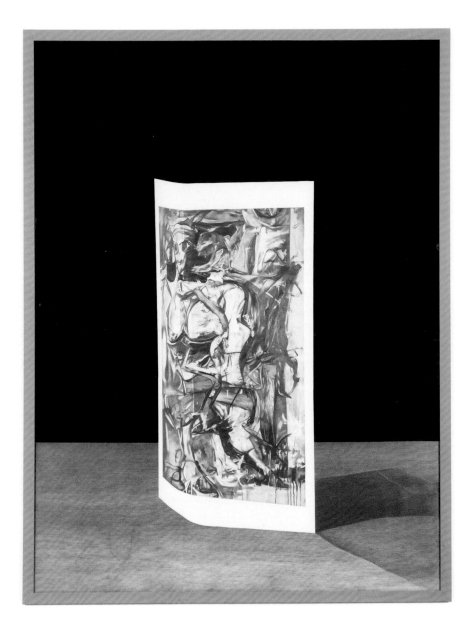

Jacqueline Donachie

Jacqueline Donachie's art deals with ideas of communication, participation and how public spaces are designed, managed and used. Alongside this very public approach, however, is a deeply personal exploration of biomedical research. The artist became interested in this area after several close family members were diagnosed with a genetic illness. Donachie works across a range of materials including drawing, photography, sculpture and installation. For example, *Tomorrow Belongs to Me* (2006), the result of a collaboration with Darren Monckton, a professor of human genetics at the University of Glasgow, is a research project and film installation. It examines the personal impact of illness on individuals and families, but the artist also engaged with the scientific community whose research sought to explain how such illness arose.

The artist also organises temporary events that involve the public. Often these projects will be accompanied by a small book as a means to provide a sense of longevity. She sees these as artworks in their own right. Such ideas reinforce her interest in stimulating a connection with art away from the gallery setting.

In 2009 Donachie undertook a residency with Deveron Arts, in Huntly, Aberdeenshire. Here, the artist was interested in examining the town square and how, like many such places across the country, it has changed from a civic square into a place to park cars. Through discussion with the community she sought to challenge this transformation by restricting vehicular access, and instead offered locals the chance to cycle freely. This culminated in *Huntly Slow Down*, a group cycling parade that encouraged participants to reclaim the now empty roads with improvised chalk dispensers (contrails) attached to their bikes. Hundreds of multicoloured lines were created, mapping cycle routes across the town.

In 2013 Donachie revisited the idea for the Australian Centre for Contemporary Art in Melbourne, where she wanted cyclists to slow down and reconsider the city spaces which they usually raced past on their daily commute. Through participatory events such as these, Donachie shifts established relationships between gallery space, artist and viewer. She creates artworks that question existing patterns of everyday life and encourage us to interact with each other and our surroundings in a more direct and stimulating way. **ShC**

GENERATION LOCATION
Around Scotland: GENERATION
Public Commission. Edinburgh:
Edinburgh Art Festival
Commission.

BIOGRAPHY
Jacqueline Donachie (born 1969 in Glasgow) studied Fine Art at The Glasgow School of Art from 1987 to 1991. She was a committee member at Transmission Gallery, Glasgow, from 1993 to 1995, before going on to an MFA at Hunter College, New York, in 1996. Donachie has exhibited internationally, including the group shows *Here + Now, Scottish Art 1990-2001* at Dundee Contemporary Arts (2001) and *Talking Loud and Sayin' Something* at Gothenburg Museum of Art, Gothenburg (2008), and the solo presentation *Tomorrow Belongs to Me* at The Hunterian, Glasgow (2006). Donachie also creates public, site-specific projects and publishes artist books. She lives and works in Glasgow.

FURTHER READING
Claudia Zeiske and Nuno Sacramento, *ARTocracy*, Deveron Arts, Huntly, 2011

Tomorrow Belongs to Me, University of Glasgow, 2006

Somewhere to Stand: Selected Projects, Talbot Rice Gallery, Edinburgh, 2004

Melbourne Slow Down, 2013
Powdered chalk, plastic dispenser, 100 cyclists
Commissioned by Australian Centre for Contemporary Art, Melbourne for the exhibition *Desire Lines* (2013)

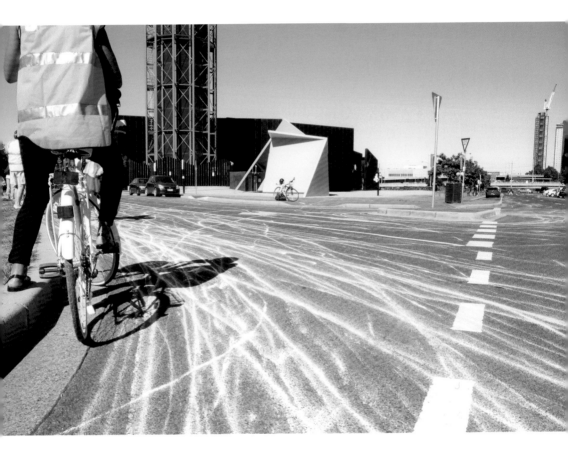

Alex Dordoy

Alex Dordoy aims to expand the traditional flatness of painting and image-making by producing works that explore beyond the limits of the canvas or page and move into the three-dimensional physical world. He makes work across a variety of media including painting, printmaking, wall drawing and sculpture – often blurring the boundaries between each with a playful, innovative and experimental approach to materials.

He is interested in the interplay between the physical and virtual worlds and the combining of new digital technologies with traditional materials. Sourcing material from the Internet, as well as using his own photography, Dordoy uses computer programs such as Photoshop® to create multi-layered and complex collages. He manipulates and layers images, patterns and motifs until resemblance to, and understanding of, the original sources are lost. These constructed images are then transferred onto handmade objects, directly onto gallery walls or meticulously transformed into large-scale paintings.

Folded, Unfolded, Sunk and Scanned is a series of individually cast and sequentially numbered sculptural works that Dordoy has made over recent years. They are produced in Jesmonite® and resemble a delicate, unfolded paper aeroplane. Manipulated images are applied onto the surface through a process of transfer printing. The rich colour and detail from the print is absorbed into the setting Jesmonite, completing the transition from digital information to object.

Alongside working with digital technologies, Dordoy has continued to find fascination in painting. *Milk and Silk* (2013) is taken from two found images that the artist has transformed into a flattened lenticular, an image that changes as you look at it from different angles. One section of the coloured bands is a distorted image of Caster Semenya (a South African middle-distance runner who has appeared in several works by Dordoy), intersected by a black-and-white image of an outstretched hand holding a lit candle, the melting wax pouring over the side of the palm. The artist has accurately reproduced his digital composition onto the canvas, fusing the immediacy of modern technology with the traditional, time-consuming processes involved in painting. **J-AD**

GENERATION LOCATION
Edinburgh: Scottish National Gallery of Modern Art.

BIOGRAPHY
Alex Dordoy (born 1985 in Newcastle upon Tyne) studied on the painting and printmaking course at The Glasgow School of Art, graduating in 2007. He moved to Amsterdam in 2009 to undertake a two-year residency at the independent artists institute, De Ateliers. Important solo exhibitions have included *persistencebeatsresistence* at Inverleith House, Edinburgh (2014), *Krast and Caster Crack Autumn* at Grimm Gallery, Amsterdam (2013), and *Winner* at The Modern Institute, Glasgow (2009). His works are held in public and private institutions around the world including the Scottish National Gallery of Modern Art, Edinburgh and the David Roberts Art Foundation, London. He lives and works in London.

FURTHER READING
Alex Dordoy, The Modern Institute/Toby Webster Ltd, Glasgow, 2012

Chris Sharratt, review of *Alex Dordoy* at The Modern Institute, Glasgow, *Frieze*, issue 147, May 2012

Neil Clements – Alex Dordoy – Morag Keil, Grimm Fine Art, Amsterdam, 2008

Folded, Unfolded, Sunk and Scanned No. 43, 2012
Toner and oil on jesmonite

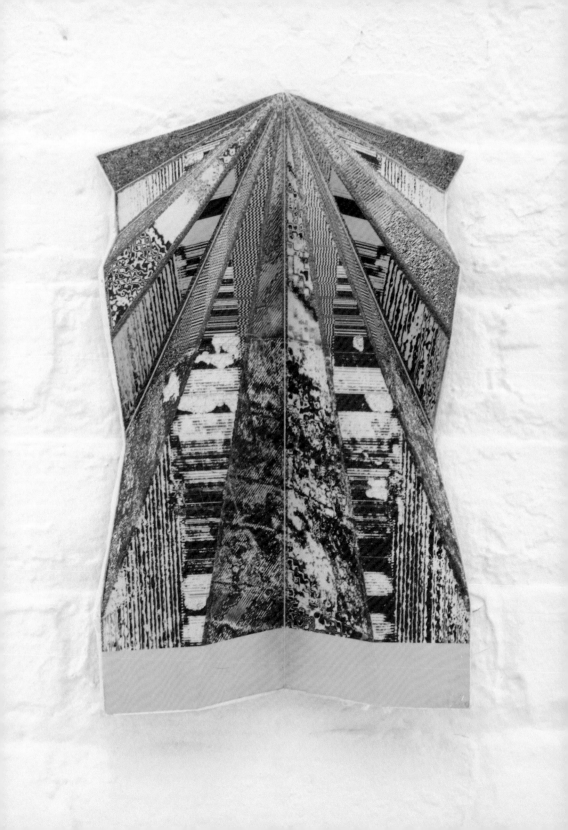

Katy Dove

Working with animation, drawing, painting and printmaking, Katy Dove is interested in the intuitive relationship between sound and image and in the way that both can encapsulate everyday experiences. She is also a musician and often uses specially composed musical scores to accompany her animations, which feature organic and geometric moving forms and colourful patterns. She builds rhythms through their combination. Her drawings and prints evoke similar ideas while using the symbols of musical notation to suggest the abstract qualities of music and the overarching influence it has on her work. Her print *FACE* (2010) is inspired in part by the animator Norman McLaren (1914–1987) and his innovative use of visual notation.

Her recent animation *Meaning in Action* (2013) captures an array of soft pastel colours that are rhythmically revealed on-screen. Overlaying these emerging hues, silhouettes of hands, legs and arms reveal further colours and combinations of colour within them. Dove's use of these bodily features creates new moving forms and suggests movements akin to dance or performance. She uses a heavily distorted guitar-led soundtrack and a chanting vocal build to a crescendo that unites both sound and image, evoking the psychological state suggested by the choreographed movements.

Similar approaches can be found in Dove's earlier animation *October* (2011), in which footage of mountains and forests shot on location were superimposed with drawings rendered in her familiar animation techniques. Here, birds fly across the screen and mingle with hovering animated elements. The influences of nature that feature in the film are mirrored in the work's drawn elements. The foliage forms inspire patterns on-screen while geometric lines appear to draw themselves across the surface of the video. *October* sees Dove's work expand beyond the frame of the animation and draw connections with the wider world.

The artist also collaborates with Anne-Marie Copestake and Ariki Porteous under the name Full Eye. They are interested in mantra, the repetition of words or sounds to aid meditation, and their work includes writing, voice and percussion. In her solo work, Katy Dove creates meditative spaces through the combinations of sound and image and contemplative responses to colour and rhythm. **StC**

GENERATION LOCATIONS
Banff: Duff House.
Dundee: Cooper Gallery.

BIOGRAPHY
Katy Dove (born 1970 in Oxford) received a BA (Hons) from Duncan of Jordanstone College of Art & Design, Dundee, in 1999. The solo show *Thought Becomes Action* (2013) took place at Spacex, Exeter. She has participated in numerous group exhibitions including *Drawn In* (2011) at the Travelling Gallery, Scotland; *Sounds Good* (2011) at Location One, New York; *Blink! Light, Sound & the Moving Image* (2011) at Denver Art Museum; and *Running Time: Artist Films in Scotland from 1960 to Now* (2009) at the Scottish National Gallery of Modern Art, Edinburgh. Dove was a member of the band Muscles of Joy from 2007 to 2011. She lives and works in Glasgow.

FURTHER READING
'Katy Dove and Victoria Morton in conversation', *MAP*, issue 21, Spring 2010

FACE, 2010
Intaglio etching over Hosho chine-collé, 55.5 × 38.5 cm
Signed, numbered and dated by artist on verso

Raydale Dower

From the noise of a piano crashing to the floor to a distorted recording of Beethoven's Fifth Symphony, Glasgow-based artist and musician Raydale Dower creates sculptural installations and events that explore sound, music and our experience of space. Through a combination of objects, performance, sound and musical elements, Dower creates provocative, multi-sensory environments that emphasise the sculptural properties of sound and its cultural associations. Dower's works use acoustic instruments, analogue components and advanced digital technologies to explore the limits of both musical and non-musical sound. He is interested in both the history of music and its modern experimental form, including improvisation. Influences range from electronic and noise music, to Baroque composition and the musical experiments of radical twentieth-century art movements such as Surrealism, Fluxus and Dada.

In 2011 Dower presented *Piano Drop* in the theatre space of Tramway, Glasgow, capturing the catastrophic act of dropping a piano from the ceiling. It used advanced sound technology to dramatise themes of time and sound. The final work consisted of a slow-motion digital reanimation of the original event, presented as a surround-sound installation. Central to this is Dower's interest in gesture, sonic space and sculptural form. He often re-enacts or refers to the work of other artists to explore these themes. For the performance *Beethoven's 5th(X8)* (2010), he re-created a 1920 Stefan Wolpe performance using eight copies of Beethoven's Fifth Symphony on eight turntables at various speeds. This created all manner of mutations and distortions, using cacophony, repetition and silence to explode the structure of the original composition.

Dower's more ambitious works involve theatre, performance and high spectacle, often made through collaboration with other artists and musicians. In 2010 Dower launched *Le Drapeau Noir*, a temporary artists' café and cabaret-style programme of events, developed with fellow artists and musicians Rob Churm and Tony Swain. Presented for the Glasgow International Festival, the café provided a place for improvised performances and situations. *Le Drapeau Noir* became a living sculpture, animated by the audience, artists and performers in equal part. **CJ**

GENERATION LOCATIONS
Dundee: Dundee Contemporary Arts. Glasgow: Tramway – Performance Programme.

BIOGRAPHY
Raydale Dower (born 1973 in Aberdeen) studied Sculpture at Duncan of Jordanstone College of Art & Design, Dundee and received an MDes in Sound for the Moving Image from The Glasgow School of Art. Exhibitions and projects include: *The Glasgow Weekend*, Volksbühne Theatre, Berlin (2013); *Piano Drop*, Tramway, Glasgow (2011) (realised with a Creative Scotland Vital Spark Award); *On Memory and Chance*, The Changing Room, Stirling (2011); *Beethoven's 5th(X8)*, Art Basel, Miami Beach, Miami (2010); *Le Drapeau Noir* for 2010 Glasgow International festival (realised with an Open Glasgow Award); and *The Associates*, Dundee Contemporary Arts (2009). Dower co-founded bands Uncle John & Whitelock (2001–6) and Tut Vu Vu (2007–ongoing). He lives and works in Glasgow.

FURTHER READING
Vexillology Issue No.1: Le Drapeau Noir, Raydale Dower, Glasgow, 2012

Le Drapeau Noir (exterior), 2010
A temporary artists' café and programme of events for Glasgow International 2010

Nick Evans

Nick Evans's bold sculptural installations bring together the imagery and motifs of ancient and lost civilisations with a keen interest in the historical relationship between sculpture and the decorative. His works reinvigorate sculpture by creating new and dynamic forms, combining traditional techniques and materials with a distinctive visual language.

Evans's signature white plaster sculptures combine both abstract and figurative elements. The finished works bear a resemblance to limbless slumped human bodies, tree stumps or found objects. They draw heavily on the works of British sculptors from the mid-twentieth century, most notably Henry Moore and Barbara Hepworth. The artist works with a limited number of moulds, beginning with a single shape which is cast repeatedly and then the casts joined together to create a multitude of possible outcomes. When works are displayed, Evans often leaves the joins visible, allowing a scarred trace of the production process to remain.

The artist often places his plaster forms within elaborate decorative environments – atop tables, on tiled floors, within wallpapered rooms, on revolving plinths – producing a stage or setting for his works. He draws his imagery from a wide range of sources. *Solar Eyes*, his exhibition at Tramway, Glasgow in 2013, brought together references to ancient Mayan and Egyptian pyramids as well as the twentieth-century French sculptor Niki de Saint Phalle. By removing symbols from their original contexts, previous meaning is lost and new associations can be made. Certain motifs crop up time and again within Evans's work, in particular the bone and the tadpole. The tadpole appears within his 2011 installation *Oceania* – composed of three limb-like plaster forms, precariously perched on roughly sawn oak stools and positioned like a family group. A brightly coloured patterned patchwork of screen-printed wooden tiles, lain in a roughly symmetrical style, provides a stage for these works. The ordered nature of this floor design provides a contrast with the unruly plaster bodies and wooden bases above. For GENERATION, The McManus: Dundee's Art Gallery and Museum has invited Evans to produce a large-scale work for its contemporary gallery space. He has used the museum's World Cultures collection as a starting point and inspiration. J-AD

GENERATION LOCATION
Dundee: The McManus: Dundee's Art Gallery and Museum.

BIOGRAPHY
Nick Evans (born 1976 in Mufulira, Zambia) spent his childhood years in Somerset. He graduated from the Environmental Art course at The Glasgow School of Art in 2000, spending a year of this study at the Royal College of Fine Arts in Stockholm. Important exhibitions have included: *Function / Dysfunction. Contemporary Art from Glasgow*, Neues Museum, Nuremberg (2013); *Solar Eyes*, Tramway, Glasgow (2013); *Primary School*, Inverleith House, Edinburgh (2008); and *Abstract Machines*, Tate St Ives, Cornwall (2006). In 2011 he was awarded the National Galleries of Scotland inaugural Artists' Fellowship Award. He lives and works in Glasgow.

FURTHER READING
Julia Kelly, *Oceania*, Scottish National Gallery of Modern Art, Edinburgh, 2011

Jonathan Griffin, *Flesh and Bones*, Liste 16, Basel, June 2011

Nick Evans Abstract Machines, Tate St Ives, Cornwall, 2006

Solar Eyes, 2013
Installation view: Tramway, Glasgow, 2013

Ruth Ewan

For Ruth Ewan, history doesn't just belong in the past. It informs the present and tells us how we might live in the future. Her projects and exhibitions often unearth neglected historical figures or remind us of ground-breaking political movements.

Ewan's ongoing work *A Jukebox of People Trying to Change the World* is a CD jukebox with a twist. She has collected more than 2,000 songs with subjects ranging from the commemoration of historical events to political protest. They are divided into over seventy categories including feminism, land ownership, poverty, civil rights and ecology.

Ewan has examined the Dundee School Strike of 1911, re-created the metric clocks that were designed to run on French Revolutionary time, and documented the Socialist Sunday School Movement in Scotland, which aimed to provide an alternative to the church.

Edinburgh gallery Collective commissioned the artist to create a guided walk for the vicinity of their new home on Calton Hill in the city. Produced in collaboration with Astrid Johnston, the podcast *Memorialmania* (2013) tells the story of the area's history, geology and geography. But while the walking tour, narrated by Tam Dean Burn and Ruth Milne, seems at first to be a standard tourist guide to the area's monuments, it slowly emerges as a history of Edinburgh's radical movements and a celebration of the hill's unruly history. The tour pays particular attention to the Martyrs' Monument in the Old Calton Burial Ground. It commemorates the men, including Thomas Muir and William Skirving, who were deported to the penal colony of Botany Bay in the 1790s for leading campaigns for electoral reform inspired by the French Revolution.

Ewan has also made a series of prints reflecting Edinburgh's radical past. *May the People* (2013) reproduces the text of a banner from the Chartist movement, which called for political reform in Britain between 1838 and 1848.

Ruth Ewan works in many different ways: in sculpture and installation, in print, text, events and performance, but her art is less about objects than about ideas. Above all it is about people and the ways they have tried, and keep trying, to transform the world they live in. **MJ**

GENERATION LOCATION
Edinburgh: Collective.

BIOGRAPHY
Ruth Ewan (born 1980 in Aberdeen) graduated from Edinburgh College of Art in 2002. Her solo exhibitions and projects have been shown at Tate Britain (2014), Kunsthal Charlottenborg, Copenhagen, Glasgow International Festival of Visual Art (with the Common Guild) in 2012 and Dundee Contemporary Arts in 2011. She was included in two important surveys of contemporary art – *Altermodern* (The Tate Triennial) at Tate Britain, London and *Younger than Jesus* at the New Museum, New York – both in 2009. Recent group shows include *Art Turning Left* at Tate Liverpool and *In the Heart of the Country* at the Museum of Modern Art, Warsaw in 2013. She lives and works in London.

FURTHER READING
Ruth Ewan, edited by Caroline Woodley, *Liberties of the Savoy*, Book Works, London, 2012

Ruth Ewan, Dundee Contemporary Arts and Kunsthal Charlottenborg, Copenhagen, 2012

May the People, 2013
Letterpress Print
Produced by Smail's, Innerleithen

MAY THE

People awake to the

Recognition of their Rights;

HAVE THE

Fortitude to demand them;

The Fortune to obtain them,

AND HENCEFORTH

Sufficient Wisdom and Vigour to

DEFEND THEM.

→ Graham Fagen

There is an inherent diversity and openness in Graham Fagen's artistic and conceptual approach. He works in sculpture, drawing, photography, filmmaking, writing and text, neon, installation and performance. Although his works draw on varied references and embrace all manner of materials and media, they all, in some way, touch on the role of society, history and cultural turning points in the lives of both individuals and communities. Whether made for a gallery or in the public realm, Fagen's works are frequently developed over time, involving the collaboration and participation of others.

Fagen's points of departure include slavery, the cultural influences of music, nature and the symbolic power of flowers, urban planning and regeneration. A significant strand in his work has been the use of theatrical strategies, of which *Peek-A-Jobby* (1998) is an early example. Fagen cites a Shakespearean device, in which the pivotal act of a play, such as a murder, takes place off-stage, thereby using the audience's imagination as an essential tool beyond the visual action of the drama. As well as combining two elements – a script and a stage set – *Peek-A-Jobby* relies on our decisions and imagination as we encounter it. We can read the play, visualise the story on the set and potentially become a 'player' ourselves. Exploring the lines that art bridges between reality and artifice, *Peek-A-Jobby* articulated ideas Fagen has developed in subsequent projects, including *The Making of Us* (2012) in which he collaborated with a theatre director and cinematographer to deconstruct the processes of staging and filmmaking.

Elsewhere, Fagen has used his own experiences. In an unpublished 2011 essay, commissioned by the Mackintosh Museum at The Glasgow School of Art, he explored his conflicted attitude towards the architecture of the School and its architect Charles Rennie Mackintosh, whose imagery adorns souvenirs in shops across Scotland. The essay paved the way for an exhibition project at the Mackintosh Museum in 2014, in which Fagen considers the implications of Mackintosh's drawing and its relationship to his own practice. In 2015 Fagen will represent Scotland at the Venice Biennale. **LA**

GENERATION LOCATIONS
Ayr: Maclaurin Art Gallery. Dumfries: Gracefield Arts Centre. Dundee: Cooper Gallery. Edinburgh: City Art Centre; Scottish National Gallery of Modern Art. Glasgow: The Glasgow School of Art. Kilmarnock: Dick Institute.

BIOGRAPHY
Graham Fagen (born 1966 in Glasgow) achieved a BA at The Glasgow School of Art (1984–8) and an interdisciplinary MA at Kent Institute of Art & Design (1989–90). Solo exhibitions and commissions include: Tramway, Glasgow (2012); Artspace, San Antonio, Texas (2011); The Fruitmarket Gallery, Edinburgh (2002); The Imperial War Museum (official war artist, Kosovo) (2001); Group shows include: *Running Time*, Scottish National Gallery of Modern Art, Edinburgh (2009); *ZENOMAP*, Venice Biennale (2003); and *British Art Show 5* (2000). He lectures at Duncan of Jordanstone College of Art & Design, Dundee. He lives and works in Glasgow.

FURTHER READING
Laura Mansfield, *Roses and Palm Trees*, Foreground, Bristol, 2010

Graham Eatough and Graham Fagen, *Killing Time*, Dundee Contemporary Arts/Suspect Culture, 2006

Graham Fagen: Love is Lovely, War's Kinda Ugly, The Fruitmarket Gallery, Edinburgh, 2002

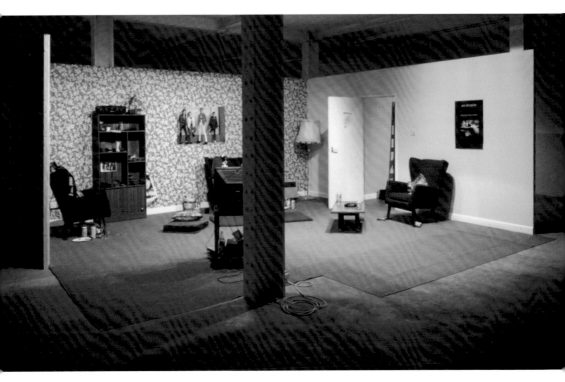

Peek-A-Jobby, 1998
Installation and script
Installation view: Matt's Gallery, London

Moyna Flannigan

Moyna Flannigan paints images of fictional characters who reflect the mood of our time. Her paintings and works on paper cast a critical and often humorous eye on the effects of power on personal, cultural and political identity. Although they have their roots in Flannigan's keen observation of the world around her, her figures have increasingly developed a mythic quality. Their failings, incongruities or follies are our own, only more spectacular and more compelling.

Flannigan develops her paintings slowly, working on more than one painting at a time. Light and space are created through successive layers of contrasting colours. The image forms after many changes, additions and subtractions.

She does not work from photographs or models but builds an image from a multitude of sources, which are passed through the filter of her memory and vivid imagination. Flannigan's keen observations of humanity continue a tradition of reflecting human foibles and eccentricities from the art of Francisco de Goya (1746–1828) to the tradition of slapstick. Her recent paintings of women present the female figure on a monumental scale. In 2007 Flannigan inserted her figurative paintings into the collection of traditional portraits hung at Mount Stuart, a stately home on the Scottish Isle of Bute. In this grand setting Flannigan's paintings presented a probing commentary on the age-old tradition of portraiture.

At the Gallery of Modern Art for the GENERATION exhibition Flannigan draws on the story of Adam and Eve to reflect an underlying conflict between individualism and conformity. Her series of drawings *The First People* was inspired by sources as wide ranging as Masaccio's *Expulsion from the Garden of Eden* (1425) in the Brancacci Chapel, Florence and John Lennon and Yoko Ono's 1969 *Bed-In*. The idea of exodus is further developed in a group of large paintings of people on the move through a vast, film-like space. Parallels can be drawn with current events but Flannigan's painted reality is created from the uncertainty of dream, memory and experience. **SMcG**

GENERATION LOCATION
Glasgow: Gallery of Modern Art.

BIOGRAPHY
Moyna Flannigan (born 1963 in Scotland) completed her BA at Edinburgh College of Art in 1985. In 1987 she received an MFA from Yale University School of Art. Her work is represented in many international public and private collections. Recent exhibitions include: *The Body Stretches to the Edge*, Galerie Akinci, Amsterdam (2013); *Moyna Flannigan: New Work – What you see is where you're at, Part 3*, Scottish National Gallery of Modern Art, Edinburgh (2010) and *Trouble Loves Me*, Sara Meltzer Gallery, New York (2008). She currently lives and works in the Edinburgh area.

FURTHER READING
Anthony Crichton Stuart *et al.*, *A Footprint in the Hall 2007: Moyna Flannigan at Mount Stuart*, Mount Stuart Trust, Isle of Bute, 2007

Keith Hartley and Dilys Rose, *Once Upon Our Time: Portrait Miniatures by Moyna Flannigan*, National Galleries of Scotland, Edinburgh, 1999

Maman, 2014
Oil on linen, 260 × 195 cm

→ Luke Fowler

Luke Fowler's art brings together personal associations with social and political subject matter. In his films he often combines self-shot 16mm footage, specific to his chosen subjects, with archival material in order to reveal his own relationship to historic moments. Fowler is also involved in experimental music and it forms the focus of several of his films. In music he works with Richard Youngs and runs the record label, Shadazz.

Fowler's trilogy of films *What You See Is Where You're At* (2001), *Bogman Palmjaguar* (2007) and *All Divided Selves* (2011) examines the work of iconoclastic Scottish psychiatrist RD Laing (1927–1989), and the legacy of his teaching. Laing called for a radical transformation of conventional medical models of mental illness. *Bogman Palmjaguar* builds a portrait of its subject, an isolated man, with a passionate interest in nature. *What You See Is Where You're At* and *All Divided Selves* make use of a wide range of archival footage taken from documentaries, news and television programmes to explore the persona of Laing and his fluctuating representation in popular media including the news and national press.

Fowler's recent 61-minute film *The Poor Stockinger, the Luddite Cropper and the Deluded Followers of Joanna Southcott* (2012) builds a profile of the Marxist historian EP Thompson (1924–1993). Thompson was a prolific writer, and was recognised as a key figure in the New Left in Britain. Fowler's film looks at Thompson's early work with the Workers' Educational Association, an initiative promoting and supporting adult education for the working class in Yorkshire. The artist uses archival material from a variety of sources alongside material shot by himself in the areas around West Riding, where Thompson taught his progressive approach to education. The film contextualises the historian's work and politics, contrasting them with our contemporary perspective. Like many of Fowler's films, *The Poor Stockinger, the Luddite Cropper and the Deluded Followers of Joanna Southcott* reflects on the value of such approaches and political beliefs and asks what can be learned from them in our current social and political climate. **StC**

GENERATION LOCATION
Edinburgh: Scottish National Portrait Gallery.

BIOGRAPHY
Luke Fowler (born 1978 in Glasgow) obtained his BA (Hons) at the Duncan of Jordanstone College of Art & Design, Dundee in 2000. Recent solo exhibitions include: *Common Sense*, La Casa Encendida, Madrid (2013); *The Poor Stockinger, the Luddite Cropper and the Deluded Followers of Joanna Southcott*, Wolverhampton Art Gallery (2012); and *Luke Fowler with Toshiya Tsunoda and John Haynes*, Inverleith House, Edinburgh (2012). Recent group exhibitions include: *Soundings: A Contemporary Score*, Museum of Modern Art, New York (2013); *Otherwise Unexplained Fires*, Malmö Konsthall, Malmö, Sweden (2013); and *British Art Show 7* (2010). Fowler was nominated for the Turner Prize in 2012 and received the inaugural Jarman Award in 2008. He lives and works in Glasgow.

FURTHER READING
Will Bradley and Stuart Comer, *Luke Fowler*, JRP|Ringier, Zurich, 2009

**The Poor Stockinger, the Luddite
Cropper and the Deluded
Followers of Joanna Southcott**
(still), 2012
HD video, surround sound
Commissioned by The Hepworth,
Wakefield, Wolverhampton
Art Gallery and Film and
Video Umbrella, through the
Contemporary Art Society Annual
Award: Commission to Collect

→ Alex Frost

Alex Frost makes drawings and sculptures for gallery exhibitions and public spaces. From the contents of our shopping baskets to our perennial search for functioning Wi-Fi, his work explores the social and the personal without passing judgement and touches on points where contemporary and historical issues meet. This is shown in his playful use of particular processes. For example his use of mosaic suggests both archaeological remains and more recent community projects.

Adult (Ryvita/Crackerbread) (2007) is from a series of sculptures, irregular shapes decorated with mosaic tiles, that incorporate the recognisable packaging motifs and logos of commercial brands. In these works, Frost selects products that are promoted and consumed as aspirational and sophisticated. Imagining them as relics of the future, he is interested in how, today, they symbolise particular kinds of adult lifestyles and social habits but over time their meanings will change.

The Connoisseurs (2009) is a series of painted polystyrene sculptures that are modelled on noses and displayed upturned in a gesture associated with taste and opinion. Made during the artist's residency at Glenfiddich Distillery, they were first displayed outdoors floating on the distillery pond. Since then they have also been exhibited indoors where they complement Frost's drawn portraits. These are made using a process of 'blind drawing' by brushing ink through holes in perforated paper.

The Old & New Easterhouse Mosaic (and everything in between) (2012) was a project that included the creation of a 25-metre-long wall mosaic at The Bridge, Easterhouse, Glasgow. Frost developed this work out of an interest in challenging received ideas about the role of community art. His work took the original *Easterhouse Mosaic* (1983–2004), a celebrated part of East Glasgow's cultural heritage, as a starting point. The New Easterhouse Mosaic was a decorative design made from coloured porcelain tiles. It features symbols relating to the building to which it is attached and includes facial profiles of some of the people who use it. Alongside this permanent work, Frost documented more than sixty other mosaics he found in the local area in wax crayon rubbings. **BH**

GENERATION LOCATION
Argyll & Bute: Cove Park.

BIOGRAPHY
Alex Frost (born 1973 in London) graduated BA (Hons) in Fine Art at Staffordshire University (1995) and MFA at The Glasgow School of Art (1998). Solo exhibitions and projects include: *Alex Frost – Reproduction*, Glasgow Print Studio (2014); *Self-Defence and Other Hobbies*, the Park Gallery, Falkirk (2013); *Future Spotters (Kassel, 1987 & Münster, 2013)*, Wewerka Pavilion, Münster (2013); *The Old & New Easterhouse Mosaic (and everything in between)*, Platform, Glasgow (2012); and *The Connoisseurs*, Dundee Contemporary Arts (2010). His work has been included in group exhibitions at Battat Contemporary, Montreal, Canada, The Drawing Room, London, the Gallery of Modern Art, Glasgow, Museum Ludwig, Cologne, Germany and the New Forest Pavilion, Venice Biennale. He lives and works in Glasgow.

FURTHER READING
Graham Domke, *Alex Frost: The Connoisseurs*, Dundee Contemporary Arts, 2010

Francis McKee, 'Alex Frost: Mis-shapes', in *ArtSway's New Forest Pavilion*, ArtSway, Sway, Hampshire, 2009

Will Bradley, Mark Segal and Michael Stanley, *Alex Frost: Supplements*, ArtSway, Milton Keynes Gallery and Sorcha Dallas, 2008

Adult (Ryvita/Crackerbread), 2007
Ceramic tiles, grout, glue on polystrene
Collection of Glasgow City Council,
Glasgow Life (Glasgow Museums)

Michael Fullerton

Michael Fullerton works in painting, printmaking, sculpture and film. Unusually for a contemporary artist, portraiture is a crucial part of his art. At first his painted portraits seem to be in the tradition of historical artists such as famous eighteenth-century painter Thomas Gainsborough. Indeed, he has frequently referred to Gainsborough as an influence. On closer inspection, however, and in combination with his other works, his paintings challenge many of the traditional assumptions of portraiture. They ask what kinds of people are portrayed and question how much information a painting can store about its subject. They investigate different kinds of representation and how representation might be related to power.

Fullerton's choice of subjects is important. He paints individuals rather than situations, but he is drawn to figures whose lives are connected to complex political histories. He has depicted people including Paddy Hill, wrongfully convicted for an IRA bombing, a man jailed for anti-capitalist protest and a member of Glasgow's Housing Benefit Anti-Fraud Unit. Looking at the artist's depiction of Alan Turing, can we grasp anything of his extraordinary life? Turing is well known as one of the pioneers of computing, and for his work breaking German codes in the Second World War. But Turing was also homosexual, and was found guilty of 'indecency' in 1952, 'treated' with chemical castration and later committed suicide. Fullerton gives a sense of individuality and dignity to figures such as Turing (pictured opposite), but he is also aware that portraits can never fully represent a person's complex history.

For his exhibition at Glasgow Print Studio, Fullerton has made portraits of figures related to issues of technology, communication and justice. They include Kim Dotcom, the controversial file-sharing entrepreneur charged by the United States with copyright infringe-ments worth $500 million and Samuel Goldwyn, founder of the MGM film company, are also depicted. Closer to home, Fullerton has made a portrait of the current governor of Barlinnie Prison in Glasgow. Through these paintings Fullerton reflects on the changing ways in which images are produced and shared. Who owns images and whom do they serve? **DP**

GENERATION LOCATION
Glasgow: Glasgow Print Studio Gallery.

BIOGRAPHY
Michael Fullerton (born 1971 in Bellshill, Scotland) graduated with BA and then MFA (2002) from The Glasgow School of Art. Solo exhibitions include: *Columbia*, Chisenhale Gallery, London (2010); *Pleasure in Nonsense*, Carl Freedman Gallery, London (2007); *Get Over Yourself*, Greene Naftali Gallery, New York (2006); *Suck on Science*, Art Now, Tate Britain, London and CCA, Glasgow (both 2005); and *Are You Hung Up?*, Transmission Gallery, Glasgow (2003). Group exhibitions include: *British Art Show 7* (2010); *Tate Triennial* selected by Beatrix Ruf, Tate Britain, London (2006); and *Bloomberg New Contemporaries*, Cornerhouse, Manchester and 14 Wharf Road, London (2003). He lives and works in Glasgow.

FURTHER READING
John Calcutt, *Michael Fullerton: Pleasure in Nonsense*, MER, Ghent, 2012

Sam Thorne, 'Once in a lifetime', *Frieze*, issue 111, November–December 2007

Why Your Life Sucks, 2010
Oil on linen, 61 × 46 cm

Douglas Gordon

Douglas Gordon makes videos, installations, photographs and text pieces, using both found and original material, in an attempt to lay bare the ambiguities of human life. In Gordon's world nothing is good or evil – but both at the same time. Gordon's religious upbringing made him deeply aware of human beliefs and he uses these throughout his work. In addition his interest in psycho-analysis led him to explore the complexities of the human mind and especially the nature of schizophrenia. Gordon explores the degree to which we are all subject to shifting identities. He uses techniques of doubling and mirroring in works including *Divided Self I and II* (1996), a video showing a smooth arm and a hairy arm wrestling.

In *24 Hour Psycho* (1993), Gordon takes Alfred Hitchcock's famous 1960 film *Psycho* and slows it down so that it runs for twenty-four hours. This key work is deceptively simple, but has devastating consequences, exposing the way that memory works in the flow of our consciousness. Everyone knows the plot of *Psycho* and can anticipate what will happen, but in Gordon's version, this is constantly frustrated, since the future never seems to come.

The text installation *List of Names* (1990–ongoing) also explores the role of memory. The artist attempted to remember everyone he had ever met. In a way, it is a self-portrait, since we are what we remember. Likewise, a work such as *Pretty Much Every Film and Video Work From About 1992 Until Now* (1999*)*, an array of video monitors showing a lifetime of Gordon's creative achievements, is a series of windows into his mind. In *Zidane: A 21st Century Portrait* (2006) – a video installation that Gordon made with Philippe Parreno in 2006 – all the cameras used to make the work are trained on its subject, the footballer Zinedine Zidane, rather than the game itself.

Gordon had begun this move towards exploring the inner world of other people in *Feature Film* (1999). In that work he concen-trated his camera on the hands and face of a conductor. We do not see the orchestra. Gesture and facial expression are the only clues we have to what is going on in the conductor's mind – all except, of course, for the music. This is the element that engenders those movements and allows us special insight. **KH**

GENERATION LOCATIONS
Edinburgh: Scottish National Gallery of Modern Art. Glasgow: Gallery of Modern Art. Thurso: Caithness Horizons.

BIOGRAPHY
Douglas Gordon (born 1966 in Glasgow) trained at The Glasgow School of Art from 1984 to 1988 and at the Slade School of Art, London from 1988 to 1990. He won the Turner Prize in 1996, the Premio 2000 at the 47th Venice Biennale in 1997, the Hugo Boss Prize in 1998 and the Käthe Kollwitz Prize in 2012. He spent 1996–7 in Hanover and Berlin on a DAAD scholarship. Important shows have been staged in Frankfurt (2011), Edinburgh and New York (2006), London and Bregenz (2002), Los Angeles (2001), Liverpool and Paris (2000), and Eindhoven (1995). He teaches at the Städelschule, Frankfurt and lives and works in Berlin and Glasgow.

FURTHER READING
Katrina Brown, *Douglas Gordon*, Tate, London, 2004

Douglas Gordon, *Déjà-vu: Questions and Answers* (3 volumes), Musée d'Art Moderne de la Ville de Paris, 2000

Pretty Much Every Film and Video Work From About 1992 Until Now, 1999
Video installation, currently 82 videos, 101 monitors

Ilana Halperin

Ilana Halperin's work covers much ground yet at its core is a means to connect our immediate lived experience with the harder-to-comprehend aeons of geological time. How can we conceive of the temperature of underground magma or the brevity of our own life on this planet? Through immersion in various media – across creative writing, performance, printmaking, sculpture and film – she weaves stories into her art that drive scientific fieldwork and laboratory experimentation. Her subject matter is eclectic: often one finds ephemeral islands, petrified raindrops, meteorites and body stone collections alongside celebrations of a shared birthday with an Icelandic volcano.

Halperin thinks of geology like a torn-apart book, where each layer of rock is a page in a story. To understand how the story fits together again, we must make imaginative leaps connecting one layer to another.

Halperin conceives of human time by placing herself or others directly in geologically striking places, such as the thermal springs of Iceland (*Geothermal Sculptures*, 2011), underground caves in France and, for her work *Meeting on the Mid-Atlantic Ridge* (1999), at the very edge where the tectonic plate that supports North America meets its European counterpart.

She conducts fieldwork with specialists worldwide – usually mineralogists, geologists, vulcanologists and archaeologists – talking and learning about rocks and our relationship with them. Travel is vital to Halperin's method, as she searches out active volcanic regions where new landmass forms, such as Iceland or Hawaii (e.g. *Physical Geology (new landmass/fast time)* in 2009), or for older now inactive geological sites, such as the north-west of Scotland, where the islands of Mull, Iona and Staffa feature in her project for GENERATION. The inspiring Hebridean context offers up many links. Staffa with its distinctive basalt structure has been a pilgrimage site particularly for Romantic-minded artists, from the composer Felix Mendelssohn, to visual artists such as JMW Turner, Joseph Beuys and Matthew Barney. Serendipity plays its part, as the stone quarried at Fionnphort in Mull was used to build the piers of Halperin's native island of New York – a stone bridge across the Atlantic. **AP**

GENERATION LOCATION
Isle of Mull: An Tobar.

BIOGRAPHY
Ilana Halperin (born 1973 in New York) graduated with BA (Hons) from Brown University, Providence, Rhode Island in 1995 and obtained an MFA at The Glasgow School of Art in 2000. Recent solo shows include: *The Library*, National Museums of Scotland, Edinburgh (2013); *STEINE* and *Hand Held Lava*, Berlin Medical History Museum / Schering Foundation, Berlin (2012); *Physical Geology*, Artists Space, New York (2009); and *Nomadic Landmass*, doggerfisher, Edinburgh (2005). Group shows include: *Volcano*, Compton Verney, Warwickshire (2010); *Experimental Geography*, ICI, New York (2009); *Estratos*, PAC Murcia, Spain (2008); and *Sharjah Biennial 8*, UAE (2007). Halperin was Artist Fellow, National Museums Scotland, 2012–13 and Artist-Curator at Shrewsbury Museum, 2011–14. She lives and works in Glasgow.

FURTHER READING
Sara Barnes and Andrew Patrizio (eds), *Ilana Halperin: Neue Landmasse / New Landmass*, Berlin Medical History Museum, 2012

Nato Thompson (ed.), *Experimental Geography*, ICI, New York, 2008

Nomadic Landmass, Camden Arts Centre, London, 2005

Meeting on the Mid-Atlantic Ridge, 1999
C-print on MDF

Charlie Hammond

Charlie Hammond's work in painting, printmaking and sculpture carries out a serious play with the materials and processes of art. A keen sense of the ridiculous – in art and in life – is often evident in the things he makes. So too is his deep thinking about art's history and its place in the contemporary world. Hammond's ability to turn the difficult task of producing art into an enjoyable process makes him a gifted and prolific collaborator. As well as being a member of the artist collective Poster Club, he has often worked with peers such as artists Michael Bauer, Jonathan Owen, Torsten Lauschmann and Anne-Marie Copestake.

In recent years Hammond has focused especially on painting. He usually works in series that explore a theme through a set of specific approaches to the conventions and materials of the medium. For example, his *Sweats* series of paintings use techniques such as duplicating hand-painted marks by applying a roller to the wet paint, or cutting out sections of works to form figures and gluing them to other canvases. These works use a simple, cartoon-like motif depicting a sweaty armpit to suggest that work is their subject matter. These approaches can all be seen in *Sweating in the Landscape / Enterprise Valley* (2012). Instead of making the act of painting seem either heroic or leisurely, the *Sweat* paintings imply that it is a messy, dirty business. A recent work in this series titled *Sweaty Sink* (2013) compares the work of painting with another activity that involves using brushes to move liquid around – doing the washing up.

In an earlier series, Hammond applied imitation paint-squirts, made of glazed ceramic, to stained canvases. Here the basic options for how paint is applied – the artist can let it soak into the canvas or build up upon it – were playfully made into the content of the pictures themselves. These elements were used to suggest faces, bottoms or fragments of cars. Hammond calls these latter works *Exploded Vehicles*. Painting itself is a kind of 'exploded vehicle' in his art; it provides him with useful bits and pieces that can be put together to go somewhere new. **DP**

Sweating in the Landscape / Enterprise Valley, 2012
Oil, collaged canvas, charcoal / canvas, 117 × 92 cm

GENERATION LOCATION
Glasgow: Tramway.

BIOGRAPHY
Charlie Hammond (born 1979 in Aylesbury) studied BA (Painting) at The Glasgow School of Art and was a committee member at Transmission Gallery, Glasgow (2003–5). Solo exhibitions include: *The Sweats*, Galerie Kamm, Berlin (2012); *Euro Savage* (with Michael Bauer), Linn Lühn, Cologne (2010); *The New Improvement Scheme*, Sorcha Dallas, Glasgow (2009); *The Doeruppers,* Michael Benevento, Los Angeles (2008); and *Very Still Life*, Anton Kern Gallery, New York (2007). Group exhibitions include: *Matter in the Wrong Place* (with Torsten Lauschmann), Woodend Barn, Banchory (2013); *A Picture Show*, Gallery of Modern Art, Glasgow (2013); *When Flanders Failed*, Royal Hibernian Academy, Dublin (2011); *Collection of …*, White Columns, New York (2009); *Expanded Painting 2*, Prague Biennial (2007); and *Keep Passing the Open Windows or Happiness*, Galerie Gisela Capitain, Cologne (2006). He lives and works in Glasgow.

FURTHER READING
Jerwood Contemporary Painters 2010, Jerwood Visual Arts, London, 2010

Lauren Cornell, Massimiliano Gioni and Laura Hoptman (eds), *Younger Than Jesus: Artist Directory*, Phaidon, London, 2009

Iain Hetherington

Iain Hetherington's paintings reflect on a world where access to technology has allowed everyone to produce their own imagery. He deals with the problems of authenticity, value and validation in our contemporary, digital culture. His paintings are made in groups, but use those elements of studio work, like forgetfulness, applying paint without care and retaining flaws, that can come as a surprise during painting. The resulting differences between individual paintings are thus small but important.

In the series of paintings *Diversified Cultural Workers* (begun 2007), figures or 'characters' are formed from a mass of smears and paint marks, reminiscent of those on a traditional painter's palette. But the figures are adorned by the baseball caps and gold chains of hip-hop and so-called 'ned' cultures. Rather than clichéd pictures of underprivileged social groups, these characters may be cultural administrators dressed in street garb. It is a strange reversal of working-class culture's appropriation of the upper-class clothes of country gents. It is hard to tell if they are just 'getting down' with street culture or if access policies have reached their logical conclusion with galleries and theatres overrun by a wild mob, fighting, spraying graffiti and looting.

In a new series of works, *There's Wally* (begun 2011), the presence of the internationally recognisable comic-book character 'Wally' is suggested by the appearance of his signature stripy hat and cane. In Hetherington's paintings Wally appears in empty dramas, 'fight clouds' and abstractions or doodled, pseudo-analytic diagrams, rather than the crowd scenes familiar from the books. In these works, Hetherington shifts attention to the art world itself, presenting the artist's image as a product of a series of networks where high visibility is more important than quality. The dream of everyone being an artist reaches its conclusion as a banal reality … everyone is an artist, anyone can wear Wally's hat, but where did art go? **CJ**

echo@ornans/hello, 2013
Oil on canvas

GENERATION LOCATION
Glasgow: Tramway.

BIOGRAPHY
Iain Hetherington (born 1978 in Glasgow) graduated from The Glasgow School of Art with a Master's degree in 2004. A solo show, titled *Harmless Domain*, was held at The Old Hairdressers, Glasgow in 2013. Recent group exhibitions include: *Iain Hetherington, Jacob Kerray and Owen Piper*, CCA, Glasgow (2013); *The Irregular Correct – New Art from Glasgow*, Fremantle Arts Centre, Australia (2012); *Industrial Aesthetics*, Times Square Gallery, New York (2011); *Nothing in the World but Youth*, Turner Contemporary, Margate (2011); *Beholder*, Talbot Rice Gallery, Edinburgh (2011); *Hau auf die Leberwurst*, Bender Space, London (2011); *Jerwood Contemporary Painters*, Jerwood Space, London (2010); *Newspeak: British Art Now*, Saatchi Gallery, London (2010); *Play*, Monica De Cardenas, Milan (2009); *Nought to Sixty*, ICA, London (2008); and *Diversified Cultural Workers*, Mary Mary, Glasgow (2008). He lives and works in Glasgow.

FURTHER READING
Newspeak: British Art Now, Saatchi Gallery, London, 2010

Lauren Cornell, Massimiliano Gioni and Laura Hoptman (eds), *Younger Than Jesus: Artist Directory*, Phaidon, London, 2009

Nought to Sixty, ICA, London, 2008

Louise Hopkins

Since the early 1990s, Louise Hopkins has used furnishing fabrics, maps, song sheets, comics and pages of magazines to create works that address the process and problems of representation. Her project is to transform existing surfaces into paintings or drawings, taking them from the everyday world and giving them a new status. With an experimental approach, she starts with her own physical gesture to explore colour, form and mark-making, using pencil, ink or paint, and often produces several versions before fixing on the final composition. The relationship between the original and new surface is ambiguous. The printed materials she chooses often have social or political associations. The certainty that maps, shopping magazines or manufactured textiles might offer seems to be questioned when they are transformed into a painting or drawing.

Among Hopkins's earliest works are those produced on furnishing fabrics, such as *Aurora 13* (1996). Although prepared in the same way a canvas would be made ready for a traditional painting – stretched over a wooden frame and painted with layers of translucent gum – the found fabric is reversed to present a shadow of the 'real' print. Hopkins has meticulously painted over this ghostly image, leaving a section exposed. On first glance it is not clear what has been painted, and what existed before.

Untitled (169) (2006) is one of many map pieces Hopkins has made. She has applied ink over a world map, developing strokes in different directions and leaving the names of oceans and countries intact. With these names transformed into islands in a sea of ink, our understanding of geography is upended as new relationships are revealed. Hopkins's works suggest a chain of contrasts – between mass-produced and handcrafted, reality and artifice, positive and negative, surface and depth, hidden and exposed. In an increasingly fast-paced, image-led world, Hopkins's interventions are labour-intensive and time-consuming. She slows down time, inviting us to absorb the information she eradicates or exposes through the physical act of painting. In this way, she makes us question the things we see – not only in her work, but in the world around us. **LA**

GENERATION LOCATION
Linlithgow: Linlithgow Burgh Halls.

BIOGRAPHY
Louise Hopkins (born 1965 in Hertfordshire) studied at the University of Northumbria before completing an MFA at The Glasgow School of Art in 1994. Solo exhibitions include Mummery + Schnelle, London (2008 and 2014); The Fruitmarket Gallery, Edinburgh (2005); Andrew Mummery Gallery, London (1999 and 2003); and Tramway, Glasgow (1996). Group exhibitions include: *A Picture Show*, Gallery of Modern Art, Glasgow (2013) and *Here + Now: Scottish Art 1990–2001*, Dundee Contemporary Arts (2001). Hopkins was among six artists chosen to represent Scotland at the 52nd Venice Biennale in 2007. Her work is held in collections internationally including the Jumex Collection, Mexico and the Museum of Modern Art, New York. Hopkins teaches at The Glasgow School of Art. She lives and works in Glasgow.

FURTHER READING
Kate Macfarlane and Katharine Stout, 'Louise Hopkins', in Tania Kovats (ed.), *The Drawing Book*, Black Dog Publishing, London, 2007

Louise Hopkins: Freedom of Information: Paintings Drawings 1996–2005, The Fruitmarket Gallery, Edinburgh, 2005

Louise Hopkins, Tramway, Glasgow and Andrew Mummery, London, 1996

Untitled (169), 2006
Acrylic ink on printed world map, 29.5 × 21 cm
Scottish National Gallery of Modern Art, Edinburgh

Kenny Hunter

Kenny Hunter makes elegant sculptures in many materials including wood, plastic, iron and bronze. He remains fascinated by the processes involved in making sculpture in the studio and the power that they have to transform materials in order to express his complex and vivid ideas on historical time.

His central concern is with monumental sculpture and how it continues to evoke remembrance in a modern world. He sees history as a series of recurrent themes that each time come back slightly altered. For Hunter, the human condition is relatively stable and universal despite the belief systems, that occur across eras and geography. His sculptures reflect this in their graphic character and unusual mix of very traditional and modern subject matter. His sculpture encapsulates moments in which human cultures, ancient and recent, clash together and become more strange and complicated the longer we consider them. Doubt, for Hunter, is a precondition for an open, tolerant and civilised society.

Through his commitment to sculpture in public space, Hunter has completed numerous art commissions, including *iGoat* (2010), a hand-sculpted goat standing atop packing cases in London's Spitalfields. It is a symbol of non-conformity and a reference to the area's rich social history. Through these works, he delights in bringing together both 'what is now and what has always been'. He enjoys the sense of familiarity, change and reflection that public art demands when visitors return to his sculptures over many years.

Hunter's sculptures often depict everyday contemporary objects – from televisions, drums, boxes and tins (invariably as plinths) to shelves, bookends, rucksacks and bin bags. Animals, whether mythic, farmed or domestic, regularly feature. The human figures spring from everyday life, such as adolescents or working people – as in *Citizen Firefighter* (2001), his monument for Strathclyde Fire and Rescue – yet are captured in traditional sculptural poses that seem from another era. They are made ironic through juxtaposition with their equally everyday accessories. Building on these large themes, his concerns for his GENERATION projects at Paxton House in Berwickshire and House for an Art Lover in Glasgow range across collective and family memory, nation building, the British Empire, Modernism and heritage. **AP**

GENERATION LOCATIONS
Berwick-upon-Tweed: Paxton House. Edinburgh: City Art Centre. Glasgow: House for an Art Lover.

BIOGRAPHY
Kenny Hunter (born 1962 in Edinburgh) studied for his BA (Hons) in Fine Art Sculpture at The Glasgow School of Art from 1983 to 1987. Selected public artworks include: *The Unknown*, Borgie Forest, Sutherland (2012); *iGoat*, Spitalfields, London (2010); and *Citizen Firefighter*, Central Station, Glasgow (2001). Solo exhibitions include *A Shout in the Street*, Tramway, Glasgow (2008) and *Natural Selection*, Yorkshire Sculpture Park, Wakefield (2006). Group shows include *What am I doing here?*, Esbjerg Kunstmuseum, Denmark (2013) and Busan Biennale Sculpture Project, Korea (2013). Hunter is a lecturer at Edinburgh College of Art. He lives in Glasgow.

FURTHER READING
Kenny Hunter: Time and Space Died Yesterday, essay by Peter Joch, Edition Scheffel, Bad Homburg, 2012

Natural Selection, essays by Clare Lilley and Alex Hodby, Yorkshire Sculpture Park, Wakefield, 2006

Kenny Hunter, essays by Andrew Patrizio and Ross Sinclair, Arnolfini, Bristol, 1998

iGoat, 2010
Paint, aluminium, concrete

Stephen Hurrel

Stephen Hurrel works with video, sound, sculpture and words to explore relationships between people and places. His artworks combine art, science and technology to explore and record the interactions and tensions between nature and contemporary society. They draw our attention to current ecological issues such as the impact of industry on the natural environment. As well as making art for the gallery, Hurrel produces commissioned artworks responding to specific places such as rural landscapes and marine environments.

Zones – An Audiology of the River Clyde (1999) consisted of a series of boat trips with audio accompaniment via headphones. Passengers were taken on a 40-minute journey along the River Clyde with a soundtrack, part real and part constructed, composed of archive material and on-site recordings. The work highlighted the river's significant history as a place of industry and community and imagined its future as a base for commerce and telecommunication industries.

Beneath and Beyond: Seismic Sounds (2008) is an immersive audio-visual gallery installation that transmits live sounds from within the earth. Created using computer software developed for the Internet, it presents a unique relationship between awe-inspiring natural phenomena and cutting-edge technology. The work is partly informed by historical artworks including twentieth-century Land Art and the artist's fascination with European landscape painting of the nineteenth century.

The use of digital technology to access aspects of the natural environment that are rarely seen or heard is also a key element of *Dead Reckoning* (2012). Produced during a residency at a marine mammal research station in Cromarty, north of Inverness, this film, with accompanying soundtrack, traces a journey through a seascape using video footage and underwater recording equipment. It offers an emotive, cinematic journey through an environment where nature coexists with oil rigs, cruise ships and wind turbines. In the last few years Hurrel has undertaken other research expeditions at sea to locations as diverse as the Outer Hebrides, Gran Canaria and the Azores. **BH**

GENERATION LOCATION
Helmsdale: Timespan.

BIOGRAPHY
Stephen Hurrel (born 1965 in Glasgow) undertook undergraduate and postgraduate studies in Fine Art at The Glasgow School of Art from 1984 to 1989. Exhibitions and projects include: *Sea Change*, Royal Botanic Garden, Edinburgh (2013); *Mapping the Sea: Barra*, Cape Farewell Commission, Barra (2012); *Beneath and Beyond*, Tramway, Glasgow (2008); *Turbulent Terrain,* Latrobe Gallery, Australia (2009); *Here + Now*, Dundee Contemporary Arts (2000); and Zones – *An Audiology of the River Clyde*, Glasgow (1999). Hurrel's work has been included in festivals such as: Walk & Talk Azores – Public Art Festival, Portugal (2013); Soundwave ((5)), San Francisco (2012); FesteArte Video Art Festival, Rome (2010); and Glasgow International (2005 and 2008). He lives and works in Glasgow.

FURTHER READING
Ruth Little, 'The slow craft of contemporary expeditions: Islandings', *Expeditions*, University of the Arts London, 2012

Venda Louise Pollock, 'Event: Space by Stephen Hurrel', in Rhona Warwick (ed.), *ARCADE: Artists and Place-making*, Black Dog Publishing, London, 2006

Stephen Hurrel, *In Transit: Australian Residency and Other Works*, University of Tasmania, Hobart, 1998

Dead Reckoning (still), 2012
HD video

Callum Innes

Callum Innes is a painter. His work does not depict the world around him, but he nevertheless maintains that it is not abstract, as it responds to the world in which he lives and the emotions that he experiences.

Until 1988 he worked in a figurative manner, but after a stay in Amsterdam, where he was confronted by the uncompromisingly abstract work of such artists as Barnett Newman and Lucio Fontana, he abandoned the mythological themes in his art and aimed at greater honesty, clarity and directness. The breakthrough came when he painted a leaf on a piece of corrugated cardboard *From Memory* (1989). The painted image sank into the vertical corrugations and became part of the history of the material. It was a revelation and was to lead directly to the way that Innes works to this day.

Instead of trying to depict his inner thoughts and feelings, he developed a painstaking process of applying paint to his prepared surfaces, before removing areas of that paint by the use of turpentine. It is not so much an act of destruction as an act of unveiling. Innes has spoken of a process like alchemy, the ancient belief that ordinary substances can be changed into gold. A surface of dark olive-green, for example, will reveal a golden residue when it is removed. Innes uses this procedure in a number of carefully prescribed types of painting, including what he called exposed paintings, monologues and formed paintings, all of which he established between 1989 and 1992.

The most common are his exposed paintings. In these he began by removing the paint from one vertical half of the canvas. Barely perceptible traces of the paint linger on the exposed canvas, but especially at the slightly ragged edge of the painted surface. Innes went on to use several layers of different colours of paint, so that, after removal, the paint residues were often of a different colour to that of the intact area of paint. For each successive group of exposed paintings he developed new strategies, especially in placing different blocks of colour next to each other. Each of Innes's painting types has its own basic procedure, but common to them all is a formal and emotional richness within strictly defined limits. **KH**

GENERATION LOCATION
Edinburgh: Scottish National Gallery.

BIOGRAPHY
Callum Innes (born 1962 in Edinburgh) studied at Gray's School of Art, Aberdeen from 1980 to 1984 and at Edinburgh College of Art from 1984 to 1985. In 1987–8 he spent a year in Amsterdam on a Scottish Arts Council residency. He was nominated for the Turner Prize in 1995 and won the NatWest Prize for Painting in 1998 and the Jerwood Painting Prize in 2002. Solo shows have been held in Nuremberg (2013), Hong Kong (2012), Sydney (2007), St Ives (2003), Dublin (1999 and frequently thereafter), Bern (1999), Birmingham (1998), New York (1997 and frequently thereafter), Zurich (1997), Edinburgh (1993 and frequently thereafter) and London (1990 and frequently thereafter). Innes lives and works in Edinburgh.

FURTHER READING
Fiona Bradley and Elizabeth McLean (eds), *Callum Innes: From Memory*, Hatje Cantz, Ostfildern and The Fruitmarket Gallery, Edinburgh, 2006

Callum Innes 1990–1996, Inverleith House, Edinburgh, 1996

Callum Innes, Institute of Contemporary Arts, London, 1992

Exposed painting Phthalocyanine Blue, 2014
Oil on linen, 235 × 230 cm

Fiona Jardine

Fiona Jardine produces texts, presentations, curated exhibitions and publishing projects. She is interested in the way that knowledge is classified, presented and exchanged across the fields of art and design history, philosophy and literature. Jardine often produces writing that responds creatively to the work of other artists or historical materials. Her text *The Pyramid* was an experimental fiction that grew out of a residency with Joanne Tatham and Tom O'Sullivan at Burghead, Morayshire (2006). *Barrie Girls* (2013) was a response to images from the archive of Barrie knitwear in Hawick produced as part of a collaborative exhibition with curatorial team Panel, Sophie Dyer and Maeve Redmond.

In 2011 she curated the exhibition *Troglodytes* for Paisley Museum as part of the Contemporary Art Society centenary projects to team artists with public collections. *Troglodytes* connected nineteenth-century paintings to twentieth-century studio ceramics by exploring the idea of aesthetic and biological 'kinship' through the role of criminology in the design theory of modernist architects and theorists like Adolf Loos and Le Corbusier. Her project *Five Foot Shelf* for Collective in 2012 responded to an artists' exchange project linking Beijing, Istanbul and Edinburgh. It drew comparisons between the exchange of knowledge and international trade.

The presentation *Spark for Artists* (2014), took its cue from the role of art and artists in the novels of Muriel Spark and from the philosopher Arthur Danto's borrowing of a fictional text mentioned in one of Spark's works. The title of Danto's 1981 book *The Transfiguration of the Commonplace: A Philosophy of Art* refers to a religious tract being written by the character Sandy/Sister Helena in Spark's most famous novel, *The Prime of Miss Jean Brodie* (1961).

A new commission, *Let the Day Perish*, will be presented at Hospitalfield, Arbroath in 2014. It describes a journey, its detours and coincidences, around and between the churches of Guthrie and Fowlis Easter, which sit some 15 miles apart in Angus. It is a poetic speculation that draws in layers of fiction, myth and history and an investigation into the lure of ancient artefacts, an enquiry into the possibilities of discovery and a portrait of the area. The project revisits themes, places and working methods used in *The Pyramid* and is scored in collaboration with the artist Sue Tompkins. **MJ**

GENERATION LOCATION
Arbroath: Hospitalfield Arts.

BIOGRAPHY
Fiona Jardine (born 1970 in Galashiels) graduated from Duncan of Jordanstone College of Art & Design, Dundee (1998) and from The Glasgow School of Art (2003). She has been researching the place of signatures in art for a PhD at the University of Wolverhampton. She has exhibited widely throughout the UK as well as in Rotterdam, Mexico City, Athens, Antwerp, New York, Paris and Montreal. She teaches in the School of Textiles & Design at Heriot-Watt University in the Scottish Borders. She lives in Glasgow.

FURTHER READING
Fiona Jardine, 'Abominable abdominal: thoughts on *Étant Données* and *The Large Glass*', *Petunia*, Issue 3, 2011

Fiona Jardine, *Joanne Tatham and Tom O'Sullivan: The Pyramid*, The Watchie, Catterline, 2006

Courtesy of F. Jardine / Hospitalfield

Jim Lambie

Jim Lambie's playful and imaginative work in collage, installation and sculpture creates an immediate visual impact and shows his interest in the psychology of space and colour. Using materials such as glitter, paint, mirror and vinyl tape, he assembles, alters and embellishes rooms and ordinary objects such as chairs, clothes, doors and posters. Lambie's work reflects his everyday surroundings and makes sharp-eyed references to aspects of contemporary society whilst letting us get close to his working processes and experiments carried out in his studio.

Zobop (from 1998) is one of his best-known works. It has been made for numerous displays and exists in many different versions. Each one is unique in its response to the architectural footprint of a given area. It consists of different widths of colour or monochrome adhesive vinyl tape, which is applied directly to a floor. Building from an initial line that winds round the very edge of the room, *Zobop* creates an optical effect of movement and a sense of melting or merging space. These works fill a room but also provide a surface for Lambie's sculpture to stand on.

Often the readily available materials that Lambie uses for his sculptures have formal qualities in common such as their colour or finish and frequently they directly relate to our everyday lives as objects that we own, wear or hold. *Plaza* (2000) consists of plastic bags that are pinned to a wall in a line, filled with paint and burst open. Like Lambie's *Zobop* floors, the work seems to hold an energy that is implicit in the action and rhythm undertaken to create it: the process of cutting each bag to release the paint and allow it to spill onto the wall and floor.

Shaved Ice (2012) is a recent example of an installation that reflects Lambie's interest in responding to the unique character and architecture of the spaces where he exhibits. It consists of brightly coloured ladders that run from floor to ceiling. They have mirrored inserts between their steps, which accentuate and reflect both their surroundings and the visitors negotiating the room. **BH**

GENERATION LOCATION
Edinburgh: The Fruitmarket Gallery.

BIOGRAPHY
Jim Lambie (born 1964 in Glasgow) studied Fine Art at The Glasgow School of Art (1990-4). He was nominated for the Turner Prize in 2005. Solo exhibitions include: *Shaved Ice*, The Modern Institute, Glasgow (2012); *Beach Boy*, Pier Arts Centre, Orkney (2011); *Unknown Pleasures*, Hara Museum of Contemporary Art, Tokyo (2008); *Kebabylon*, Inverleith House, Edinburgh (2003); and *Voidoid*, Transmission Gallery, Glasgow (1999). Group exhibitions include: 19th Biennale of Sydney (2014); *Color Chart: Reinventing Color, 1950 to Today*, Museum of Modern Art, New York (2008); 54th Carnegie International, Pittsburgh (2004); *ZENOMAP*, Venice Biennale (2003); and *Painting at the Edge of the World*, Walker Art Center, Minneapolis (2001). He lives and works in Glasgow.

FURTHER READING
Michael Bracewell, *Reflections on the Art of Jim Lambie*, Modern Art Oxford, 2004

Jim Lambie, Voidoid, The Modern Institute/Toby Webster Ltd, Glasgow, 2004

Ross Sinclair, 'Jim Lambie', *Frieze*, issue 46, May 1999

Zobop Colour
Coloured vinyl tape
Installation view: *Voidoid*, Transmission Gallery, Glasgow, 1999
Scottish National Gallery of Modern Art, Edinburgh

Torsten Lauschmann

Torsten Lauschmann's art is notable for its innovative and idiosyncratic approach across a range of formats including photography, sound, video, online projects, performance and installation. He is interested in the earliest forms of magical and cinematic entertainment, as well as the latest technological advances. He tweaks the mechanics of both digital and analogue technologies, producing works that explore our relationship with machines, as well as our understanding of the moving image and illusion.

Made using a range of materials, found objects and technological processes, his works defy categorisation and deliberately avoid the notion of a signature style or appearance. Instead Lauschmann is interested in delving into the fundamentals of life and human nature – resulting in artworks that range from the melancholic, poetic and romantic to the theoretical and the absurd. The combination of the home-made and the high-tech is another integral part of many of Lauschmann's works – their lo-fi and DIY appearance can often mask the complexity of their construction.

The artist often transforms that which we take for granted, focusing our attention on how we live our lives. *Digital Clock (Growing Zeros)* (2010) is both a 24-hour-long film and a functioning clock. It shows red, handmade wooden blocks set against a jet-black background, emulating (albeit in a rather rough form) the numerals found on a digital LCD display. The blocks are animated by Lauschmann's hands, furiously moving the seconds, minutes and hours in order to try to keep up with the progression of time.

Digital Clock (Growing Zeros) highlights the difference between experiencing an artwork and the simple act of reading the time. The labour involved in the physical act of making the work is also made visible, with the movement of the artist's hands replacing what is normally a technological process. The pace at which Lauschmann's hands are required to move can also be read as an allusion to our continuing race to keep up with the latest cutting-edge digital developments. **J-AD**

GENERATION LOCATION
Edinburgh: Scottish National Gallery of Modern Art.

BIOGRAPHY
Torsten Lauschmann (born 1970 in Bad Soden, Germany) studied Fine Art Photography at The Glasgow School of Art (1997), and gained his MA in Media Art from ZKM in Karlsruhe (2001). Solo shows have been staged at Dundee Contemporary Arts (2012), Collective, Edinburgh (2010) and Arnolfini Gallery, Bristol (2008). In 2010 he received the inaugural Margaret Tait Award at the Glasgow Film Festival. He was shortlisted for the Jarman Award (2011). A visiting lecturer at both Duncan of Jordanstone College of Art & Design in Dundee, and Edinburgh College of Art, he lives and works in Glasgow.

FURTHER READING
Startle, Torsten Lauschmann, Dundee Contemporary Arts and Film and Video Umbrella, London, 2012

Steven Cairns, 'Torsten Lauschmann', *Frieze*, issue 126, October 2009

Mick Peter, 'Torsten Lauschmann', *Frieze*, issue 111, November–December 2007

Digital Clock (Growing Zeros)
(still), 2010
HD projection, 24 hours (looped)

Owen Logan

Owen Logan's words and photographs tell us about the world, not as we might want it to be, but in all its messy reality, torn by conflict and competition for resources and riven with global inequalities.

His photo-essay *Masquerade: Michael Jackson Alive in Nigeria* (2001–5) follows the exploits of a costumed performer as he travels across the country. The young black soul singer's transformation into the white 'king of pop' is used as an allegory for the conflicts and tensions in Nigeria. Working with the author Uzor Maxim Uzoatu, Logan presents a biting satire on the relationship between the Nigerian political elite and foreign business interests. The project has its roots in Logan's long-term interest in the politics and economics of the oil business, and its complex impact on communities. He believes it is important to understand that impact through the history of empires and the way Western countries use economics to exploit the rest of the world today.

For GENERATION, *Masquerade* is shown in the context of a group exhibition, *The King's Peace: Realism and War*, which expands upon Logan's central themes by questioning the meaning of 'peace' in modern societies. Co-curated by Logan, it raises important questions about how domestic politics and economics across the globe have been shaped by warfare.

With a background in documentary projects, including a major photo-essay on Italian emigration to Britain, Logan works in a way that he describes as realist. In *Masquerade* humour, montage and storytelling are used to describe circumstances and capture connections that straight documentary depictions often miss. This approach continues throughout *The King's Peace* exhibition with each contributor assembling words and images in ways that question the illusion of reality so easily achieved with cameras. Rather than capturing the spectacle of combat or the ghostly aftermath of violence, these realist photographers and filmmakers have been reluctant to show the human drama of war for fear of making it appear natural or eternal. Instead they examine the fundamental ties between conflict and peace, recognising the crucial role that images play in how societies communicate and comprehend notions of security. In this way they articulate the need for a genuine and democratic peace. **MJ**

GENERATION LOCATION
Edinburgh: Stills.

BIOGRAPHY
Owen Logan (born 1963 in Edinburgh) is a Scottish researcher and photographer. He is also a contributing editor to the independent arts magazine *Variant* and a research fellow in the field of socio-economics at the University of Aberdeen. He lives and works in Edinburgh and Toulon.

Together with the first presentation in Scotland of his photo series *Masquerade: Michael Jackson Alive in Nigeria* (2001–5), *The King's Peace: Realism and War* includes works by Adam Broomberg and Oliver Chanarin, Philip Jones Griffiths, Grupo de Artistas de Vanguardia, Fred Lonidier and Snapcorps with Stuart Platt and Martha Rosler.

FURTHER READING
Owen Logan and John-Andrew McNeish (eds), *Flammable Societies: Studies on the Socio-economics of Oil and Gas*, Pluto Press, London, 2012

The National Anthem Band,
2001–5
Silver gelatin print
From the series *Masquerade: Michael Jackson Alive in Nigeria*

Tessa Lynch

As part of GENERATION, Tessa Lynch has made a major new work for the outdoor setting of Jupiter Artland near Edinburgh. Responding directly to its location, the work is inspired by 'barn raising', which is an old form of communal house or barn building popular in Britain from medieval times and in North America in the nineteenth century. On a number of occasions throughout the project, Lynch and a group of volunteers will collectively raise or build a structure like a modern house, before it is dismantled and laid flat on the site until the next build. It can be altered, and thus will be different on each occasion.

Lynch is particularly interested in the historical belief that the law would allow people to keep land if they could build a cottage on it and light a fire in the hearth before sunset on the same day. She sees this idea as a method of ensuring agreement about new homes, as people would need help from their local community to achieve this. Her reinvention of medieval land-claiming and construction suggests that building should become more democratic. The work is designed to generate thought and discussion around ideas of home ownership and of how, in a modern age dominated by digital communication, we can form and maintain communities.

By involving a group performance, site-specific sculpture and issues surrounding social politics, these pieces develop ideas that have long been part of Lynch's work. Her *News You Can Use* series, performed in Edinburgh and London in 2007, encouraged performers to pick up handmade props, overcome their self-consciousness and re-enact news stories together. Recent works in her series *Gob-ons* (2013) consist of simplified drawings of everyday items, such as barbeques, salt shakers and plants that are transformed into sculptural objects. In creating them, Lynch is exploring what it is that makes these seemingly frivolous objects into artworks. When exhibited they are often shown in multiples, drawing our attention to the fact that they are not unique and encouraging us to think about the purpose of the gallery space. **LY**

GENERATION LOCATION
Edinburgh: Jupiter Artland.

BIOGRAPHY
Tessa Lynch (born 1984 in Surrey) studied at Camberwell College of Art, Saga University of the Arts, Kyoto, Japan and Edinburgh College of Art before completing an MFA at The Glasgow School of Art in 2013. Solo exhibitions and performances include: *Better Times*, Whitstable Biennale, Kent (2012); *Alexandrite*, Collective, Edinburgh (2010); *Revolving Doors Relaxed*, with Trolley Gallery, London (2010); *You Are Here*, Collective, Edinburgh (2010); *New Work Scotland (News You Can Use)*, Collective, Edinburgh (2007); and *Rome In A Day*, Annuale, Embassy Gallery, Edinburgh (2007). She lives and works in Glasgow.

FURTHER READING
Neil Cooper, *I Swear I Was There – The Legendary Pasts of Tessa Lynch*, Collective, Edinburgh, 2010

Rosalie Doubal, *Getting Along, Keeping Moving*, Collective, Edinburgh, 2010

Rose Ruane on Tessa Lynch – *New Work Scotland*, Collective, Edinburgh, 2007

Gob-ons, 2013
Aluminium
Installation view: *The Glue Factory*, The Glasgow School of Art, MFA degree show 2013

Lorna Macintyre

Lorna Macintyre works mainly with sculptural installation and photography. Materials such as wood, mirrored glass, metals and fabric have also been important elements in Macintyre's art.

Her installations frequently begin with a period of research. However, she uses unpredictable and intuitive processes of making and assembling her work. This means that the works are relatively abstract. They are poetic rather than literal in their relationship to her research. For her exhibition at Mount Stuart, Macintyre has taken the house's stained-glass zodiac windows and the circular, coloured windows in the ceiling – known as *oculi* – as her starting point. The windows represent both astrology and nature and use a changing sequence of colours to suggest the seasons.

Macintyre is particularly interested in the way colour takes on a symbolic role here. Her works echo this idea and are arranged throughout the house and grounds in groupings that relate to spring, summer, autumn and winter. The sequence of carefully composed installations includes crystal-glazed tiles that the artist made by hand. As in previous works, Macintyre here subtly refers to the history and visual character of the place in which she is exhibiting. In her 2012 exhibition *Midnight Scenes and Other Works*, Macintyre made installations titled after Apollo and Artemis, which explored the symbolism connected to these mythological figures. Classical mythology is an important touchstone for the artist, but she does not attempt to illustrate or represent the stories told in myths. Instead, she is interested in the way mythologies create associations between imaginary figures and particular materials or natural phenomena – the Greek god Apollo is associated with the sun, for example, or the goddess Artemis with moonlight. Mythology often tells stories of metamorphosis or transformation. Macintyre's work also deals with processes in which substances are transformed. She has often used the nineteenth-century 'cyanotype' photographic technique, for example.

Macintyre has cited William Carlos Williams's poem *Paterson* as an inspiration, with its repeated phrase 'No ideas but in things.' These words could be a fitting motto for her own art, which deals with complex ideas through the transformation and careful arrangement of materials. DP

GENERATION LOCATION
Isle of Bute: Mount Stuart.

BIOGRAPHY
Lorna Macintyre (born 1977 in Glasgow) studied BA Environmental Art and an MFA at The Glasgow School of Art. Solo exhibitions include: *Midnight Scenes and Other Works*, Mary Mary, Glasgow (2012); *Nocturne*, Kettle's Yard, Cambridge (2012); *A Tree of Night*, Galerie Kamm, Berlin (2011); *Granite and Rainbow,* WIELS Contemporary Art Centre, Brussels (2010); *Form and Freedom*, Kunsthaus Baselland, Muttenz/Basel (2010); *The Word for World is Forest*, Galerie Kamm, Berlin (2008); *Miseries and Wonders are Twins, They are Born Together*, Project Room, Glasgow (2004); and *Illusions of Grandeur*, Switchspace, Glasgow (2003). She lives and works in Glasgow.

FURTHER READING
'Lorna Macintyre interviewed by Kitty Anderson', *Millions*, February 2013

Mark Sladen, Isla Leaver-Yap and Richard Birkett, *Nought to Sixty*, Institute of Contemporary Arts, London, 2009

Glider, 2012
Cyanotype, 39.4 × 28.9 cm

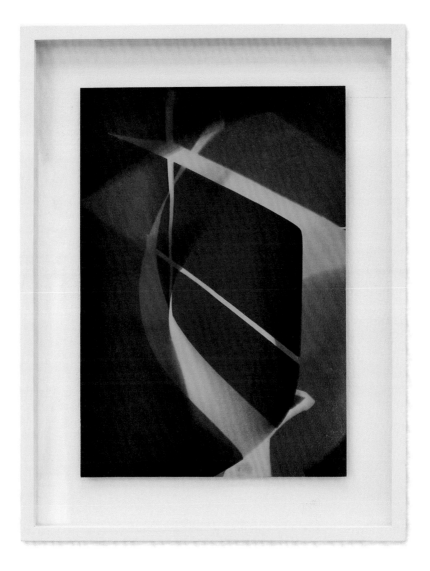

Rachel Maclean

What would happen if we used gamesmanship to decide our political future, if comic Internet memes took over the real world and if the values and vibes of sporting patriotism were infectious, but to a sinister degree? Using recent technology, Rachel Maclean constructs fantasy narratives set in computer-generated landscapes that play on thorny issues of identity, social life and politics. Maclean plays each of the characters in her films, prints and photographs, donning outlandish self-made costumes and thick make-up. She superimposes the figures onto colourful backdrops using the green screen techniques of Hollywood filmmaking and draws on existing sources found on the internet or television.

Maclean's film *LolCats* (2012) takes the Internet meme of the same name as its starting point. Here the film's lead, an Alice-in-Wonderland-like character, observes a world awash with feline attributes, from menacing workers to familiar corporate logos. Using television interviews interspersed with audio music clips, her characters mime along to pre-recorded dialogue, which she pieces together to form a dreamlike logic.

For GENERATION, Maclean has developed themes first touched on in her recent exhibition *I HEART SCOTLAND* (2013), which looked at popular markers of Scottish identity and the political debate around independence. Shown in the context of the Commonwealth Games, her new film *A Whole New World* is a black comedy, which examines what it means to be British and the ways in which national identity is constructed and deconstructed in the age of globalisation and digital connectedness. Set in a blasted post-apocalyptic landscape, the film revisits the legacy of the British Empire, drawing on video games like Prince of Persia, mining current political debates and touching on classic movie fare of foreign adventures and cross-cultural love affairs. *A Whole New World* doesn't offer a singular vision of our brave new world, but a fractured and sometimes absurd universe, where ideas and identities are constantly shifting. Mixing high art and popular culture, advanced technology with traditional theatrical values, humour with serious politics, Maclean has fashioned a unique visual universe in her art, one that is as digitally sophisticated as it is handcrafted and laborious. **StC**

GENERATION LOCATION
Glasgow: CCA.

BIOGRAPHY
Rachel Maclean (born 1987 in Edinburgh) received her BA (Hons) from Edinburgh College of Art in 2009. Recent solo exhibitions include *I HEART SCOTLAND* at Edinburgh Printmakers and *Over the Rainbow* at Collective, Edinburgh (both 2013). In the same year, Maclean received the Margaret Tait Award. Recent group exhibitions include *As real as walking down the street and going to the grocery store* at Rowing, London; *New Ideas for the City* at the State Museum of Urban Sculpture, St Petersburg; and *Costume: Written Clothing*, Tramway, Glasgow (all 2013). She lives and works in Glasgow.

FURTHER READING
Rachel Maclean, *I HEART SCOTLAND*, Edinburgh Printmakers, Edinburgh, 2013

The Lion and The Unicorn (still), 2012
Digital video
Commissioned by The Edinburgh Printmakers for Year of Creative Scotland 2013

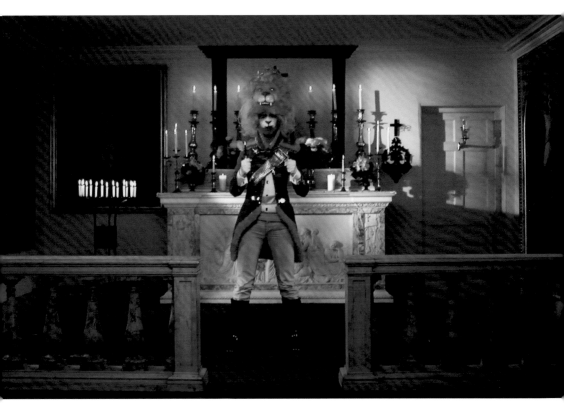

Sophie Macpherson

From street style to theatrical costume, high art to DIY clothing, Sophie Macpherson playfully questions the role of clothes and gesture in our day-to-day lives working across drawing, sculpture, text and film. In her art, hyper-stylised outfits sit alongside prop-like objects in theatrical settings or performances. Clothes become animated as performers in her films or appear like sculptures in the gallery space, and sculptures are re-used as props in her performances. Through such substitutions of artwork, body, costume and prop, Macpherson explores our relationship to clothes and their display.

Examining the potency of clothes for subcultural groups, Macpherson often combines highly theatrical notions of costume with elements of street style. The wardrobe worn by the faceless figures that appear in her films and drawings fuses elements of casual branded street-wear with references to theatrical costume. Hoodies, tracksuits and white trainers meet elements of Bauhaus, cabaret and Art Deco to create moments of camp theatricality, gang subculture, high fashion and consumer fetishism.

Macpherson's films and live works inhabit a stage-like space where human figures, backgrounds and objects are equally important. Performers appear dressed in brightly coloured or patterned outfits against backdrops of a similar nature, blurring the distinction between people and props. Macpherson draws her choreography from everyday movements and actions, which when they are repeated can become strange, uncanny and ritualised.

In her 16mm film *A Series of Movements* (2011) she explores this relationship between everyday behaviour and abstract action, using her sculptural works as props. The film *American Dance* (2010) features the artist herself wearing a pair of male-cut Levis and performing a series of movements derived from both Scottish traditional dance and Los Angeles contemporary street dance. Developing these themes into an ambitious live format, in 2011–12 Macpherson worked with Clare Stephenson on *Shoplifters, Shopgirls*, a series of vignettes, or short scenes, carried out by a temporary troupe comprised of Macpherson's artistic peers. **CJ**

GENERATION LOCATION
Glasgow: Tramway –
Performance Programme.

BIOGRAPHY
Sophie Macpherson (born 1972 in Aylesbury) graduated with a BA from The Glasgow School of Art in 1996. She was a committee member at Transmission Gallery, Glasgow (1998–2000). She co-curated the Sunday-night art/performance events *Flourish Nights* in Glasgow from 2002 to 2003. Recent projects and exhibitions include: *Costume-Written Clothing*, Tramway, Glasgow (2013); *The Irregular Correct* at the Fremantle Arts Centre, Fremantle, Australia (2012); *Studio 58: Women Artists in Glasgow Since World War II*, Mackintosh Museum, The Glasgow School of Art (2012); *Her Noise: Feminisms and the Sonic,* Tate Modern, London (2012); *Shoplifters, Shopgirls* (with Clare Stephenson), Tramway, Glasgow (2011); *The Voice is a Language,* Glasgow International festival (2010). She was a founding member of the musical collective Muscles of Joy. She lives and works in Glasgow and Berlin.

FURTHER READING
'Shoplifters Shopgirls', interview of Sophie Macpherson and Clare Stephenson, *MAP*, Summer 2011

'Glasgow', *Art Review*, September 2011

A Series of Movements (still), 2011
16mm colour film with sound

Chad McCail

Chad McCail's work recalls the kind of visual information that we are bombarded with every day. His drawings, paintings, prints and sculpture recall school textbooks, how-to guides, comics and the instructional pamphlets, posters and slogans that are a feature of public information campaigns.

This material is often used by authority figures such as governments or teachers, but the artist turns his sources on their head. Rather than telling us what we should or shouldn't do he uses these techniques to imagine and describe ideal worlds where people take care of each other and share their resources without conflict. Or he uses images as a way to explain the processes that he believes have driven our fear of such change. McCail's subject is ourselves: how we grow up, are educated, our workplaces, our economy, relationships between the sexes and the very structure of society itself.

Some of his work imagines a utopian future where we are happy and free. *Wealth is Shared* (2000) is a series of three paintings, influenced by the simple texts and images of Ladybird children's books. They show a world where the wealthy share their property and where men and women strive to understand and improve their relationships. In the third of these paintings, *Wealth is Shared – No One Charges, No One Pays*, a supermarket has been changed into a giant greenhouse where people grow and harvest food and children play happily in a nearby river.

Other works describe the processes which McCail thinks restrain or intimidate our emotional and intellectual development. *Monoculture* (2010) is a large print influenced by the look of early computer games and the way they allow players to progress upwards through different levels of the game. It shows children being educated and finally emerging into the world. However, the teachers are shown as stiff, pixelated robot figures and as the children move upwards through the system they lose their individuality and become robotic too. The adult world they enter is a grey desecrated landscape of factories and smoke. McCail's work uses deceptively simple means to tell us about our complex world and how we might change it. **MJ**

GENERATION LOCATION
Edinburgh: City Art Centre.

BIOGRAPHY
Chad McCail (born 1961 in Manchester) studied English at the University of Kent and obtained a BA in Fine Art from Goldsmiths, University of London in 1989. His solo exhibitions include: *Systemic*, Northern Gallery of Contemporary Art, Sunderland (2010); *We are not dead*, Gallery of Modern Art, Glasgow (2006); *Food, Shelter, Clothing, Fuel*, Baltimore Museum of Art, Baltimore (2004); and *Life is driven by the desire for pleasure*, The Fruitmarket Gallery, Edinburgh (2003). His many group exhibitions include *Eye on Europe: Prints, Books and Multiples, 1960 to Now*, MoMA, New York (2006); *British Art Show 5* (2000); and *Beck's Futures*, ICA, London (2000). He lives and works in Thankerton, South Lanarkshire.

FURTHER READING
Chad McCail: Life is driven by the desire for pleasure, The Fruitmarket Gallery, Edinburgh, 2003

Chad McCail, *Active Genital*, Bookworks, London, 2002

No One Charges, No One Pays, 2000
Gouache on paper, 76.2 × 152.4 cm
Scottish National Gallery of Modern Art, Edinburgh

Lucy McKenzie

Lucy McKenzie is interested in blurring the boundaries between art and design, as well as art and life. Her work challenges our notions about the role of the artist and encompasses a wide range of visual and written forms. She is involved in curating, fiction writing, illustration, decorative and trompe-l'oeil painting, sculpture, installation, fashion design and interior design.

Underpinning all these activities is her desire to form new associations or meanings through the use of both existing and newly made source material and to explore and critique existing orthodoxies. Drawing from an eclectic array of sources, including art and design history, contemporary culture, crime fiction, politics and pornography, the resulting works are rich with references.

McKenzie's use of traditional techniques such as decorative and trompe-l'oeil painting is a significant aspect of her work. Over recent years she has produced a body of paintings which take the form of the *quodlibet* – the name given to a trompe-l'oeil or illusionistic painting depicting ribbons, letters, playing cards, and/or other material of a kind that might be found on a writing desk. McKenzie's works in this vein have the appearance of cork pinboards with various items attached to them, or tabletops strewn with objects. An example is *Quodlibet XX (Fascism)* (2012), in which she has used the form of a mood board to explore the aesthetics of the twentieth-century Italian Fascist movement. Attached to a pinboard are paint sample booklets, architectural drawings for a bathroom, as well as images of different types of marble – all materials that point towards the idea of the interior, or of decoration. Also visible is a flyer for the 1933 *Triennale di Milano* – the showcase for modern decorative and industrial arts held regularly in Milan.

By linking these elements, McKenzie is alluding to how a 'Fascist' may choose to have his or her bathroom decorated – the combination of extreme politics, mundane daily life and the use of design. Rather than making a definitive statement, the impression with McKenzie's *quodlibet* works is of subjects under investigation or research in process – deliberately without the closure associated with a finished work. **J-AD**

GENERATION LOCATION
Edinburgh: Scottish National Gallery of Modern Art.

BIOGRAPHY
Lucy McKenzie (born 1977 in Glasgow) graduated from Duncan of Jordanstone College of Art & Design, Dundee in 1999. From 2007 to 2008 she studied decorative painting at Van Der Kelen Logelain in Brussels. She formed the interior design company Atelier E.B. with Edinburgh-based designer Beca Lipscombe and illustrator Bernie Reid. Solo shows have been held at the Stedelijk Museum, Amsterdam (2013), the Museum of Modern Art, New York (2008) and the Van Abbemuseum, Eindhoven (2004). McKenzie was a guest professor at the Düsseldorf Kunstakademie in 2011–13. She lives and works in Brussels.

FURTHER READING
Catriona Duffy and Lucy McEachan (eds), *The Inventors of Tradition*: Beca Lipscombe, Lucy McKenzie, Walther König, Cologne and Koenig Books, London, 2011

Lucy McKenzie, Barbara Engelbach and Kasper König *Lucy McKenzie: Chêne de Weekend*, Walther König, Cologne, 2009

Quodlibet XX (Fascism), 2012
Oil on canvas, 65 × 50 × 2.5 cm
Private collection

Wendy McMurdo

Wendy McMurdo is a photographer and filmmaker who focuses on the relationship between technology and identity expressed through the images and ideas of childhood. She looks at the psychological world of children and young people, both as a protected space and, increasingly, as a ground for marketing wars and a prematurely forced adulthood.

McMurdo has been a long-time expert in leading-edge, digital photography – a working process that nevertheless owes much to early photography pioneers. This allows her to reflect directly on the innate relationship between child's play, make-believe and technological image making. In her earlier works – for example, *In a Shaded Place* (1995) – she used photographic techniques to make unnerving images in which children would confront their own doubles.

She recognises that our relationship with the digital world has not stood still. The introduction of computers into early learning has meant that children very quickly become fully networked, online and social beings. This is affecting whole generations and reframing how we develop a sense of identity, how we behave and interact with each other.

McMurdo's *The Skater* (2009) created figures inhabiting a similar fantastical world, somewhat like a computer gamer. The related film work, *The Loop* (2009), showed a girl mimicking the actions of a figure skater on a neighbouring screen, highlighting the desire to play in both physical and digital realms. What is going through this young gamer's mind, as she mirrors the expert adult caught on an unworldly screen that she studies? We witness the very borderline between fantasy and reality as it forms in the mind of a child.

Recently, McMurdo has extended her technological interest by exploring the growth of artificial intelligence, particularly 'social robots'. In the series *My Real Baby* (2009 onwards) scenes were created that put advanced 'servant' robotics together with people (both young and adult) in ways that emphasise these humanising electronic forms. Just how much closeness can we tolerate with a responsive machine? Artists such as McMurdo use advanced lens-based techniques to reflect and comment vividly on developments in contemporary science. **AP**

GENERATION LOCATION
Glasgow: Street Level Photoworks.

BIOGRAPHY
Wendy McMurdo (born 1962 in Edinburgh) graduated BA (Hons) in Fine Art at Edinburgh College of Art in 1985. She studied at the Pratt Institute, New York (1986) and completed her MA at Goldsmiths College, London in 1993. She is currently completing a PhD (by publication) at the University of Westminster. She received a Henry Moore Fellowship (1993–5) and was a lecturer at Duncan of Jordanstone College of Art & Design, Dundee from 1990 to 2002. Solo exhibitions include *In a Shaded Place – The Digital and the Uncanny*, British Council touring exhibition (2009) and *The Skater*, ff30 commission, Ffotogallery, Wales (2009). Group exhibitions include *The Digital Eye: Photographic Art in the Electronic Age*, The Henry Art Gallery, University of Washington, Seattle (2011) and *Unheimlich*, Fotomuseum, Winthertur, Switzerland (1999). She lives and works in Edinburgh.

FURTHER READING
'Wendy McMurdo: Digital Play', *Source – photographic review*, Spring 2012

Wendy McMurdo: The Skater, Ffotogallery, Cardiff, 2009

Wendy McMurdo, Centro de Fotografia, Ediciones Universidad de Salamanca, Spain, 2001

The Somnambulist, 1995
Digital photograph
from the series *In A Shaded Place*

Alan Michael

Alan Michael's paintings and photo-based works draw on cultural and social history and cast a critical eye on cultural nostalgia and the anxiety of the contemporary condition. Weaving together references to subculture that were at one time charged with meaning, Michael hints at their casual re-use as emblems of class, style and taste. Two important movements of late twentieth-century art – Pop Art and Photorealism – provide formal reference points for his work.

Michael's paintings adopt a similar approach to the way that advertising and the media combine images of 'high art' or cultural resonance with banal everyday commodities. Sources from art history, design and fashion appear alongside plants, cars, food, text, logos and other commonplace objects. Michael approaches these subjects with the same indifference – isolating, splitting and repeating his subjects within the frame of the canvas so that they appear coolly detached and anonymous. Serial representations of iconic British culture and emblems of the middle classes, such as the classic brogue shoe and the new Mini Cooper, collide with the stylistic symbols of 1980s fashion, music and contemporary experience. References to subculture and the artist's own life also feature in the work; quotations from Glaswegian bands appear as innocuous wallpaper-like backgrounds in his earlier paintings.

The seemingly disparate nature of the combinations of images and references belies Michael's meticulous and labour-intensive process. His paintings border on the forensic in their detail, yet Michael is more interested in the display of pointless labour and repetition than achieving perfection. His work reflects wider shifts within Internet culture and the vast economy of the circulation of images. Echoing these themes, the exhibition *Res Gestae* at David Kordansky Gallery, Los Angeles (2011) combined repeated images of the high-street fashion, cult designers at work and examples of a final-year student presentation. It reflected on moments when general cultural ambience was on the verge of giving way to celebrity or commercial success. Paintings of well-known fashion designers alternated with imagery taken from wholesale magazines or advertising, combining references to the amateur, the subcultural and the rarefied. **CJ**

GENERATION LOCATION
Glasgow: Tramway.

BIOGRAPHY
Alan Michael (born 1967 in Glasgow) studied at Duncan of Jordanstone College of Art & Design, Dundee and The Glasgow School of Art, and was a committee member at Transmission Gallery, Glasgow (1999–2001). Recent solo exhibitions include: *P.A.* Vilma Gold, London (2014); *Note to Self* (with Lucy McKenzie), The Artist's Institute, Hunter College, New York (2013); *The Manuel xx*, OHIO, Glasgow (2013); *Res Gestae*, David Kordansky Gallery, Los Angeles (2011); *Silhouette Formulas*, HOTEL, London (2010); *Mood Casual*, Art Now, Tate Britain, London (2008); and *Touch Void*, Talbot Rice Gallery, Edinburgh (2008). His work has also been featured in numerous group shows including *The Tate Triennial*, Tate Britain (2006). He lives and works in London.

FURTHER READING
Lucy McKenzie and Alan Michael, *Unlawful Assembly*, Fiorucci Art Trust, Milan, Cologne and London, 2014

Judith Vranken, 'Reviews: Alan Michael at David Kordansky', *Flash Art*, March–April 2012

Alan Michael, HOTEL, London and David Kordansky Gallery, Los Angeles, 2010

Natwest, Anon-nets, Bornagain, 2013
Oil on canvas, 102 × 145 cm

Jonathan Monk

The starting point for many of Jonathan Monk's works is something made by someone else. Replicating everything from handwritten notices to world-famous works of art, Monk has developed a diverse body of work that encompasses almost every possible form. Re-making and adapting a vast array of images, signs and objects, he brings irony, wit and, at times, autobiography to bear on the items he references. His approach is similar to that of the musician recording a cover version of a song: always demonstrating some fondness for, and interest in, the original.

In recent years, Monk has created versions of works by some of the most well-known – and highly valued – artists of our time, such as Jeff Koons and Gerhard Richter. In 2008, he had multiple copies made of a famous and instantly recognisable work by Andy Warhol: a portrait of Chairman Mao. Made by hand in China, Monk's copies were shown together as a unique work entitled *Andy Warhol's Chairman Maos Hand Made in The People's Republic of China* (2008), inverting the questions of origin, value, reproduction and skill triggered by Warhol's screenprinted original.

Monk's series of 'holiday paintings', exhibited at the Gallery of Modern Art One in Edinburgh, were made and first exhibited while he was living in Glasgow. They are all derived from handwritten signs in travel agents' windows advertising cheap package holidays. He has reproduced the signs, making them all the same size, with the writing mimicking that found on the originals.

First exhibited at the CCA, Glasgow in 1992 in an exhibition entitled *On the Cheap*, the paintings were sold individually, each for the price of the holiday they advertised. In doing so, Monk emphasised the questions of choice and value suggested by the content of the signs, effectively offering the viewer a choice between a short holiday and a painting.

As one critic has written, 'Jonathan Monk's work seems predicated on testing out possible exceptions to the rule that remakes and sequels are never quite as good as the originals.' KB

GENERATION LOCATION
Edinburgh: Scottish National Gallery of Modern Art.

BIOGRAPHY
Jonathan Monk (born 1969 in Leicester) studied at Leicester Polytechnic before moving to Glasgow where he studied at The Glasgow School of Art, graduating in 1991. He has had solo exhibitions at the ICA, London (2005), Tramway, Glasgow (2008) and the Palais de Tokyo and Musée d'Art Moderne, Paris (2008). His work has been included in numerous group exhibitions internationally, including the 50th and 53rd Venice Biennale exhibitions (2003 and 2009). Monk moved to Los Angeles in 1997 and has lived and worked in Berlin since 1999.

FURTHER READING
Jonathan Monk, *Studio Visit*, JRP|Ringier, Zurich, 2010

Frédéric Paul (ed.), *Jonathan Monk: Until Then ... If Not Before*, bilingual edition, Domaine De Kerguehennec, Bignan, 2007

Holiday Painting (Tenerife 15th January £119), 1995
Acrylic on canvas, 60.5 × 40.5 cm

Cameron Morgan

From the thrill of reaching the top of a hill to the adrenalin-soaked atmosphere of the wrestling ring, Cameron Morgan is a self-taught artist whose art reflects his everyday interests, activities and pleasures. These include gardening, hill walking and the themes and characters of classic Hollywood movies.

Morgan began making art at an early age. He often improvised with whatever materials were close at hand, making papier-mâché models for example. As a young man he was given a Polaroid™ camera as a gift, and for thirty years now he has documented his daily life and his work as an artist. These days he works in painting, photography, drawing and, occasionally, ceramics.

Morgan's vibrant paintings feature bold, flat and heavily saturated colour. Their strong lines evoke stained-glass windows and the tradition of murals in public building. His images of nature are highly stylised. *Coconut Palms* (2013), for example, with its strong violet, red and blue hues and emphasis on pattern, is not a straightforward visual description of the trees, but an image with great energy and impact.

While his art doesn't have religious themes, his human figures often recall those in religious paintings. Morgan, though, applies these visual styles to sympathetic and sometimes humorous renderings of characters such as strongmen, wrestlers, athletes and rock musicians. His commission for Clydebank's Golden Jubilee National Hospital in 2012 pictured the visual drama of the operating theatre, with a dramatic close-up of two surgeons in green scrubs surrounded by their tools and instruments.

The strongest theme in Morgan's art is physical endurance and the overcoming of adversity. These ideas are also reflected in the demanding size of his wall paintings and the physical challenges that he sets himself in making his work. His major mural *Let the Games Begin* at Project Ability, Glasgow in 2011 explored sports from track athletics to wrestling, but its massive scale and strong colour also meant that visitors were encouraged to think about their own bodies and abilities.

For GENERATION, Morgan will make a new wall painting in the Project Ability gallery space in Glasgow. Visitors will be able to see him at work in the gallery for the month before the exhibition. **MJ**

GENERATION LOCATION
Glasgow: Project Ability.

BIOGRAPHY
Cameron Morgan is self-taught. Solo exhibitions include *Let the Games Begin*, Project Ability Gallery, Glasgow (2011). Group exhibitions include *Big i,* Big i Project, Osaka, Japan (2013); *Aspire @ Platform*, Platform, The Bridge, Glasgow (2013); *Lennox Castle Stories*, Trongate 103, Glasgow (2012); *Crunch Art Fair*, Celf O Gwmpas, Art & Philosophy Festival, Hay-on-Wye (2011); *Glesga Boys*, Oriel Beaufort Gallery, Llandrindod Wells (2011); and *Vollkonzentriert*, Galerie Alte Turnhalle, Bad Dürkheim, Germany (2011). His works have been commissioned for public places including the Golden Jubilee National Hospital in Clydebank, SECC in Glasgow, the Tron Theatre in Glasgow and Manchester Airport. He lives in Stenhousemuir and works in Glasgow.

Coconut Palms, 2013
Oil on canvas

Victoria Morton

Victoria Morton's work includes painting, sound, found objects, garments and photography. While it often appears spontaneous or improvised, it is based on a deep understanding of art theory. Her work as an artist sits alongside an active involvement with music production, most recently as a member of the band Muscles of Joy and in collaboration with Jer Reid.

The painting *Dirty Burning* (1997) – named after the 1992 album *Dirty* by Sonic Youth – was a pivotal work for the artist. It was painted over a period of a year, with no preconceived final image in mind, continually changing and expanding to include ideas and actions from many different kinds of sources. The work *Dream House*, a collaborative sound and light environment by composer La Monte Young and visual artist Marian Zazeela which Morton saw in New York in 1991, had a profound influence on the artist and on *Dirty Burning*, as it uses repetition, tone and duration to confuse expectation and slow down the act of looking. By making the canvas extraordinarily full of colour and form, Morton wished to create an expansive space to envelop and perhaps overwhelm the viewer. This desire relates to Morton's interest in music's non-verbal expressive qualities and the belief that paintings can resonate on psychological and emotional levels as well as contain theoretical ideas.

In more recent installations, paintings and sculptures (using found objects) are brought together, extending the composition of the paintings. Morton weaves reflections on historical painting, literature and day-to-day life into the artworks, which combine to communicate an altered sense of lived experience. A painted headboard is positioned in the middle of a room, a dress is draped on a metal frame, the battered wooden stepladders that the artist used when painting large canvases remain in the gallery. These actions emphasise the domestic and suggest that painting belongs in the real world rather than the sanctified, dehumanised environment of the museum. **LY**

GENERATION LOCATION
Edinburgh: Scottish National Gallery of Modern Art.

BIOGRAPHY
Victoria Morton (born 1971 in Glasgow) received a BA (Hons) in Fine Art – Painting in 1993 and her MFA in 1995, both from The Glasgow School of Art. Morton has held numerous solo exhibitions including: *Tapestry (Radio On)*, Isabella Stewart Gardner Museum, Boston, USA (2012); *Her Guitars*, The Modern Institute, Glasgow (2011); *Victoria Morton*, Inverleith House, Edinburgh (2010); *ba BA ba*, Sadie Coles, London (2008); *Sun By Ear*, Tramway, Glasgow (2007); *Victoria Morton*, Bonner Kunstverein, Bonn, Germany (2004); and *Plus and Minus*, The Fruitmarket Gallery, Edinburgh (2002). Recent group exhibitions include *Studio 58: Women Artists in Glasgow since WWII*, Mackintosh Museum, The Glasgow School of Art (2012), *Every Night I go to Sleep*, Modern Art, London (2010) and *Edge of the Real*, Whitechapel Gallery, London (2004). She works in Glasgow and also in Fossombrone, Italy.

FURTHER READING
Neil Cooper, 'Muscles of Joy: No-one's little girls shouting out loud', *MAP Magazine*, 6 November 2012

Victoria Morton, Royal Botanic Garden, Edinburgh, 2010

Victoria Morton: Plus and Minus, The Fruitmarket Gallery, Edinburgh, 2002

Tapestry (Radio On), 2012
Installation view: Isabella Stewart Gardner Museum, Boston, 2012

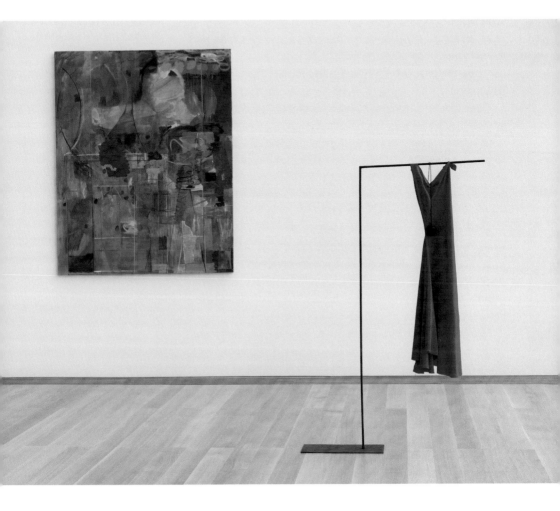

Scott Myles

Scott Myles works in sculpture, printmaking, drawing, text, photography, painting and performance. If there is a signature to his work it isn't to be found in a single aesthetic or 'look', or in the use of a particular material, but in the ideas and concepts that underpin all his projects.

Three themes often inform Myles's approach. The first is an interest in gift-exchange as a way that objects can create relationships and as a process in which the meaning of objects change. In *Learn The Language* (2003) he added his own statement to the blank side of a free poster created by the influential artist Felix Gonzalez-Torres. Here the object is transformed from a free gift into a reply or gesture that reciprocates the gift.

Secondly, Myles's art often explores the theme of commerce and work. An important early piece *Untitled (Smoking)* (2001) involved Myles employing a smoker to take cigarette breaks throughout a single day in Glasgow's business district. This paid smoker blended with the 'real' workers taking 'real' breaks. The usual relationship between work and escape from work was reversed.

Finally, Myles is particularly drawn to the structures that make up our everyday environment. He has used window frames, doors, office furniture, stationery, shelves and shop signs in his work, often transforming these materials to emphasise how they suggest different economic, social or psychological relationships. In *Analysis (Mirror)* (2012), he took two bus shelters as readymade sculptures. He inverted one atop the other and had both coated in silver so that they reflect themselves, the viewer, and the room where they are displayed. The work's title suggests an analysis of an ordinary structure (the bus shelter), the self-analysis that might be occasioned by looking in the mirror, and the complex ideas of psychoanalysis. *Habitat* (2013) is a life-size electroformed copper cast of a Habitat sign left behind after the company went into administration in 2011. The work reproduces the scuffed logo including the film of the black plastic that covered it after the closure. This might be a sign of mourning, of personal or economic loss. Whatever shape Myles's works take, they ask us to think about how personal and social meanings are layered in objects, images and structures. **DP**

GENERATION LOCATION
Glasgow: The Modern Institute.

BIOGRAPHY
Scott Myles (born 1975 in Dundee) studied Fine Art at Duncan of Jordanstone College of Art & Design, Dundee. Solo exhibitions include: *Excess Energy*, David Kordansky Gallery, Los Angeles (2013); *YOU*, Meyer Riegger, Berlin (2012); *This Production*, Dundee Contemporary Arts (2012); *ELBABLE*, The Breeder, Athens (2011); *ELBA*, Glasgow Print Studio, Glasgow (2010); *ASKIT*, The Modern Institute, Glasgow (2007); and *Scott Myles*, Kunsthalle Zürich, Zurich (2005). Group exhibitions include *Every Day*, Gallery of Modern Art, Glasgow (2013) and *Tate Triennial: New British Art*, Tate Britain, London (2006). He lives and works in Glasgow.

FURTHER READING
Dominic Paterson, 'Houses in motion', in *Scott Myles: This Production*, Dundee Contemporary Arts, 2013

Beatrix Ruf (ed.), *Scott Myles*, Kunsthalle Zürich, 2007

Analysis (Mirror), 2012
Found object, silver, UV lacquer
Installation view: *This Production*, DCA, Dundee, 2012
Rennie Collection, Vancouver

Rosalind Nashashibi

Rosalind Nashashibi creates works in film, sculpture, photography and printmaking. Her films, in particular, reveal the rhythms and patterns of everyday life and explore the boundaries between reality and fiction. Working in 16mm film, her early works focused on real situations, but did not reveal stories about her subjects; rather, she is fascinated by the rituals played out by social groups and the individual's place within the society.

Midwest (2002) is an example of this approach. Focusing on body language and gesture rather than words and conversation, it is an exploration of the passing of time. Made during an artist's residency project in Omaha, Nebraska, it is a record of ordinary life in the racially segregated city; with areas so neglected they appear to be reverting to a rural landscape. Within this context the artist evokes the melancholic side of a community that seems to be both drifting along and waiting for something to happen.

In 2005, Nashashibi moved away from purely observational films. Delving deeper into the meeting of mythology, performance and anthropology, she began to film in the borders where reality and fiction meet. *Carlo's Vision* (2011) is based on an episode in Pasolini's unfinished novel *Petrolio* in which the protagonist has a vision in a busy shopping street in Rome. Nashashibi transports the vision from the 1970s to the present day, updating the voices to reflect the current political and social reality in Italy. Colliding real space with fictional space, viewers of the film are watching alongside the streets' passers-by.

Such ideas were further cemented in Nashashibi's 2012 commission from Scottish Ballet and Glasgow International Festival, *Lovely Young People (Beautiful Supple Bodies)*, in which she invited local residents in Glasgow to watch Scottish Ballet rehearsals. The film creates a tension between the dancers' movement – the ritual and discipline involved in learning the routine – and the figures watching the performance. The camera records their gaze and their whispered thoughts about what they are seeing. In Nashashibi's film, the watcher becomes the watched, highlighting the artist's interest in the way the lens of the camera captures and transforms how we interact with our environment and with each other. **ShC**

GENERATION LOCATION
Edinburgh: Scottish National Gallery.

BIOGRAPHY
Rosalind Nashashibi (born 1973 in Croydon) studied art at Sheffield Hallam University from 1992 to 1995. In 1998 she began an MFA degree at The Glasgow School of Art, graduating in 2000. She has exhibited widely and her solo shows include Tate Britain, London (2004) Kunsthalle, Basel (2004), Chisenhale Gallery, London (2007), Presentation House, Vancouver (2008), ICA, London and Bergen Kunsthall, Norway (2009), Murray Guy, New York (2013), Objectif Exhibitions, Antwerp (2013). In 2003 Nashashibi was the first woman to be awarded the Beck's Futures Art Prize. In 2007 she exhibited as part of *Scotland + Venice* at the 52nd Venice Biennale. She lives and works in Liverpool.

FURTHER READING
Rosalind Nashashibi, Institute of Contemporary Arts, London, 2009

Adam Szymczyk, *Rosalind Nashashibi: Over In*, Kunsthalle Basel, 2004

Francis McKee *et al.*, *Rosalind Nashashibi*, The Fruitmarket Gallery, Edinburgh, 2003

Midwest (still), 2002
16 mm colour film transferred to BetaSP
Scottish National Gallery of Modern Art, Edinburgh

→ Jonathan Owen

Jonathan Owen's art is about transformation. Finding photographs that have been reproduced in books, the artist uses an ordinary rubber to erase parts of the image; he does not add anything to the surface of the page. To date Owen has worked on two such series: public statues, and Hollywood film stars on set. In early examples he operated in a systematic manner, whereas his more recent works have seen him move in a more intuitive way. Owen knows that the task could easily be accomplished with computer programs like Photoshop®. However, he values the inevitable imperfections that arise when it is done by hand with an ordinary eraser. The residual trace of the figure, which looks like a ghostly apparition, leaves clues as to what was once there.

Owen describes this process of removal as a form of two-dimensional carving. It thus makes sense that his work has evolved three-dimensionally. This began with wooden nutcrackers that Owen intricately altered through carving, first displayed in 2011. These small, captivating sculptures were followed by bold interventions with nineteenth-century marble statues, which he transforms into partially collapsed yet elegant reductions of their original form.

Mercury (2012) shows Owen's interest in altering the dynamism of the figure. The artist has carved the figure of Mercury's torso into the form of a chain. The sculpture's head now slumps forward, as though lamenting. By contrast, in *Untitled* (2013) the head of a military figure is dramatically distorted, yet the torso remains untouched. The artist has carved the figure's head into a cage with an intricate three-dimensional star pattern that echoes the medal on his lapel. A moveable marble sphere is trapped inside. In removing the facial features and not titling the work, he focuses attention on the physicality of the sculpture as an object rather than a biographical or allegorical statement. Owen is interested in how figures are immortalised through sculpture and photography and how his own actions question their place in history. **ShC**

GENERATION LOCATIONS
Edinburgh: City Art Centre; Scottish National Gallery of Modern Art.

BIOGRAPHY
Jonathan Owen (born 1973 in Liverpool) studied Fine Art at Leeds Metropolitan University, graduating in 1996, before obtaining an MFA from Edinburgh College of Art in 2000. Owen began exhibiting with solo shows at Collective, Edinburgh, and doggerfisher, Edinburgh (both 2001), and as part of the group show *New: Recent Acquisitions of Contemporary British Art* at the Scottish National Gallery of Modern Art, Edinburgh (2002). The Ingleby Gallery, Edinburgh, held solo presentations of Owen's work in 2011 and 2014. He has gone on to exhibit in the UK and internationally. He lives and works in Edinburgh.

FURTHER READING
Isobel Johnstone, *The Secret Confession*, Edinburgh College of Art, 2010

Collage: Assembling Contemporary Art, Black Dog Publishing, London, 2008

Alice Dewey, *New: Recent Acquisitions of Contemporary British Art*, National Galleries of Scotland, Edinburgh, 2002

Untitled, 2013
19th-century marble bust with further carving
Scottish National Gallery of Modern Art, Edinburgh

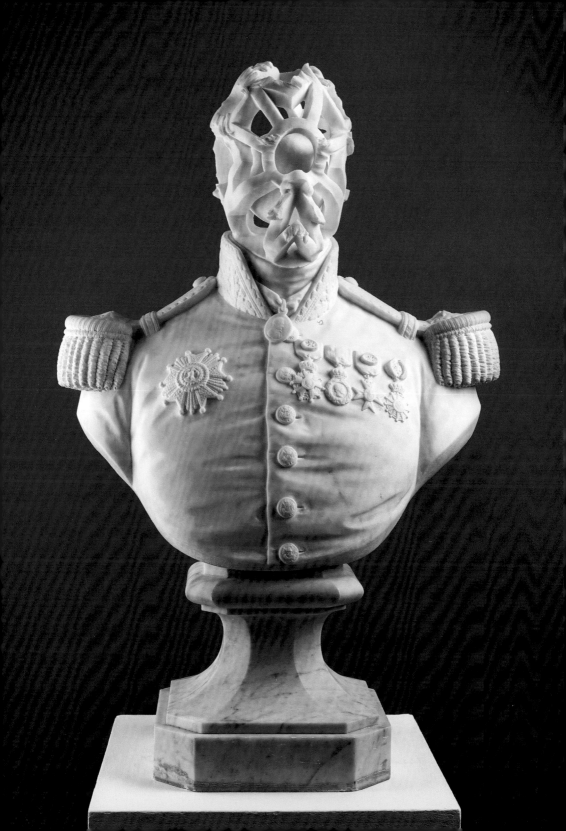

→ Nicolas Party

Nicolas Party begins with objects that are familiar to us in our daily lives and reworks them in a way that heightens or exaggerates their presence. Coffee pots, cups, cutlery, geometric shapes, plants and portraits – both human and animal – often appear in his work, which includes painting, drawing, sculpture, printmaking and curatorial projects.

Party continually tests the boundaries of process and technique; oil paintings may take many months to complete, while charcoal or paint landscapes can fill vast walls in only a matter of days. Rocks transform into fruit, and animals shift into furniture and tableware. Each of Party's subjects is depicted with a formal elegance, based on imagination rather than observation. But Party also works with an interest in artists that have come before him, including the painters Paul Cézanne (1839–1906), Giorgio Morandi (1890–1964) and David Hockney (born 1937).

Party's background as a graffiti artist gives his art both a particular sense of modern design culture and an ability to effortlessly manipulate scale and context. Moving from interior to outdoor projects and from small to large scale, he does so with a lightness of touch that energises what are often highly traditional subjects such as still life and portraiture. Many of Party's exhibitions feature brightly coloured wall paintings formed of repeated patterns. They command space and connect the different forms of work on display. In turn they also remind us of the artist's physical presence within the gallery. Increasingly his work actively involves people. He has held dinner parties for which he designed a menu, tableware and furniture (later displaying these elements as sculpture), and invited children to the gallery to play with his handmade 'art props'. These recall historic works such as artist Francis Picabia and composer Eric Satie's collaboration on the 1924 ballet *Relâche* or David Hockney's 1975 stage set for the opera *The Rake's Progress* at Glyndebourne. **LY**

GENERATION LOCATION
Various: GENERATION Public Commission.

BIOGRAPHY
Nicolas Party (born 1980 in Lausanne, Switzerland) completed a BA in Fine Art at the Lausanne School of Art before undertaking an MA at The Glasgow School of Art, graduating in 2009. Party's solo exhibitions include *Still Life oil paintings and Landscape watercolours*, The Modern Institute, Glasgow (2013); *Cully Jazz*, Davel 14, Cully, Switzerland (2013); *Still Lives and Big Naked Women*, Gregor Staiger, Zurich (2012); *Still Life, Stones and Elephants*, the Swiss Institute in New York (2012); *Still Life, Gold and Peeling Paint*, ReMap, Athens (2012); *Dinner for 24 Elephants*, The Modern Institute, Glasgow (2011); and *Elephants at the Woodmill*, The Woodmill, London (2011). He lives and works in Brussels.

FURTHER READING
Chris Sharratt, 'Strange fruits', *Frieze d/e*, issue 12, December 2013–February 2014

Chris Sharratt, 'Nicolas Party', *Frieze*, issue 156, June–August 2013

Maria Hoberman, 'Nicolas Party', *Swiss Institute Contemporary Art*, no.1, March 2012

Still life with an olive, 2012–13
Oil on canvas, 139.5 × 183 cm
Collection of Bert Kreuk

Katie Paterson

Katie Paterson's interests extend far beyond earthly boundaries. Using both the universe and innovative cutting-edge science, she produces poetic works that explore the cosmos as well as the very fabric of life. Her complex and technically challenging projects are born from intense periods of research and draw on scientific and technical expertise from around the globe. Previous works have involved collaboration with specialists in the fields of geology, cosmology, ecology, astronomy and, more recently, genetics.

The artist's finished works distil and communicate complex ideas about the universe and human existence, transforming scientific information into objects of both beauty and simplicity. Whether through photography, installation, sculpture or sound, the minimalist and often low-key appearance of much of Paterson's work disguises the depth of research and logistics that underpin her art.

Paterson has a long-running interest in forms of communication, and this is particularly evident in her 2007 installation, *Earth–Moon–Earth (Moonlight Sonata Reflected from the Surface of the Moon)*, where a version of Beethoven's melancholic 1802 work, *Moonlight Sonata,* was sent to the moon and back. Translated into Morse code, the original score was then transmitted using Earth–Moon–Earth (EME) – a form of radio communication through which messages are sent from Earth, reflected from the surface of the moon, and then received back on Earth. After travelling around 480,000 miles, the returned code was transferred back into musical notation. As a result of its contact with the uneven surface of the moon, some of the original notes were lost.

When exhibited, the reflected sonata is played through a digital grand piano, the ghostly keys seeming to move of their own accord. Hearing the moon-altered music, with its pauses and missing notes, we are reminded of the immense journey that it has undertaken. This journey also serves to highlight many of the interests which run through Paterson's practice – making visible the intangible, action and reaction, as well as the seeming insignificance of humanity within the huge expanse of the universe. **J-AD**

GENERATION LOCATIONS
Edinburgh: Ingleby Gallery; Jupiter Artland.

BIOGRAPHY
Katie Paterson (born 1981 in Glasgow) was educated at Edinburgh College of Art (2000–4). She undertook an MA at the Slade School of Art, London (2005–7), then spent a year in Iceland. Key solo shows have been staged at the Ingleby Gallery, Edinburgh (2014), BAWAG Contemporary, Vienna (2012) and Modern Art Oxford (2008). Group exhibitions include *Light Show*, Hayward Gallery, London (2013) and *Altermodern: Tate Triennial 2009*. From 2012 to 2013 Paterson was Artist-in-Residence at the Wellcome Trust Sanger Institute, Cambridge. She lives and works in Berlin and Glasgow.

FURTHER READING
Andrew Benjamin, *Marking Time*, Museum of Contemporary Art Australia, Sydney, 2012

Gerald A Matt and Catherine Hug, *Space: About a Dream*, Kunsthalle Wien, Vienna, 2011

Nicolas Bourriaud, *Altermodern: Tate Triennial 2009*, Tate, London, 2009

Earth-Moon-Earth (Moonlight Sonata Reflected from the Surface of the Moon), 2007
Disklavier grand piano
Installation view: The Slade School of Fine Art, 2007

→ Toby Paterson

Toby Paterson finds inspiration in what might seem the most unpromising of places, including the concrete landscapes of post-war housing schemes and the decaying remains of utopian building projects. His work stems from an interest in the ideas of architects who were influenced by Modernism and working in the post-war period. He draws on first-hand experiences of visiting and recording built environments around the world, but his artworks go far beyond simply documenting such places: he creatively interprets and re-imagines architectural spaces. Architecture is the starting point from which he explores the effects of the passage of time on the spaces that surround us, hinting at the economic, social or political ideas behind building projects.

Paterson studied painting, and the painted image remains central to his art. The large wall painting *Apollo* (2001) shows the strikingly sculptural concrete form of Victor Pasmore's *Apollo Pavilion* (completed 1970) set against a background of coloured shapes and seemingly isolated, out of time, in its setting. The work was made following Paterson's first visit to the new town of Peterlee, County Durham, where Pasmore, an artist, working as the consulting director of urban design oversaw an experimental and forward-thinking landscaped housing project.

Paterson is particularly drawn to architectural projects that are deliberately overlooked or thought of as unsuccessful and left vulnerable in the face of encroaching urban change. Close to home this has led to various works examining the projects of the Scottish architectural practice Gillespie, Kidd & Coia during the period 1956–87 and elsewhere buildings in London, Warsaw and The Hague.

His exhibition *Quotidian Aspect* at Le Grande Café, Saint-Nazaire, France (2012) demonstrated how he constructs complex architectural spaces to view his work. He complements his painted, wall-mounted works with freestanding, sculptural display structures, models and reliefs made of aluminium, wood or Perspex™.

As well as working in galleries, Paterson has undertaken many commissions for indoor and outdoor public spaces. Works such as *Powder Blue Orthogonal Pavilion* (2008) have brought his art closer in nature to the buildings and spaces that inspire him. **BH**

GENERATION LOCATIONS
Dumfries: Gracefield Arts Centre. Edinburgh: City Art Centre; Scottish National Gallery of Modern Art. Inverness: Inverness Museum and Art Gallery. Kirkcaldy: Fife Contemporary Art & Craft @ Kirkcaldy Galleries. Peebles: The Gallery, Tweeddale Museum.

BIOGRAPHY
Toby Paterson (born 1974 in Glasgow) studied at The Glasgow School of Art (1991–5). Selected exhibitions and projects include: *Resetting* with Stroom Den Haag, the Netherlands (2013); *Quotidian Aspect*, Le Grand Café, Saint-Nazaire, France (2012); *Consensus and Collapse*, The Fruitmarket Gallery, Edinburgh (2010); *Poised Array*, BBC Scotland Headquarters, Glasgow (2007); *New Townscape 1 & 2*, The Home Office, London (2005); and *New Façade*, CCA, Glasgow (2003). He lives and works in Glasgow.

FURTHER READING
Fiona Bradley *et al.*, *Toby Paterson: Consensus and Collapse*, The Fruitmarket Gallery, Edinburgh, 2010

Steven Gartside and Sam Gathercole, *Concrete Thoughts: Modern Architecture and Contemporary Art*, Whitworth Art Gallery, Manchester, 2006

Vermilion Isometric, 2012
Acrylic on Perspex, 31.5 × 31.5 × 2 cm
Installation view: *Remnant*, Glasgow Print Studio, Glasgow, 2012

Mick Peter

Glasgow-based sculptor Mick Peter transforms imagery from fiction, illustration and graphic design into playful installations, liberating images from the flat surface of the page to create witty and exuberant sculptures. Sketches and squiggles are transformed in scale and remade in substantial materials such as concrete, acrylic resin and polyurethane. The resulting sculptures, despite their robustness, have an uneasy feeling about them, as though they are not yet entirely complete.

In the pre-digital era, any element that belonged on the final page was illustrated or hand-cut, copied and pasted. Peter often takes this process one step further, folding images into new shapes to create the basis of his sculptural forms. In the exhibition Trademark Horizon (2013) at SWG3 in Glasgow, Peter collaged commercial trademarks, to create the models for a series of works made in acrylic resin. Out of context, scaled up and placed within the gallery, the logos appeared like monumental objects, their familiarity stripped away.

Peter's exhibition Lying and Liars (2012), at Collective in Edinburgh, featured eccentric hand-drawn characters in an environment of cement wall reliefs. The title was a reference to British novelist and filmmaker BS Johnson (1933–1973) who, through his experimental novels, pioneered new approaches to storytelling. The exhibition followed Johnson's idea that fiction is a form of 'lying', exploring the conflict between conventional storytelling and formal experimentation.

For GENERATION, Mick Peter has created a similar environment for Jupiter Artland near Edinburgh. His installation features cement wall reliefs, objects and monstrous 'popcorn'. The modular cement forms remind us of public sculpture. The unpredictability of popcorn, meanwhile, represents both the 'accidental' sculptural nature of the eventual form and the processes used: they are made in expanding polyurethane, a similarly unpredictable material. Peter has also created a pair of 'folded' sculptures for Tramway's Hidden Gardens in Glasgow. In this instance the characters are stylised hippies who have taken up residence on the lawn, the backdrop providing a counterpoint to their unusual scale. **CJ**

GENERATION LOCATIONS
Edinburgh: Jupiter Artland.
Glasgow: Tramway.

BIOGRAPHY
Mick Peter (born 1974 in Berlin) obtained his BA from the Ruskin School of Drawing & Fine Art, Oxford in 1997 and his MFA from The Glasgow School of Art in 2000. Recent solo shows include: Trademark Horizon, SWG3, Glasgow (2013); Lying and Liars, Collective, Edinburgh (2012); Tao Foam, GRIMM, Amsterdam (2011); Two Nots, Galerie Crèvecoeur, Paris (2011); The Nose: Epilogue, Cell Projects, London (2010); Dr Syntax versus the Paperweights, The Changing Room, Stirling (2010); and The Nose, La Salle de bains, Lyon (2010). Recent group shows include: The Universal Addressability of Dumb Things, Nottingham Contemporary (2013); British British Polish Polish, Centre for Contemporary Art, Ujazdowski Castle, Warsaw (2013); and British Art Show 7 (2010). He lives and works in Glasgow.

FURTHER READING
La Salle de bains – Depuis 1999, Les Presses du Réel, Lyon, 2013

Mark Sadler, 'Philip Guston/ Mick Peter', Frieze, issue 151, November–December 2012

The British Art Show 7, Hayward Gallery, London, 2011

Porcine Lout, 2012
Jesmonite
Installation view: Lying and Liars, Collective, Edinburgh, 2012

Ciara Phillips

Ciara Phillips works mainly in printmaking and her approach is expansive and experimental. Her interest lies in both the physical processes involved in printing and the capacity to explore, test and develop ideas through it. Printing requires time, space and sometimes collaboration with others, which for Phillips, distinguishes it from the directness of drawing an image straight onto a page. Printing has also been linked with political and social activism – a tool to call for action. Phillips brings all these connections into play in her art, whether she is working alone or with others.

Phillips uses screenprinting in which ink is pulled over and pushed through mesh in order to transfer an image onto paper or fabric. She exploits the opportunities offered by this method, layering colour with images and working on both small and large scales. *A Lot Of Things Put Together* (2013) is a large hanging piece made of five overlapping sheets of printed cotton. Abstract symbols and blocks of colour are combined with black-and-white photographs of figures. This artwork provided a starting point for an extensive work on paper, *Things Put Together* (2013). In both of these, Phillips uses repetition to produce visual echoes across the fabric or paper. The rhythmic aspect of these compositions is playful, but it also acts to co-ordinate the individual images into a whole, new statement. The titles of the works are drawn from the educator and activist Sister Corita Kent (1918–1986), an American artist whose use of art as an instrument for education and inspiration has been important to Phillips. The idea of 'things put together' not only points to the artist's enjoyment of collage, but is a more general comment about making art.

Phillips has also developed her thinking through projects dealing with collective making. Her *Workshop* (2010–ongoing), held at The Showroom, London in 2013, created a studio within the gallery where she made prints every day, often working experimentally with community groups and other artists and designers. Phillips's project transformed the gallery into a place for investigation, social action, discussion and debate. **LA**

GENERATION LOCATION
Edinburgh: Scottish National Gallery of Modern Art.

BIOGRAPHY
Ciara Phillips (born 1976 in Ottawa, Canada) has a BA in Fine Art from Queen's University, Kingston, Canada and an MA from The Glasgow School of Art (2004). Solo exhibitions have been staged at The Showroom, London (2013); Inverleith House, Edinburgh (2013); Atelier am Eck, Düsseldorf (2010); and Washington Garcia Gallery, Glasgow (2009). Group exhibitions include: *There Will Be New Rules Next Week*, Dundee Contemporary Arts (2013); *Pull Everything Out* (with Corita Kent), Spike Island, Bristol (2012); *Who Decides?*, Stadtgalerie Mannheim, (2012); *Zwischenraum: Space Between,* Kunstverein Hamburg (2010). Phillips is the founder of the artist collective Poster Club and a lecturer in painting and printmaking at The Glasgow School of Art. She lives and works in Glasgow.

FURTHER READING
Oliver Basciano, 'Ciara Phillips', in *Function/Dysfunction. Contemporary Art from Glasgow*, Neues Museum, Nuremberg, 2013

Gabrielle Schaad, Review of *Start with a practical idea*, Frieze d/e, issue 6, Autumn 2012

Things Put Together, 2013
Screenprint on paper, 525 × 477 cm
Installation view: *Function / Dysfunction. Contemporary Art from Glasgow,* Neues Museum, Nuremberg

Alex Pollard

Alex Pollard creates paintings and installations that focus upon the political dynamics of contemporary culture. His work deals with the figure of the artist within a hyper-connected digital society and with the impact of today's information economy on art and artists.

Agassi Abstracts (2012) are a series of digital paintings based on the graphic design of tennis player Andre Agassi's T-shirts from the 1990s. They are loaded with retro references – presenting an over-the-top example of 'bad boy' grunge or 'rebel' street styling. They also sardonically adopt the 'cool yet slightly punk' vibe of recent contemporary painting, which seems to play into a celebration of the artist as punk rock-star. Pollard draws attention to the self-conscious construction of the 'counter-cultural rebel'. This work critically reflects on how our digital information economy uses niche material – information and references now having a value as commodities in themselves.

Rumours, like Internet 'memes' are copied, shared and distorted making chatter, gossip and communication an important and highly political part of our current conditions both inside and outside of the art world. *Rumorz Kitten-Heel Boots* (2012) are suede boots featuring a repeated print of the logo of forgotten US girl-band Rumorz. The band flopped in the 1990s because their sound and styling was 'too 1980s'. As a reference Rumorz are interesting in a fine art context for their lack of counter-cultural credibility, but they are at present not a piece of information worth trading. In *Doormats* (2012) Pollard asked art-world contacts, including fellow artists, curators, tutors and his students, to draw caricatures of him, which were subsequently printed onto mats. The awkward power relations within this social network are made tangible. *Doormats* are a form of collaboration achieved through charm or obligation, folding the immaterial and emotional labour of the art business into the work itself. **CJ**

Rumorz Kitten Heel Boots, 2012
Printed suede, rubber, plastic –
modelled by a performer
Installation view: *Hot Lava*, Glasgow
Project Room, October 2012

GENERATION LOCATION
Glasgow: Tramway.

BIOGRAPHY
Alex Pollard (born 1977 in Brighton) studied at The Glasgow School of Art in 1996–9. He was a committee member at Transmission Gallery, Glasgow between 1999 and 2001. Solo exhibitions include: *Hot Lava*, Project Room, Glasgow (2012); *Collaborations*, Sorcha Dallas, Glasgow (2010); *Tea-Leaf Demeanour*, Whitechapel Project Space, London (2008); and *Black Marks*, Talbot Rice Gallery, Edinburgh (2007). Group exhibitions include the Santorini Biennale in 2012, *The Irregular Correct* at the Fremantle Arts Centre, Australia (2012) and *Counterfacture* at Luhring Augustine, New York (2007). In 2005 Pollard represented Scotland at the 51st Venice Biennale. He is a PhD candidate at Goldsmiths College, London and a lecturer at The Glasgow School of Art and Wimbledon College of Arts. He lives and works in London.

FURTHER READING
Lauren Cornell, Massimiliano Gioni and Laura Hoptman (eds), *Younger Than Jesus: Artist Directory*, Phaidon, London, 2009

Fiona Bradley (ed.), *Scotland & Venice*, Scottish Arts Council, Edinburgh, 2008

Echo Room: Contemporary British Art, British Council, 2007

Charlotte Prodger

Charlotte Prodger's source material is often culled from social situations including Internet forums, 'ripped' YouTube videos, personal e-mails and anecdotes from friends as well as the records that she plays as a DJ. Her work consists of sculpture, moving image, spoken word, printed texts and performance. For each new project she reworks previous themes, images and technical paraphernalia, to produce a distinct visual language.

Works such as-*(2011) and *Percussion Biface 1–13* (2012) are presented on video monitors. They show ripped YouTube videos of intimate actions involving branded sportswear, for example disembodied feet and hands carefully cutting up brand new trainers. A spoken word voice-over includes, among personal anecdotes, anonymous comments in response to the YouTube videos. These works, which arise out of the shared perspectives of an anonymous Internet community, draw parallels with the forms of the Structural Film movement in artists' film of the 1960s and 1970s.

Distance and desire are key themes in the stark physical display of Prodger's work. Audio and video are played through equipment with its own highly specific technological capacity, design history and subcultural aesthetics, including HantarexTM monitors, Sharp® GF777 boom boxes and RokitTM speakers. Vertical forms such as speaker tripods and monitor stands become anthropomorphic in height: supporting technology at the scale of the human body. Separating out these elements spatially enables Prodger to think about them as characters and consider the relationships between them.

In recent works such as *PROSPEX* (2013), the line between display and content becomes less distinct. A more explicitly sculptural work, *PROSPEX* is constructed of a found image of a man's wrist wearing a Seiko™ divers' watch that Prodger has encased between thick layers of Perspex™ with circular holes cut through it. Here, the optical nature of Perspex – transparent but impenetrable – is agitated by the actions of the artist. The gesture of punching through to the image creates a restricted opening into a terrain that is at once familiar and oblique. **LY**

GENERATION LOCATION
Glasgow: Tramway – Performance Programme.

BIOGRAPHY
Charlotte Prodger (born 1974 in Bournemouth) graduated with a BA from Goldsmiths College, London in 2001 and MFA from The Glasgow School of Art in 2010. Recent solo exhibitions include a show at the McLellan Galleries for Glasgow International Festival 2014; *Percussion Biface 1–13* at Studio Voltaire, London (2012), and *handclap/punchole* at Kendall Koppe, Glasgow (2011). She has participated in group exhibitions and performances at: Artists Space, New York; Tramway, Glasgow; Pieter Performance Space, Los Angeles; HOTEL, London; Essex Street, New York; LUX Temporary Gallery, Cologne; Poor Farm, Wisconsin; and LUX Biennial of Moving Images at ICA, London, as well as in *Assembly* at Tate Britain, London. Prodger's writing has been published in *2HB* and *F.R.DAVID*. Collaborations include *HDHB* with Corin Sworn and *Fwd: Rock Splits Boys* with Isla Leaver-Yap. Prodger was shortlisted for the 2013 Jarman Award. She lives and works in Glasgow.

FURTHER READING
Nicole Yip, 'In Focus: Charlotte Prodger', *Frieze*, issue 153, March 2013

Isla Leaver-Yap, 'Re Homos and light', *Mousse Magazine*, October 2012

Nicolas Linnert: 'Charlotte Prodger and Jason Loebs', *Artforum*, August 2012

handclap/punchhole, 2011
Installation detail

Mary Redmond

Mary Redmond's sculptures often combine the industrial and the handmade. She frequently uses materials more usually found on building sites than in artworks, such as metal fencing, corrugated iron, breeze blocks or plastic tubing. Redmond uses these materials by altering and rearranging them to form abstract sculptural compositions. In this way everyday objects and materials are removed from their normal situations and expected meanings. Her work also sometimes responds to the history of modernist art, design and craft. Rather than following Modernism's principle of 'form follows function', however, Redmond explores form in a more personal and playful way.

For her project at Platform in Glasgow, Redmond has produced a large-scale, site-specific sculptural installation using industrial building materials. The work is informed by the artist's research into architecture and urban spaces including Easterhouse where Platform is based. Amongst the works Redmond has made for Platform are hundreds of 'tumbleweed' sculptures. These pieces are made from rope, electrical tape and the 'debris netting' used on scaffolding. Tumbleweed has, thanks to its frequent appearance in movies, come to be a clichéd symbol of desert landscapes, or of any desolate, abandoned place. Glasgow is itself a city marked by many derelict sites and buildings. Redmond's pieces, however, suggest possibility, movement and imagination as well as dereliction or desolation.

Alongside these tumbleweed sculptures are suspended 'barriers' made from corrugated PVC roof sheeting. These 'barriers' take on a symbolic resonance in the context of the immediate area with its myriad of real and imagined fences, walls and boundaries.

As with these new sculptures, Redmond has often treated mass-produced materials in a tactile manner in her work. For instance, she might bash and reshape industrial sheet metal by hand, or hand-dye threads to use in sculptural compositions. By doing so she brings a personal touch to her work that complicates the materials' expected meanings. By showing how humble materials can take on new form, especially through painstaking work, Redmond suggests possibilities of humanising and caring for the worlds we inhabit. **DP**

GENERATION LOCATION
Glasgow: Platform.

BIOGRAPHY
Mary Redmond (born 1973 in Glasgow) graduated with a BA in Environmental Art and an MFA at The Glasgow School of Art. Solo exhibitions include: *Low Block Seasonal*, The Modern Institute, Glasgow (2012); *The Floating World*, Dundee Contemporary Arts (2010); *Juno And the Stallion*, Talbot Rice Gallery, Edinburgh (2005); and self-titled shows at Galerie Christian Drantmann, Brussels (2004), Alona Kagan Gallery, New York (2003) and The Modern Institute, Glasgow (2002). Group exhibitions include: *Function / Dysfunction. Contemporary Art from Glasgow*, Neues Museum, Nuremberg (2013); *Studio 58: Women Artists in Glasgow since World War II*, Mackintosh Museum, The Glasgow School of Art (2013); *Equals*, Paisley Museum and Art Gallery (2012); and *Dialogue of Hands*, City of Glasgow College (2012). She received a Paul Hamlyn Foundation Award for Artists in 2009. She lives and works in Glasgow.

FURTHER READING
Sarah Lowndes, 'Mary Redmond', *Frieze*, issue 72, January–February 2003

Here + Now: Scottish Art 1990–2001, Dundee Contemporary Arts, 2001

Low-Grade Oscillator (detail), 2013
Installation view: *Function / Dysfunction. Contemporary Art from Glasgow*, Neues Museum, Nuremberg, 2013

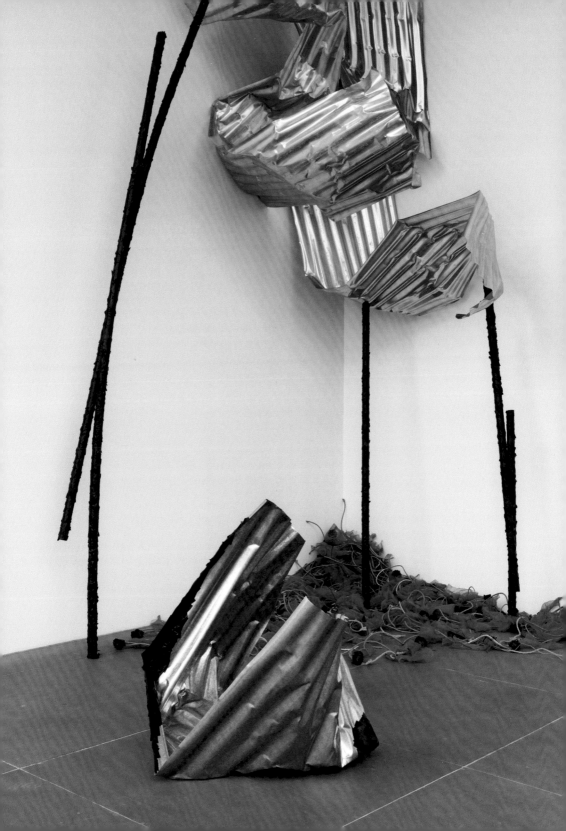

Carol Rhodes

The landscape paintings of Carol Rhodes place us on, or near, the edge. From an aerial viewpoint, eerily distant from the world below, you find you are on the edge of town. You see a coastal container port maybe, an airport on the city outskirts, or, in a painting like *Industrial Belt* (2006), a piece of scrubby land crowded with anonymous offices and factory units.

Rhodes's unpeopled landscapes are invented, created in the studio from aerial photographs and other sources, but they are also instantly familiar. *Town* (2005) could be any town. *Service Station* (2008), a rigid pattern in a muted green landscape, is nowhere in particular but it might be somewhere you know. All of this, however, is tricky. Look close and a road may peter out. There is an uncertain border between inner and outer worlds, a suggestion of the body in the tangled roads or in the crevices that open in the landscape of some of her works.

Technology is sometimes visible, but it is also an implied presence in all of Rhodes's paintings. Their aerial viewpoint has its roots in techniques of surveillance first developed through battlefield photography. But the paintings also evoke more ancient points of view: Renaissance townscapes, the little landscape models built by eighteenth-century painters, the miniatures that the artist might have encountered during her childhood in India. Rhodes has been distinguished by a singular dedication to her chosen art form, and has created a body of work unique in contemporary painting.

Her works are made in oil paint on board. They are small, smooth, densely worked and unusually intense. There is a mismatch between the vast landscapes and their tiny scale. Symbols of mobility – airports or motorways – are curiously stilled and empty. The movement in her paintings is provided instead by the vertiginous sweep of the landscape, the opening of a sudden chasm on rough ground, or by the movement of the paint itself. They tell us about the painter's discipline in careful depiction and painstaking construction. Yet they also claim the painter's freedom, to invent and to deceive. Rhodes's landscapes make and remake familiar worlds, they mark boundaries and they break them. **MJ**

GENERATION LOCATION
Edinburgh: City Art Centre.

BIOGRAPHY
Carol Rhodes studied at The Glasgow School of Art (1977–82). Solo exhibitions have been held at OHIO, Glasgow (2013), Mummery + Schnelle, London (2009 and 2013), the Scottish National Gallery of Modern Art (2007) and Brent Sikkema, New York (2002). Group shows include *Looking at the View*, Tate Britain, London (2013); *The Ground Around*, Vilma Gold, London (2010); *Direkte Malerei*, Kunsthalle Mannheim (2004); and *British Art Show 5* (2000). Her works are in major collections including Tate, Scottish National Gallery of Modern Art and the Yale Center for British Art, New Haven, Connecticut. She lives and works in Glasgow.

FURTHER READING
Carol Rhodes, Scottish National Gallery of Modern Art, Edinburgh, 2007

Town, 2005
Oil on board, 59.5 × 53.5 cm
City Art Centre, Edinburgh
Museums and Galleries

Julie Roberts

Julie Roberts creates paintings with a strong critical bite and intellectual rigour. Her main theme is the human, particularly female, body and the way that it is subjected to institutional, familial, sexual and natural constraints and injuries.

Her works from the early 1990s suggested the body through objects such as operating tables, mortuary slabs, gynaecological couches and restraining jackets. These were painted with a meticulous, heightened attention to detail. Roberts emphasised internal shadows and folds almost as if she wanted to rub our noses in their materiality and make us physically aware of what control and constraint feel like.

Roberts's fascination with the body and with hospitals was shared by a number of artists in Scotland and elsewhere, inspired by the writings of the French philosopher Michel Foucault (1926–1984) and a growing interest in the history of the early twentieth-century art movements Dada and Surrealism. The influence of the work of Sigmund Freud (1856–1939), the 'father of psychoanalysis', was crucial and in 1996 Roberts made his desk and study the subjects of several paintings. This heralded a shift in her work towards a more historical approach to her subject matter – an approach sparked by a year in Rome and its overwhelming sense of the past.

Roberts began to paint things that showed the way earlier generations had treated the themes of sex and death. In 1999 she reprised the eighteenth-century French painter Jacques-Louis David's famous painting *The Death of Marat* (1793), beginning a series of works dealing with murder. Roberts painted and drew the victims of Jack the Ripper with an almost loving attention to their bodies, clothes and even their wounds. Even if these women had been savagely butchered, their images would now be treated with tenderness.

Recent paintings have concentrated on orphaned or abandoned children. They are painted in a highly stylised manner with details emphasised as if they were ornaments. One almost feels that Roberts were trying to blot out the pain and solitude of the children by the repetitive action of her paintbrush. KH

GENERATION LOCATION
Edinburgh: Scottish National Gallery of Modern Art.

BIOGRAPHY
Julie Roberts (born 1963 in Flint, Wales) studied at Wrexham School of Art (1980–4), Central Saint Martin's School of Art in London (1986–7) and The Glasgow School of Art (1988–90). In 1992 she was a visiting student at the Hungarian Academy of Fine Arts in Budapest. From 1992 to 2003 she taught at The Glasgow School of Art. She was at the British School in Rome from 1995 to 1996 and spent a year in New York in 2001-2 on the International Studio and Curatorial Program. Notable exhibitions include displays at Talbot Rice Gallery, Edinburgh (1997 and 2010), Sean Kelly Gallery, New York (1997, 1999 and 2003), the British School in Rome (1996), the Venice Biennale (1993) and CCA, Glasgow (1992). She lives and works in Carlisle.

FURTHER READING
Lene Burkard/Lars Grambye, Francis McKee and Lisbeth Bonde, *Julie Roberts in Retro*, Kunsthallen Brandts, Odense, 2008

Keith Hartley and William Clark, *Home: Works by Julie Roberts 1993-2003*, Sean Kelly Gallery, New York, 2003

Restraining Coat II (Female), 1995
Oil and acrylic on canvas,
152.4 × 152.4 × 5 cm
Aberdeen Art Gallery and Museum Collection. Purchased in 1996 with the assistance of the Scottish Arts Council.

Anthony Schrag

From climbing a gallery wall or scaling a drainpipe to rolling down a grassy hill, Anthony Schrag's exhibitions and projects are centred on live events rather than objects such as paintings or sculptures. His events are developed from detailed research into the contexts within which they are shown. They often involve humour and physical activities relating to the human body with an element of experimentation and risk. At heart, Schrag's work asks questions about common experiences of relationships and social structures, to encourage us to understand our place within the world. His interest in involving the audience for his work has increasingly led him to collaborate with a diverse range of individuals and groups. They are active participants rather than passive viewers.

Opening (2007) was first created for Intermedia Gallery in Glasgow. It turns the formal structure of a conventional art 'opening' on its head. Usually, invited guests attend a drinks reception to launch a new exhibition whilst viewing the artwork. Here, visitors are instead required to bounce on a trampoline or navigate a network of knee-high ropes to reach a can of beer while others watch.

A Perfect Father Day? (2011) shows Schrag's interest in reaching a broad public audience with his work. It was developed as part of an artist's residency that Schrag undertook in Huntly, Aberdeenshire and examined the father's role in society. It responded to statistics highlighting the increasing number of households where male adults are absent for reasons like the need to work away from home. Schrag's activities, such as *Male Roll Model* where people of different ages were gathered and encouraged to roll down hills, were typically poignant and light-hearted. His orchestrated events encouraged reflection on the importance of nurturing and support within relationships between friends and families. **BH**

GENERATION LOCATION
Aberdeen: Aberdeen Art Gallery.

BIOGRAPHY
Anthony Schrag (born 1975 in Zimbabwe) studied Creative Writing at the University of British Columbia, Vancouver, Canada (2000) and undertook postgraduate studies in Fine Art at The Glasgow School of Art (2005). Selected exhibitions and projects include: *There Shall Be Blood*, Timespan, Helmsdale (2013); *No Such Thing As Offside*, South London Gallery, London (2012); *Tourist in Residence*, Edinburgh Art Festival (2012); *A Perfect Father Day?*, Deveron Arts, Huntly (2011); and *REBELLAND*, Gallery of Modern Art, Glasgow (2007). Schrag has undertaken residencies in Canada, Finland, Holland, Iceland, Ireland, Scotland and the USA and he is currently undertaking a practice-led PhD at Newcastle University, Newcastle upon Tyne. He lives and works in Edinburgh.

FURTHER READING
Anthony Schrag, *Legislating Risk*, website for Public Art + Research Scotland, 2011

Anthony Schrag *et al.*, *Its Not Hard: Explorations of Live Art*, Tramway, Glasgow, 2008

A Perfect Father Day?, 2011
Digital still, documentation of event
Commissioned by Deveron Arts, Huntly, Aberdeenshire

John Shankie

John Shankie's art takes everyday processes and materials and squeezes a kind of poetry from them. Whether working with film, drawings, sculpture, text, music or social events he finds a rich seam of meaning that allows the simplest everyday actions to acquire a deeper emotional or social resonance. Shankie's works often have a domestic focus. Cooking a meal, folding a napkin or recording a simple phone call have all featured in his work. In the home, or outside it, his art has often involved acts of nurturing and generosity.

For the landmark international exhibition *Trust* at Tramway, Glasgow in 1996, Shankie cooked a meal for 150 people with the artist Rirkrit Tiravanija. At the Glasgow International Festival in 2012, he worked in collaboration with the artist Andrew Miller, in the project *No Meal Is Complete Without Conversation*. Throughout the festival the artists cooked and served lunch daily in a Glasgow tenement where everything – from the food on the table to a specially designed dishtowel – was considered part of the artwork. Guests were encouraged to talk together about life and art and the conversation was recorded. The meal was free for anyone who booked; members of the public shared the experience with artists and visiting art professionals as peers and equal participants.

As a former engineer the artist is interested in making, mechanics and technical processes, but he explores them for their ability to express ideas or emotions by using them in unexpected ways. A work such as *untitled (freezer)* from 1995 takes a simple idea, that of placing clothes in a freezer instead of food. But the result is poignant, for the items on the shelves are the artist's own clothes and those of his family. The work asks us how we might keep our memories or if it is possible to preserve a poignant moment in our lives.

For GENERATION, Shankie is working at the Park Gallery in Falkirk exploring issues of memory and remembrance with a particular emphasis on the First World War Centenary. He uses simple processes such as drawing, brickwork and preservation to explore private and public legacies of the conflict. **MJ**

GENERATION LOCATION
Falkirk: The Park Gallery.

BIOGRAPHY
John Shankie (born 1957 in Lanark) was a mechanical engineer before graduating from The Glasgow School of Art with a BA (Hons) (1988) and MFA (1995). His solo exhibitions include *There is no need for you to leave the house* at Tramway, Glasgow (1995). He has participated in group shows across the UK and in the US and Europe. His collaborative works include *No Meal Is Complete Without Conversation* (2012) with Andrew Miller for the Glasgow International festival. He was awarded the Scottish Arts Council New York Residency in 2006 and teaches at The Glasgow School of Art. He lives and works in Glasgow.

FURTHER READING
Industrial Aesthetics, Hunter College, New York, 2009

Dream Machines, Dundee Contemporary Arts, 2000

John Shankie, *There is no need for you to leave the house*, Tramway, Glasgow, 1999

untitled (freezer), 1995
Installation view: *There is no need for you to leave the house*, Tramway, Glasgow, 1995

David Sherry

David Sherry draws attention both to the ordinary events of everyday life and the intricate structures of the art world, by subtle interventions or absurd exaggerations. Working mainly as a performance artist, Sherry takes a playful approach to his drawing, painting, photography and video work too. His work presents social awkwardness as an important and often painful part of being human.

In *Electrical Appliance* (2011), an enormous plug and thick wire are attached to Sherry's head. As he lies on the floor, passers-by are welcome to step over him. Absurd in a way that is typical of Sherry's work, the work also touches on serious ideas. The link Sherry makes between the human and the electrical reminds the viewer of our own relationship with power. Whether we decide to ignore the ecological and economic problems we have produced is up to us. The bright yellow prongs of the plug jut into the air, creating a comic spectacle. Whilst the artist lies still on the ground, passers-by must make a conscious decision whether or not to avoid him. Why is the plug not in use? Is the artist also commenting on the way we all can 'switch off' or zone out? This vacant state of mind seems to be of recurring interest to Sherry. *Just popped out back in 2 hours* (2008) consists of a chair, the artist, and a post-it note. The post-it note reads 'Just popped out back in 2 hours', and is stuck to the artist's head. With a glazed look in his eyes, he sits gawping as the viewer walks around him. To read the note, the viewer must lean in quite closely.

David Sherry does simple things that other people don't think to do. Although much of his art plays with a detailed knowledge of recent art history, and in particular our expectations of performance art, it also touches on everyday emotions, embarrassments and frustrations. We can see ourselves in his work. SMcG

GENERATION LOCATIONS
Glasgow: Kelvingrove Art Gallery and Museum; Patricia Fleming Projects. Various: Travelling Gallery.

BIOGRAPHY
David Sherry (born 1974 in Northern Ireland) gained his BA in Fine Art from the University of Ulster, Belfast, in 1997. He then went on to complete his MFA at The Glasgow School of Art in 2000. He has exhibited widely both nationally and internationally. In 2003, Sherry was shortlisted for the Beck's Futures Prize. Between 2006 and 2007, the artist had a residency at Villa Concordia, in Bamberg, Germany. He currently lives and works in Glasgow.

FURTHER READING
Noel Kelly and Seán Kissane (eds), *Creative Ireland: The Visual Arts*, Visual Artists Ireland, Dublin, 2012

Jesper Febricius *et al.* (eds), *Pist Protta 71: Pist Protta in Glasgow*, Space Poetry, Copenhagen, 2012

Rebecca Gordon Nesbitt (ed.), *David Sherry: Dead dog on a fire*, Nordic Institute for Contemporary Art, Helsinki, 2002

Just popped out back in 2 hours, 2008
Perfomance at Gallery of Modern Art
Glasgow City Council, Glasgow Life
(Glasgow Museums)

David Shrigley

David Shrigley's art is infused with a dark, dry humour that high-lights the absurdity of our everyday fears and aspirations. He makes sculptures, videos, performs 'public interventions', which he then photographs, and produces books. He is, however, best known for his drawings, which, with their deliberately crude, childlike quality are instantly identifiable as his own. They are exhibited or published unaltered, in the way that Shrigley first creates them (he never draws anything twice) and so they often feature scribbled-out parts and misspelt words. As well as being shown in art galleries, his drawings have appeared in a number of popular formats in maga-zines or on T-shirts, record covers and greetings cards.

Words play an important role across Shrigley's work. He is interested in how we interpret text and image together, especially when they are combined in witty or conflicting ways. *Untitled (Crap)* (2007) is typical of many works that satirise the conventions of the contemporary art world, which he knows only too well he is part of. But it may also refer to the kind of public art or sculpture that is often dumped in public places without thought or care. His studies at The Glasgow School of Art emphasised the importance of context in public art, and some of his early works are astute com-ments on poor examples of our urban environment. *Really Good*, his sculpture of a hand with its disproportionately large thumb in a 'thumbs up' position, will go on display on Trafalgar Square's Fourth Plinth in 2016.

Shrigley's wry humour extends to his sculptural works including his use of taxidermy. In *I'm Dead* (2010), a stuffed dog stands on its hind legs holding a sign declaring that it is dead. The artist is interested in the use of signs and public notices as a way of disconcerting the public. Despite the comic nature of many of his works, they are frequently underpinned by a darker theme. Shrigley may be poking fun at the way that museums display stuffed animals as though they were alive, or perhaps referring to protestors who carry placards as a way of publicly displaying messages of discontent. Like many of Shrigley's works, at its heart, it presents us with a simple and striking moral conundrum: whether we should laugh at death or not. **ShC**

GENERATION LOCATION
Edinburgh: Scottish National Gallery.

BIOGRAPHY
David Shrigley (born 1968 in Macclesfield) completed a foundation course at Leicester Polytechnic before going on to study Environmental Art at The Glasgow School of Art from 1988 to 1991. After graduating he began publishing books of his drawings before exhibiting widely. Shows have been held at: BALTIC, Gateshead (2008); Dundee Contemporary Arts (2006); Kunsthaus Zürich (2003); and Transmission Gallery, Glasgow (1995). In 2012, London's Hayward Gallery hosted *Brain Activity*, a retrospective of Shrigley's work for which he was shortlisted for the 2013 Turner Prize. He lives and works in Glasgow.

FURTHER READING
Ralph Rugoff *et al.*, *David Shrigley: Brain Activity*, Hayward Gallery, London, 2012

David Shrigley: Everything Must Have a Name, Malmö Konsthall, Malmö, Sweden, 2007

Untitled (Crap), 2007
Ink and marker on paper, 29.7 × 42 cm

Ross Sinclair

In 1990, the year Glasgow was named European Capital of Culture, posters, badges and postcards appeared around the city proclaiming the words 'Capital of Culture / Culture of Capital'. They were an early work by Ross Sinclair and encompass many of the ideas he has continued to develop: a playful and provocative use of language; an engagement with public spaces; an interest in economic and political agendas and the place of people within institutional and social structures.

Sinclair is particularly interested in the nature of identity – what it is and how it is formed. His own body became a tool in his art in 1994 when he had the words 'REAL LIFE' tattooed across his shoulders. Since then, his 'Real Life' projects have taken many forms. Several have featured Sinclair himself, photographed or filmed with his back to the camera. He has made works for the public realm and galleries using a multitude of materials and methods including posters, billboards, slogan T-shirts, neon signs (all commonly associated with advertising techniques), videos, performances and a 'Real Life' market stall in 1999. *Real Life and How to Live it in Auld Reekie* (2013) flooded Edinburgh with over 45,000 artworks using multiple forms and locations to create a dynamic portrait of the city. He often produces immersive, multimedia installations, such as *Real Life Rocky Mountain* (1996), first made at the Centre for Contemporary Arts (CCA), Glasgow. This fake hillside, populated with stuffed animals and artificial trees, rocks and grass, is an invented, idealised view of what Scotland might be. Sinclair was a fixture on the installation, strumming his guitar, and playing songs from Robert Burns to Scottish bands of the 1990s. As a former drummer in a band, a guitarist and songwriter, music remains important to Sinclair. It is a social activity that can sustain traditions or represent a worldview. For the twentieth anniversary of 'Real Life' in 2014, Sinclair has produced a project with Collective, Edinburgh that explores the past, present and future of 'Real Life' through music and collaborative activity. **LA**

Real Life Rocky Mountain, 1996
Installation view: CCA, Glasgow 1996

GENERATION LOCATIONS
Edinburgh: Collective; Scottish National Gallery of Modern Art.

BIOGRAPHY
Ross Sinclair (born 1966 in Glasgow) studied BA Environmental Art (1984–90) and MFA (1990-2) at The Glasgow School of Art, including an exchange to CalArts, Los Angeles (1992). Solo exhibitions include those at: Angelika Knäpper Gallery, Stockholm (2010); Art Metropole, Toronto (2004); Badischer Kunstverein, Karlsruhe (2002); and South London Gallery (2001). Group exhibitions include: *Nothing in the World But Youth*, Turner Contemporary, Margate (2011); *I-Lands*, Odense and tour (2009–10); and Aichi World Expo, Nagoya (2005). Collections include Hamburg Kunsthalle and the Arts Council. Sinclair is a Reader in Contemporary Art Practice and a lecturer in Sculpture and Environmental Art at The Glasgow School of Art and regularly publishes texts on art. He lives and works in Kilcreggan, Argyll.

FURTHER READING
Claudia Zeiske and Ross Sinclair (eds), *Ross Sinclair: We Love Real Life Scotland*, Deveron Arts, Huntly, 2012

Ross Sinclair: If North was South and East was West, Badischer Kunstverein, Karlsruhe, 2004

Ross Sinclair: Real Life and How to Live It, The Fruitmarket Gallery, Edinburgh, 2000

Lucy Skaer

In Lucy Skaer's art ordinary distinctions and definitions do not apply. The difference between categories we think of as opposites – such as the living and the dead, the present and the past, meaning and meaninglessness – are constantly revisited as she works to transform materials and ideas.

Skaer works in many different ways using film, drawings, sculpture, craft or decorative objects, prints, glass and ceramics. She is interested in images, materials and objects and how their meaning, importance or economic value might shift if they change role, shape or appearance. She once placed a diamond and a scorpion side by side on an Amsterdam pavement; both of course were made of carbon. She has cast modern bronze in 4,000-year-old moulds and remade a famous twentieth-century sculpture, *Bird in Space*, by Constantin Brancusi, in compacted coal dust.

In 2006, when Skaer was living and working in New York, she travelled to Mexico City to seek out the artist Leonora Carrington. The ninety-year-old painter had been a key figure in the Surrealist movement. Skaer's installation *Leonora* (2006) brings together four elements: two sculptures, including an oak table with an inlaid mother-of-pearl image of hands, a dense pencil drawing, and a film. The film is short and simple: capturing the elderly artist in her home. The work is not so much homage from one generation to another as an encounter. What might happen to Skaer's own art and ideas if they were to meet those of such a powerful predecessor? Might they also be transformed?

Reflecting the way that her own approach to art is fluid – she is never guided by a single approach to a problem or a single way of thinking – Skaer also works with other artists. With Rosalind Nashashibi she works in film and photography as Nashashibi/Skaer. She is also part of the artists' collective Henry VIII's Wives, a group of artists who met when they studied in the Environmental Art Department at the Glasgow School of Art. **MJ**

GENERATION LOCATIONS
Dundee: Cooper Gallery.
Glasgow: The Hunterian.

BIOGRAPHY
Lucy Skaer (born 1975 in Cambridge) graduated from the Glasgow School of Art in 1997. Her many solo exhibitions include: Murray Guy, New York (2014); *Exit, Voice and Loyalty*, Tramway, Glasgow (2013); *A Boat Used As A Vessel*, Kunsthalle Basel (2009); The Fruitmarket Gallery, Edinburgh (2008); and *The Siege*, Chisenhale Gallery, London (2008). She has participated in numerous group shows in Europe and America including *Art Under Attack – Histories of British Iconoclasm*, Tate Britain, London (2013). She represented Scotland at the 52nd Venice Biennale in 2007. She was nominated for the Turner Prize in 2009 and lives and works in Glasgow and New York.

FURTHER READING
Lucy Skaer: A Boat Used as a Vessel, Kunsthalle Basel, 2009

Fiona Bradley (ed.), *Lucy Skaer*, The Fruitmarket Gallery, Edinburgh, 2008

Lucy Skaer: Drawings 2004–2005, doggerfisher, Edinburgh, 2006

Harlequin is as Harlequin does, 2012
C-print and screenprint, 120 × 85 cm

Smith/Stewart

The artists Stephanie Smith and Edward Stewart, who work together as Smith/Stewart, describe all their work as sculpture. In fact they use video and sound, and make events and performances as well as objects. But these diverse works share certain qualities: a strong physical presence, an emphasis on the body and a sense of claustrophobia, uncertainty or unease. Many of their works involve placing their audiences in powerful situations, which can feel intimate or confrontational.

The duo's early video works used the artists' own bodies, in complex and sometimes disturbing scenarios. Their video *Breathing Space* (1997) confronts us with two projections each showing hooded figures, along with the sound of amplified breathing. The figures are sometimes calm, sometimes agitated. Watching the work you might feel anxious or responsible.

More recently their work has extended beyond the screen in two ways: firstly, by showing artworks that are more readily understood as sculpture; and secondly, working with specific groups of people on instructional-based performances. At Glasgow International in 2005 they showed three sculptural works: a wooden sledgehammer handle which slammed into the floor, a false white wall that slowly rotated in the centre of a room and a metal scaffolding pole that spun threateningly at neck height. The relatively short duration of the exhibition, and its setting in a low-lit former factory space, made these works seem dreamlike, as though they were disturbances conjured up by the visitor's presence rather than the artists' hands. *Enter Love and Enter Death* (2007) at Inverleith House, Edinburgh, was another sculptural installation where handmade beams divided the space. Through minimal means, the viewer's vision was obstructed and movement frustrated.

Recent works have involved working with wider participants. In *What Have We Done?* (2011) the artists invited actors to audition for a performance by asking them to turn and kiss fellow performers. The resulting video, on a continual loop, showed the group standing in a circle kissing relentlessly. An act we might link with tenderness, freedom or desire, became a trap or vicious circle or, equally, a metaphor for all our histories of intimacy. Smith/Stewart suggest that even the simplest of human acts may be a form of performance. **MJ**

GENERATION LOCATION
Edinburgh: Scottish National Gallery of Modern Art.

BIOGRAPHY
Stephanie Smith and Edward Stewart work together as Smith/Stewart. Smith (born 1968 in Manchester) obtained her BA from the Slade, London in 1991. Stewart (born 1961 in Belfast) graduated with a BA (1988) and MFA (1990) from The Glasgow School of Art. They met in 1991 while attending the Rijksakademie in Amsterdam. Solo shows have been held at the Kunstmuseum Luzern, Portikus in Frankfurt and Inverleith House in Edinburgh, and group shows in San Francisco MoMA, Kunstmuseum Bern, Kunstverein Hanover and the Kunst-Werke Institute for Contemporary Art, Berlin. Their work is represented in public collections including the Scottish National Gallery of Modern Art, Edinburgh, the Arts Council Collection and Tate, London. They live and work together in Glasgow.

FURTHER READING
Kirsten Norrie, 'Smith/Stewart: Enter Love and Enter Death', *Art Monthly*, no.312, December 2007–January 2008

Smith/Stewart Minigraph, Film and Video Umbrella, London, 2001

Ulrich Loock, '*Breathing Space*. The Third one as Medium', *Glasgow: Kunsthalle Bern*, Kunsthalle Bern, 1997

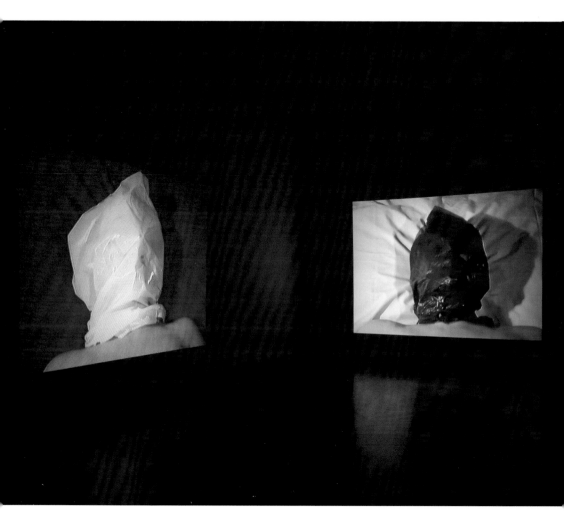

Breathing Space, 1997
Double colour video projection with sound,
Installation view: Kunsthalle, Bern
Scottish National Gallery of Modern Art, Edinburgh

Simon Starling

The journeys made by people and objects, the origins of design, and the value of materials, are just some of the things that interest Simon Starling. Some of his most notable works have transformed one object into another. An early work from 1996 took the metal of an antique silver spoon to make copies of a fake twenty-pence piece Starling had found. In 2005 he dismantled a woodshed in Basel, Switzerland, and used the material to make a small boat. He then used the boat to travel along the river Rhine, to the art museum in which he was preparing an exhibition, where he dismantled the boat to reconstruct the woodshed, which was exhibited in the museum as *Shedboatshed (Mobile architecture No.2)*.

Burn Time is one of many works by Starling to draw on the history of design - in this case the work of Wilhelm Wagenfeld (1900-1990), a German designer of industrially produced consumer goods, including table lamps and glassware. Starling's work involves one of Wagenfeld's designs: a glass 'egg coddler' - a lidded pot for cooking a single egg - designed in the 1930s and one of a number of items still in production today. *Burn Time* brings together this object with the building that now houses a museum dedicated to Wagenfeld's work in Bremen, Germany. Starling made a scale model of the building, which was originally designed as a prison, using recycled wood, during a residency as Henry Moore Sculpture Fellow at Duncan of Jordanstone College of Art & Design, Dundee in 2000. The model is larger than a typical architectural model, as it was in intended to function as a hen house. Starling built it in his studio and then transported it to Stronchullin Farm in Strone, Argyll, where it was used as an actual hen house for three months.

First exhibited at Camden Arts Centre, London in 2000, *Burn Time* includes the relocated hen house, now well worn by months on the Scottish hillside and the comings and goings of a gaggle of hens; Wagenfeld egg coddlers, which were used to cook eggs from those hens; and a small stove fuelled by wood cut from the hen house/museum model. Like many of Starling's works, *Burn Time* creates a cycle of transformation, of use, re-use and value. **KB**

GENERATION LOCATION
Edinburgh: Scottish National Gallery of Modern Art.

BIOGRAPHY
Simon Starling (born 1967 in Epsom, Surrey) studied at Maidstone College of Art (1986-7) and Trent Polytechnic, Nottingham (1987-90), and completed the MFA course at The Glasgow School of Art in 1992. From 1993 to 1996 he was a committee member of Transmission Gallery, Glasgow. His work has been shown worldwide including many significant international exhibitions such as the 50th and 53rd Venice Biennales in 2003 and 2009 respectively. He was awarded the Turner Prize in 2005. Starling was Professor at the Städelschule, Frankfurt am Main, from 2003 to 2013. He now lives and works in Copenhagen.

FURTHER READING
Simon Starling, Phaidon, London and New York, 2012

Burn Time, 2000
Hen house, brick stove, eggs, egg cookers, cooking pot, saw, tarpaulin
Installation view: *Burn Time*, neugerriemschneider, Berlin, 2001
Private collection

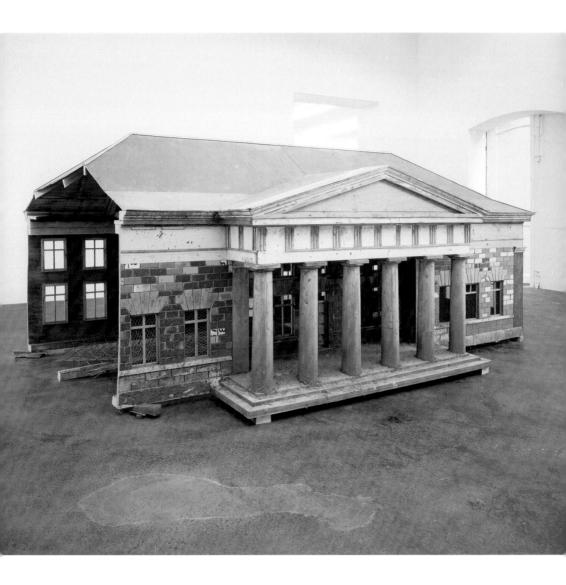

Clare Stephenson

Clare Stephenson makes highly elaborate objects and installations, which play with ideas of artistic labour. Her cut-out figures might appear at first to be sculptures but they are actually slim wooden panels onto which screenprinted images have been pasted. They are reminiscent of stage props, flat-pack design and shop-front displays. Each figure is created through a playful use of the collage process. Stephenson begins by editing and combining photographs of other sculptures, male figures from Baroque and Gothic religious statuary, until she feels they fit. The images are cut up, repeated and sometimes grossly enlarged so the image breaks up. This culminates in witty aesthetic combinations as the figures are transformed into elaborate drag queens adorned in the wardrobe of art history.

In her solo exhibitions *Parole Vaine* (2008) and *She-who-Presents* (2009) Stephenson's figures have been shown staged in groups, poised as though characters in a tableau or play. The figures themselves strike idle, decadent or camp poses and each has a name which parodies ideas of economy, production and consumption; such as *Miss Productively-Focused, Miss Quite-Quite-Abundant!* and *Our-Lady-of-the-Conscious-Optics* (all 2008).

In recent digital collage works, she has incorporated the ultimate symbol of aspiring decadence: the Martini glass. The exhibition *Abs Minimum* at the Project Room, Glasgow in July 2013 featured the Martini motif in three different fabric designs printed onto bikinis. The bikinis were strewn along the radiators and windowsills, with the redevelopment of Glasgow's 'Cultural Quarter' as a backdrop seen through the gallery windows. Stephenson used her own body as a reference (the bikinis all being her size), implicating herself and relating her own production as an artist to the development outside. This work maintains an active engagement in feminist ideas, but can also be seen as a self-conscious critique of the way that certain feminist references within the art world are reduced to symbols and disengaged from active discussion. **CJ**

GENERATION LOCATION
Glasgow: Tramway – Performance Programme.

BIOGRAPHY
Clare Stephenson (born 1972 in Newcastle upon Tyne) graduated with a BA in Sculpture from Duncan of Jordanstone College of Art & Design, Dundee in 1996 before serving on Glasgow's Transmission Gallery committee. Solo exhibitions include *Abs Minimum* at the Project Room, Glasgow (2013), *She-who-is-the-Maker-of-Objects* at Linn Lühn, Düsseldorf (2011) and *She-who-Presents* at Spike Island, Bristol (2009). Group shows and collaborative projects include: *Costume: Written Clothing,* Tramway, Glasgow (2013); *Boredom & Ornament*, ICA, London (2012); *Shoplifters, Shopgirls* (with Sophie Macpherson), Tramway, Glasgow (2012); *Madame Realism,* Marres Centre for Contemporary Culture, Maastricht (2011); *Newspeak: British Art Now*, Saatchi Gallery, London (2010); and *The Associates*, Dundee Contemporary Arts (2009). She lives and works in Glasgow.

FURTHER READING
Michael Bracewell, 'Clare Stephenson at Spike Island, Bristol', *Frieze*, issue 127, November–December 2009

Clare Stephenson biography at www.saatchigallery.com

David Musgrave, *The Imaginary Critic*, Dicksmith Gallery, London 2005

Martini Bikinis: Orange, Purple, Grey, 2013
Digital collage print on cotton/silk jersey, lycra
Installation view: *Abs Minimum*
Glasgow Project Room 2013

Tony Swain

The painter Tony Swain works with a restricted range of materials including acrylic paint and what he describes as 'pieced' newspaper: everyday broadsheet newspapers which have been taken apart and re-formed to provide the artist with a canvas. The existing words and images on the newsprint are incorporated, adapted or obliterated in the process of making a new painting.

Through this dual process of collage and painting, Swain teases out distorted landscapes and impossible structures that hover on the border between reality and fantasy. They seem unstable, as though they exist in some other dimension where the usual laws of geography and physics don't apply. The paintings are shaped by the artist until a balance is achieved between abstraction and representation.

Swain's titles emphasise the process of collage and layering of meaning. In their precise peculiarity, titles such as *Tariff of Fir*, *Commonwealth Parking* and *The Liar's Several Attempts* (all 2012) hint at an ambiguous narrative that we may or may not be able to discern among the many elements of a completed image. Rather than offering a definitive description of a work, as we might traditionally expect, they suggest a route into the myriad elements of a painting, which because its meaning cannot be easily resolved, sends us back to the way the picture itself is made.

The diversity of Swain's work can also be seen in his involvement as a musician in the highly regarded band Hassle Hound and his curatorial role in *Le Drapeau Noir* (2010) at the Glasgow International festival. In collaboration with artists Raydale Dower and Rob Churm, Swain organised a temporary artists' café and performance venue. Named after the anarchist symbol of the black flag, the project referred to early twentieth-century avant-garde venues, such as the Cabaret Voltaire in Zurich. It presented experimental performance, art and music in one space without favouring any one medium in particular, reflecting the fluid way in which art is created within the city and its artistic communities. LY

GENERATION LOCATION
Dundee: Dundee Contemporary Arts.

BIOGRAPHY
Tony Swain (born 1967 in Lisburn, Northern Ireland) completed his BA at The Glasgow School of Art in 1990. Solo exhibitions include: *Drowned Dust, Sudden Word*, The Fruitmarket Gallery, Edinburgh (2012); *Aerated Bread Company*, The Duchy, Glasgow (2012); *Afterwards in Pictures*, The Modern Institute, Glasgow (2011); *Impure Passports*, Inverleith House, Edinburgh (2009); and *Never Even*, Herald Street, London (2005). Group exhibitions include: *Le Drapeau Noir*, Glasgow (2010); *Scotland + Venice*, Venice Biennale (2007); *Herald Street and The Modern Institute present*, Gavin Brown's Enterprise, New York (2005); and *JP Munro, Alex Pollard, Tony Swain*, Transmission Gallery, Glasgow (2004). He lives and works in Glasgow.

FURTHER READING
Isla Leaver-Yap, Karla Black and Fiona Bradley, *Tony Swain: Narrative Deficiencies Throughout*, The Fruitmarket Gallery, Edinburgh, 2012

'Last Things I Need is The Shakes', in The Modern Institute (ed.), *Tony Swain: Paintings*, DuMont Buchverlag, Glasgow and Cologne, 2008

Scotland and Venice 2007, Scottish Arts Council, British Council Scotland and National Galleries of Scotland, 2007

Tariff of Fir, 2012
Acrylic on pieced newspaper, 46 × 23 cm

→ Corin Sworn

Working mainly with video and photography, Corin Sworn creates installations that look at how objects and images convey stories and histories. She combines images with spoken narrative, often recordings of her own voice, reading texts that are both newly written and quoted from other sources. Slipping between fact, fiction and fantasy, Sworn's work considers the cultural and personal meanings that we attach to things, and how they in turn come to represent people and places.

In 2010 her installation *Endless Renovation* included a set of 35mm slides that she had found in a skip near her home. Sworn used a projector to show the images, along with a recording of her voice as she tells the story of finding the slides and speculates about their origin: who might have taken the images and why. At times the voice sounds knowledgeable and truthful, while at others it is less certain.

Sworn's 2013 project for the *Scotland + Venice* exhibition at the Venice Biennale included a film called *The Foxes*. The starting point for the film was the discovery of a box of her father's old slides, including many he had taken during his research as an anthropologist in the 1970s, on visits to Peru and Spain. Sworn and her father looked at the photographs together, her father recalling the people and places in the images, his memories at times at odds with Sworn's own. She later took her father and the photographs he had taken back to Peru and filmed their journey to the places he had visited forty years previously. Alongside the film, she made a group of photographic works that combined her father's photographs with her own, with one layered on top of the other to create a composite image of the same place at different points in time.

In these and other works, Sworn creates multi-layered reflections on the creation and communication of truth, memory, history and knowledge. **KB**

GENERATION LOCATIONS
Edinburgh: Inverleith House.
Glasgow: The Common Guild.

BIOGRAPHY
Corin Sworn (born 1976 in London) grew up in Toronto. She moved to Vancouver to study Psychology at the University of British Columbia before studying an art degree at Emily Carr University of Art + Design. She moved to Glasgow in 2007 to complete an MFA at The Glasgow School of Art. Recent solo exhibitions include *The Rag Papers* at Chisenhale Gallery, London and Neuer Aachener Kunstverein, Aachen (2013); *ArtNow* at Tate Britain (2011); and *The Lens Prism* at Tramway, Glasgow (2010). She is associate professor of Fine Art at the Ruskin School of Drawing & Fine Art, Oxford and was one of three artists in the *Scotland + Venice 2013* exhibition for the 55th Venice Biennale. Sworn lives and works in Glasgow and was awarded the Max Mara Art Prize for Women in 2014.

FURTHER READING
Scotland + Venice 2013, The Common Guild, Glasgow, 2013

The Foxes (still), 2013
HD video
Commissioned by The Common Guild for
Scotland + Venice 2013

Joanne Tatham and Tom O'Sullivan

Contemporary art often seems to operate according to a set of unspoken rules. Joanne Tatham and Tom O'Sullivan's work explores such conventions by exposing them, breaking them or sometimes sticking with them to the point of absurdity. Working together since 1995, they produce sculptures, performance, drawings and photographs, written works, exhibitions and events. They often make and remake their artworks in new forms and places so they act as sets or props, which can be arranged and rearranged to draw attention to what art does and how it works.

In recent years Tatham and O'Sullivan have extended their work to curating projects and events that focus attention on their contexts. *DOES THE IT FIT* (2013) with CIRCA Projects, Newcastle upon Tyne took place at the Stephenson Works, a building once at the heart of the Industrial Revolution and now at the centre of an area of urban redevelopment. The project brought their works together with that of other artists including Chris Evans and John Smith.

For GENERATION, Tatham and O'Sullivan have worked with ATLAS Arts to make new work that spans the neighbouring islands of Skye and North Uist. In Portree, the artists have created a sculptural construction around the folly on the hill where the annual Skye Games take place. At Taigh Chearsabhagh Arts Centre on North Uist they are showing photographs of public sculptures from both Uist and Loughborough University campus. These presentations exist alongside a programme of events that, taken as a whole, will call attention to the role of art in place and in public and question how it can be expected to engage with issues of cultural identity and access.

At Tramway their work revisits *HK*, their 2001 exhibition at that venue. Large black sculptural letters spelt out the words 'Heroin Kills', an apparently simple statement, that like many of Tatham and O'Sullivan's works was anything but. Rather it presented the unresolved tensions and questions surrounding the making and exhibiting of art. The new work considers the context of GENERATION and this earlier work, drawing attention to the mechanisms of myth-making within and through art. **MJ**

GENERATION LOCATIONS
Glasgow: Tramway.
Isle of North Uist: Taigh Chearsabhagh Museum & Arts Centre. Isle of Skye: ATLAS.

BIOGRAPHY
Joanne Tatham (born 1971 in West Yorkshire) and Tom O'Sullivan (born 1967 in Norfolk) have worked together as a collaborative duo since 1995 and met while undertaking their MFA degrees at The Glasgow School of Art. Tatham graduated with a PhD from the University of Leeds in 2004. They have exhibited at Tramway, Glasgow; Kunsthaus Glarus, Switzerland; Studio Voltaire, London and Eastside Projects, Birmingham. They represented Scotland at the 51st Venice Biennale in 2005 and were shortlisted for the Northern Art Prize in 2013. They are currently living and working in Newcastle upon Tyne, London and Glasgow.

FURTHER READING
Joanne Tatham and Tom O'Sullivan, *Amongst other things an unsuccessful proposal for the 2012 Cultural Olympiad*, CCA, Glasgow/ Eastside Projects, Birmingham, 2013

Joanne Tatham and Tom O'Sullivan: A Charming Meaning, A Solid Meaning, A Struggling Meaning, The Modern Institute / Toby Webster Ltd, Glasgow and DuMont Literatur und Kunst, Cologne, 2007

DOES THE IT FIT, 2013
Installation view: Stephenson
Works, CIRCA Projects, 2013
Commissioned by CIRCA Projects,
Newcastle upon Tyne

Cara Tolmie

Cara Tolmie works across several media, including performance art, installation, sound and video, to explore theatrical conventions, language and human interaction. Using her own voice and body, as well as those of other performers, she investigates the meaning of actions and their interpretation through theatrical techniques including monologue and narration. Working with handmade self-designed sets and relying on many of her own abilities to realise her works, she constructs unique and personal narratives and scenarios.

Her 2011 performance *Myriad Mouth Line* sees the artist act alone for the audience. Using nothing but her voice, she crosses the stage calling out in a variety of styles from operatic singing to high-pitched screeching, before delivering an enigmatic monologue. She then goes on to describe the scenario as it has just happened, unravelling what has gone before. She makes connections with the critical framework for performance that questions the medium itself.

Similar approaches are seen in the recent film *Pley* (2013), shown within an installation of artist-designed furniture, which recalls that of the Italian designers and architects Memphis Group. The film features two distinct strands of content. One sequence captures a lone actress as she occupies a mysterious purpose-built room, speaking on the telephone to an unknown caller. As she speaks she meticulously makes combinations of objects found scattered throughout the construction. The second strand consists of interviews with three performers, which take place in what appears to be a backstage area. They recount exercises Tolmie has requested they perform. Yet all we are party to are their descriptions; their actual performances are absent from the film. The work highlights a divide between what is described, and what has taken place, and exposes the many ways performance can be read. Tolmie unpicks conventional narrative structures in order to create new possibilities through ambiguity. **StC**

GENERATION LOCATION
Glasgow: Tramway –
Performance Programme.

BIOGRAPHY
Cara Tolmie (born 1984 in Glasgow) received her BA (Hons) from Duncan of Jordanstone College of Art & Design, Dundee, in 2005. She participated in the LUX Associate Artists Programme in 2009–10. Recent performances include a collaborative performance with Paul Abbott for Counterflows Festival, Glasgow 2014 and *One must force the frozen circumstances to dance by singing to them their own melody* at Pavilion, Leeds and *Otiumfold*, commissioned by Chisenhale Gallery, London (both 2013). The solo exhibition *Pley* took place at Spike Island, Bristol in 2013. Recent group shows include *Home Theatre* at Baró, São Paulo (2013), *Deep Cuts* at Marres, Maastricht (2013) and *Soundworks* at the Institute of Contemporary Arts, London (2012). She lives and works in London.

FURTHER READING
Bridget Crone (ed.), *The Sensible Stage*, Picture This, Bristol, with Bridget Crone/Plenty Projects, 2012

Myriad Mouth Line, 2011
Performance

Hayley Tompkins

Painting plays a key role in the work of Hayley Tompkins, but she is not a painter in the traditional sense. She has made many colourful abstract works using watercolour on paper. But she has also painted on objects including hammers, bottles, knives, chairs, twigs and mobile phones. She has made films, and frequently used photographs in her work, including images of SIM cards, watches, batteries, currency and computer keyboards. Her installations have sometimes included readymade elements, from house plants to fragments of clothing. Tompkins's individual pieces are usually small in scale and ask us to pay careful, intimate attention to them. But her installations also subtly emphasise how each piece relates to the others and to the space of the gallery.

In works such as *Tele and Data V* (2009), Tompkins shows us an object twice over – we see both a real phone and a painting that sits directly upon it, almost like a skin. A mobile phone is, of course, an object that most people are very used to holding and having near them. It stores and releases energy and it can measure and organise time. Tompkins's works often suggest an extension of the self through images or objects. They invite us to think about the possibilities and limitations of communication, about our experiences of time, and about the potential energy in things.

The objects used in Tompkins's art are not her subject matter in themselves. Rather, she uses this 'object matter' to address subjective perception and emotions.

For GENERATION, The Common Guild presents works Tompkins made for *Scotland + Venice 2013* at the 55th Venice Biennale, which are shown in Scotland for the first time here. The installation consists of both painted and printed images. There are photographs, sourced from a commercial supplier of 'stock' images, which depict yachts, ocean views, fruit, stones and various forms of technology. There are also abstract paintings made using brightly coloured acrylic paints in shallow plastic boxes, and watercolours in plastic drinks bottles. These elements are installed in groupings on the floor of the gallery, as with *Digital Light Pool (Orange)* (2013). These pieces mark a recent shift in Tompkins's work to an interest in views or landscapes. Here, looking out, like looking within, is a form of subjective seeing. **DP**

GENERATION LOCATION
Glasgow: The Common Guild.

BIOGRAPHY
Hayley Tompkins (born 1971 in Leighton Buzzard, Bedfordshire) completed a BA in Painting and an MFA at The Glasgow School of Art. Her solo exhibitions include: *Space Kitchen*, Andrew Kreps Gallery, New York (2014); *Hayley Tompkins*, Aspen Art Museum, Aspen, Colorado (2013); *Currents*, Studio Voltaire, London (2011); *A Piece of Eight*, The Modern Institute, Glasgow (2011); *Optical Research*, Andrew Kreps Gallery, New York (2009); *Autobuilding*, Inverleith House, Edinburgh (2009); and *Transfer* (with Sue Tompkins), Spike Island, Bristol (2007). Group exhibitions include *Scotland + Venice 2013*, Palazzo Pisani, Venice Biennale (2013) and the 30th São Paolo Biennale (2012). She lives and works in Glasgow.

FURTHER READING
'Conversation: Hayley Tompkins & Joe Scotland', in *Hayley Tompkins*, The Common Guild, Glasgow, 2013

Daniel Baumann, Karla Black and Pati Hertling, *Hayley Tompkins*, Royal Botanic Garden, Edinburgh, 2009

Digital Light Pool (Orange) (detail), 2013
Acrylic on plastic trays, stock photographs, wooden boxes, glass, plastic bottles, watercolour
Installation view: *Scotland + Venice 2013*
Commissioned by The Common Guild

Sue Tompkins

Sue Tompkins's art is dominated by language whether it is spoken, painted or typed and pinned to the wall. Formerly the lead singer of the celebrated post-punk band Life Without Buildings, the artist is best known for her highly distinctive spoken-word performances where her speech is extended through movement. Her performances are filled with joy and pathos and with the detail of the everyday. Most magically, despite being performed in front of groups, they often seem to be delivered only for you, disjointed words and just-recognisable phrases are uttered with smiling intimacy, like a secret code between best friends or lovers.

Performances such as *Letherin Through the Grille* (2013), *Hallo Welcome to Keith Street* (2010) and *Country Grammar* (2003) are developed over a number of months, with words or phrases collected from daily life, typewritten and filed together until they reach a point where Tompkins intuitively knows the work is complete and the loose sheets of paper are formed into a kind of manuscript. The phrases and idiosyncratic spelling and grammar that make up the finished work become tools of production, defining the pace and rhythm of the performance. These durational pieces (often around forty-five minutes in length) are strictly edited and shaped despite their seemingly freeform style.

Alongside her performance works, Tompkins works with paint, textiles and the typed word using many of the devices found in her performance work, such as ritual and repetition. Text-based works are mainly made on a typewriter on newsprint paper, the size of which means it needs to be folded before it can be successfully inserted in the machine. Once removed, the folds become part of the finished object – a trace of the process of research and production nestled amongst the words. Tompkins's works in fabric include pieces of chiffon in a rainbow of colours, with zips pinned to them. She describes the zips as representing the act of decision-making. The location of the zip is like a map of this process. This gesture is slight yet it communicates the process of editing an artwork or personal action and of articulating its relationship to the world. **LY**

Sue Me, 2013
Acrylic on canvas, 64.3 × 54 × 4 cm
Private collection, Miami

GENERATION LOCATIONS
Arbroath: Hospitalfield Arts. Edinburgh: Inverleith House; Scottish National Gallery. Glasgow: Tramway – Performance Programme.

BIOGRAPHY
Sue Tompkins (born 1971 in Leighton Buzzard, Bedfordshire) studied Painting at The Glasgow School of Art, graduating in 1994. Solo exhibitions include: *Skype Wont Do*, Diana Stigter, Amsterdam (2013); *Its Chiming in Normaltown*, Midway Contemporary Art, Minneapolis (2012); self-titled shows at The Modern Institute, Glasgow and (with Claude Cahun) at Inverleith House, Edinburgh (both 2011); *Salute to the Dataday*, Contemporary Art Museum, St Louis (2009); and *In the Zone of your Eyes* (with Hayley Tompkins), West London projects, London (2005). She has participated in group exhibitions and/or given performances at: the 29th São Paolo Biennale, São Paulo; Bregenzer Kunstverein, Bregenz; Turner Contemporary, Margate; the *British Art Show 7*; and White Columns, New York. She lives and works in Glasgow.

FURTHER READING
Sue Tompkins, *Long Hand*, LemonMelon, UK, 2011

Sarah Lowndes, 'Rhythm and knowledge: The typed drawings of Sue Tompkins', *Art on Paper*, May 2008

Jennifer Higgie, 'In other words', *Frieze*, issue 98, April 2006

Zoë Walker & Neil Bromwich

Zoë Walker & Neil Bromwich first worked together in 1998 in Orkney to produce Walker's evocative film *Dream Cloud* for The Pier Arts Centre. Their practice has grown out of a history rooted in rural Scotland and a shared commitment to social cohesion, absurdist humour and the sublime. They respond to specific sites and engage audiences in large-scale projects, questioning aspects of society they see as unjust and encouraging dreams of a better world. Their practice ranges across sculpture, theatre, filmmaking, radio, protest, pageant and public interventions to enable participants to consider other ways of being, whether on a personal, local or global level. Operating within an art world that they believe is suspicious of authenticity and hopefulness, Walker & Bromwich challenge easy cynicism.

To cut through disillusion and negativity, their work invites us to consider the role that conviction and belief might still play. Such themes underpin *Celestial Radio 87.7FM* (2004–12) – a mirrored yacht that has journeyed over the globe from Skye to Sydney transmitting sound works that immerse audiences in visionary new readings of the diverse landscapes that the work encounters.

Since around 2008 the artists have increasingly used sociability and public involvement in their work. For them personal transformation is more likely through direct experience, through getting involved with climate change and social injustice as pressing threats. Their project *Encampment of Eternal Hope* (2012–13) for BALTIC in Gateshead built on earlier absurdist works such as *Love Cannon* (2005–ongoing) in which a pink, inflatable cannon was paraded down a street. *Encampment* had a futurist, utopian, survivalist atmosphere. It comprised a collection of dwellings, part-tent and part-plant, nestled amongst a forest of hybrid sculptures that blurred botanical and military forms.

Other works, such as *Eccentric Banquet* (2011) or *The Conch [Sound Studio]* (2010–11), operate as much as platforms to generate discussion and share experience with the public, rather than aesthetic objects alone. For GENERATION, Walker & Bromwich are creating another fantastical project with Orkney at its centre: visitors will enter into a hybrid place redolent of renewable energy, the Neolithic world and the myths of maritime changelings. AP

GENERATION LOCATION
Orkney: Pier Arts Centre.

BIOGRAPHY
Zoë Walker (born 1968 in Glasgow) graduated BA (Hons) at Edinburgh College of Art in 1991 and undertook a postgraduate course in Sculpture at the Academy of Fine Arts in Warsaw before obtaining her MA in Fine Art at Goldsmiths, London in 1996. Neil Bromwich (born 1966 in Northampton) graduated BA (Hons) in Fine Art at the Kent Institute of Art & Design in 1996. Recent exhibitions include: *The Encampment of Eternal Hope*, BALTIC, Gateshead (2012); *Celestial Radio Phosphorescence Song*, commission for the Museum of Contemporary Art, Sydney Harbour (2012); and *On the Threshold of a Dream*, Turner Contemporary, Margate (2008). Recent group shows include: *Camouflage*, Kiasma, Helsinki (2012); *Panacea Casebook* (performance with Michael Pinsky), Tate Britain, London (2010); and *Nothing to Declare*, 4th Triennial of Contemporary Art, Oberschwaben, Germany (2008). They live and work in Glasgow.

FURTHER READING
Biennale 2 Praxis Catalogue, 2nd Thessaloniki Biennale of Contemporary Art, Greece, 2009

Zoë Walker & Neil Bromwich, John Hansard Gallery, Southampton, 2008

Love Cannon, 2006
Performance, digital-video and photograph,
Les Arques, France

Alison Watt

Alison Watt became fascinated with making and looking at paintings from a young age, and today she is a champion for the importance and unique nature of the medium. She developed her art in the 1980s when, focusing on the human figure, she worked on self-portraits and studies of life models in the studio. Towards the end of the 1990s she became interested in painting folds of fabrics and draperies of the kind often used as props by life models. The absence of the human figure marked an important shift in her subject matter. But rather than abandoning the figure as subject in favour of abstraction, Watt's new paintings evoked the human body in its absence.

Watt's painting *Sabine* (2000) shows her meticulous attention to detail. It is informed by the fabric depicted in portraits of women by the nineteenth-century French artist Jean-Auguste-Dominique Ingres. Watt has described Ingres's paintings as a long-time source of fascination. She regularly cites historical painters as inspiration, although her works share many qualities with her contemporary peers.

Phantom (2007) is one of several spectacular and absorbing large-scale canvases that were painted during Watt's residency at the National Gallery in London. It is partly inspired by the painting *Saint Francis in Meditation* (1635–9) by Spanish artist Francisco de Zurbarán, which depicts a kneeling, open-mouthed figure whose face is almost completely obscured by shadow inside a hood. Watt's fabric seems to suggest the ghostly absence and presence of a human form. The folds create a point of entry into an unseen negative space at the centre of the painting.

Fount (2011) is from a series of paintings that were partly inspired by the extraordinary self-portrait photographs of the American artist Francesca Woodman, who died in 1981 at the age of twenty-two. Watt's fascination with Woodman's work came from a broader investigation of the nature of self-portraiture. Made a few years after *Phantom*, this painting is less rooted in historical source material. It conveys an intimate, sensual and emotional response to a subject. **BH**

GENERATION LOCATIONS
Perth: Perth Museum & Art Gallery. Edinburgh: Scottish National Gallery of Modern Art.

BIOGRAPHY
Alison Watt (born 1965 in Greenock) studied at The Glasgow School of Art (1983–8). Her solo shows include: *Hiding in Full View*, Ingleby Gallery, Edinburgh (2011); *Phantom*, National Gallery, London (2008); *Dark Light*, Ingleby Gallery, Edinburgh and Pier Arts Centre, Orkney (2007); *Still*, Memorial Chapel, Old Saint Paul's Church, Edinburgh (2004); *Shift*, Scottish National Gallery of Modern Art, Edinburgh (2000); and *Fold*, The Fruitmarket Gallery, Edinburgh (1997). Watt participated in the 2010 exhibition *Autoritratte* at the Sala delle Reali Poste in the Uffizi Gallery, Florence, Italy, which brought together female self-portraits from the sixteenth century to today. She was Associate Artist at the National Gallery, London in 2006–8. In 2008 she was awarded an OBE. She lives and works in Edinburgh.

FURTHER READING
Alison Watt and Don Paterson, *Hiding in Full View*, Ingleby Gallery, Edinburgh, 2011

Colin Wiggins and Don Paterson, *Alison Watt: Phantom,* The National Gallery Company, London, 2008

Graeme Murray *et al.*, *Alison Watt: Fold, New Paintings 1996–97*, The Fruitmarket Gallery, Edinburgh, 1997

Fount, 2011
Oil on canvas, 61.9 × 121.9 cm
Private collection

Cathy Wilkes

Cathy Wilkes is best known for her imaginary environments, which variously recall interiors: the sickroom, the deathbed, places of loss and catastrophe.

Wilkes makes installations, sculpture and paintings, experimenting with all kinds of media and materials, including paper cloth and clay, and collecting treasures and ingredients, which together have made a body of work spanning twenty-five years. Production – or what we see in the end – is the accumulation of all of these constituent parts. Equally important, though, are the contemplative, sensorial experiences for which it stands.

To make art is to conceive of something outside body and mind; to release and expand ourselves beyond what defines one human being as separate from others. This opening out is a thrilling and terrifying endeavour full of mystery, which Wilkes has described as a transforming force of nature. The artist's work, which is fiercely introspective, challenges us to consider the impossibility of a clear meaning, why something is as it is or why it is there at all, but also the mysterious place where art moves inside us.

Wilkes's work *Untitled (Possil, at last)* (2013) was included in the exhibition *The Encyclopedic Palace* at the 55th Venice Biennale (2013). Here, four child-like figures in antique clothing and bonnets stand around a male figure who is crouched over an empty bottle. There are two infants, one is a bride; another figure might be a shepherd. As if in a garden, a taller girl stands before an expanded field of broken pieces, unearthed from the ground where Possil Pottery once stood. 'The work is inhabited by both the living and the dead,' the artist says. 'Then it's understood that there is both materialisation and disappearance of physical things. It's understood that it is a natural retreat from material reality. It's understood that the forces of nature are electric and defining.' Wilkes's exhibition for GENERATION continues these themes, engaging with the fabric and raw materials of Tramway's gallery space. **CJ**

Untitled, 2013
Mixed media
Installation view: *The Encyclopedic Palace*,
Venice Biennale, Venice, 2013

GENERATION LOCATION
Glasgow: Tramway.

BIOGRAPHY
Cathy Wilkes (born 1966 in Belfast). She graduated from The Glasgow School of Art in 1988, represented Scotland in the 51st Venice Biennale in 2005 and was nominated for the Turner Prize in 2008. Selected solo exhibitions have been held at: Xavier Hufkens, Brussels (2013); The Modern Institute, Glasgow (2012); The Renaissance Society, University of Chicago (2012); Gesellschaft für aktuelle Kunst, Bremen (2011); and Carnegie Museum of Art, Pittsburgh (2011). Group exhibitions include: *The Encyclopedic Palace*, Venice Biennale (2013); *The Assistants*, David Kordansky Gallery, Los Angeles (2013); *Love is Colder than Capital,* Kunsthaus Bregenz (2013); *Studio 58: Women Artists in Glasgow Since World War II*, Mackintosh Museum, The Glasgow School of Art (2007); *Selective Memory*, Scottish National Gallery of Modern Art, Edinburgh (2005). She lives and works in Pollokshields, Glasgow.

FURTHER READING
Cathy Wilkes, Aspen Art Museum, Aspen, Colorado, 2011

Cathy Wilkes in conversation with Bart Van Der Heide, in *Cathy Wilkes*, Kunstverein, Munich, 2011

Emma Dean and Michael Stanley (eds), *Cathy Wilkes*, Milton Keynes Gallery, 2008

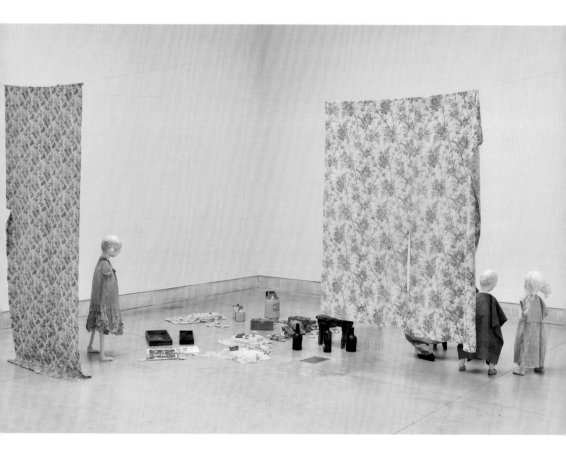

→ Richard Wright

Richard Wright makes site-specific paintings (on walls, ceilings and even floors), drawings and prints. In the 1980s he used to paint works on traditional supports such as canvas or board, but he became sickened by the rampant and cynical commercialisation of much painting of the period and even gave up painting altogether for a time. Eventually, he began to develop a new art practice, based on painting directly onto walls and other permanent surfaces, usually on a temporary basis. After an exhibition of his work was finished, the work was painted over and thus destroyed. This was idealistic in two ways. Firstly, he was not creating a marketable product. Secondly, and probably more importantly, he was responding to a real, pre-existing space, with its own formal structure and its own history, and not deciding on an arbitrary format and size for his painting surface.

In this respect Wright was very much working in the constructivist tradition, as developed by artists in revolutionary Russia – the work of El Lissitzky, for example – or by those in Holland after the First World War, artists such as Theo van Doesburg in the movement known as De Stijl. The forms that Wright developed tended to be geometrical (often repeated lines or forms), organic (such as plants) or drawn from popular culture, or sometimes a mixture of all three. If the first two were often inspired by art-historical sources, such as geometrical, non-objective art or Art Nouveau, the last owed much to musical sources (Wright has played in a band), such as record covers or fanzines. Gradually Wright's repertoire of forms has become much more complex and intricate, probably as a result of the highly elaborate drawings that he has made. His room paintings, such as the gold filigree work that he made for the Turner Prize in 2009 or the dizzying force lines – a graphic technique used in engineering – visible in the stairwell of the Scottish National Gallery of Modern Art in Edinburgh, are amazing feats of painstaking complexity. **KH**

The Stairwell Project (detail), 2011
Acrylic on wall
Scottish National Gallery of Modern Art, Edinburgh

GENERATION LOCATIONS
Edinburgh: Scottish National Gallery of Modern Art.
Glasgow: The Modern Institute.

BIOGRAPHY
Richard Wright (born 1960 in London) graduated from Edinburgh College of Art in 1982. He was awarded the Scottish Arts Council's Amsterdam Studio Residency in 1986 and an Exchange Residency at CalArts, Los Angeles in 1994. He received a postgraduate degree at The Glasgow School of Art in 1995. Notable solo shows include: Kunsthistorisches Museum, Vienna (2013); Museum of Modern Art, New York (2007); Museum of Contemporary Art, San Diego (2007); Kunstverein, Düsseldorf (2002); Kunsthalle, Bern (2001); and Transmission, Glasgow (1994). Group shows include his winning contribution to the Turner Prize exhibition at Tate Britain, London (2009), and the 55th Carnegie International, Pittsburgh (2008). Permanent works include commissions for the Rijksmuseum, Amsterdam (2012) and the Scottish National Gallery of Modern Art, Edinburgh (2010). He lives and works in Glasgow.

FURTHER READING
Richard Wright, Dundee Contemporary Arts, 2006

Richard Wright, Gagosian Gallery, New York/London, 2009

Richard Wright, Kunstverein für die Rheinlande und Westfalen, Düsseldorf, 2002

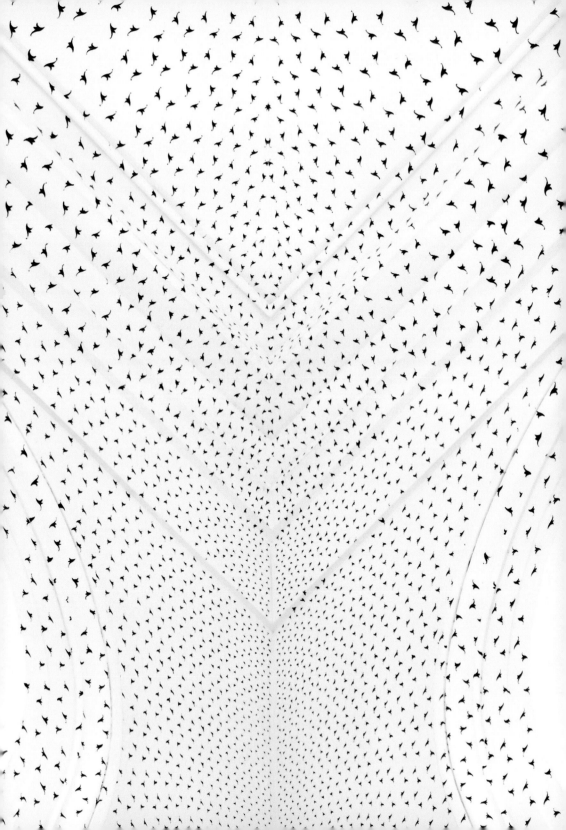

→ The Bothy Project

The Bothy Project draws on ideas about place, journeying, refuge and the environment – all ideas that can be associated with the traditional Scottish bothy: a hut or simple cottage located in a remote area of Scotland, frequently in the Highlands and Islands. These buildings were originally used by farmers and labourers for protection at night, or in bad weather when working on the land.

The aim of The Bothy Project is to create small-scale buildings, maintained through renewable energy, that provide spaces in which artists can work and live. For The Bothy Project, the special nature of the specific place in which each bothy has been built is key in providing opportunities for artists to undertake residencies that engage with the histories, stories, mythologies and people rooted within a particular place. The Bothy Project creates simple, modern and functional buildings usually comprising a single room with stove, kitchen and work area. They are constructed to be sustainable and are maintained 'off-grid'. The project works closely with artists, designers, writers and musicians in the development of each bothy.

The first art residency bothy was begun in 2011, through the support of the Royal Scottish Academy (RSA) Residencies for Scotland programme. The structure was built during an RSA residency at Edinburgh Sculpture Workshop. It was then transported to Inshriach Estate, four miles from Aviemore, where it was completed. This one-room bothy is situated in the Cairngorm National Park, surrounded by woodland by the banks of the river Spey. In 2012 The Bothy Project turned a vacant space by the canal in Glasgow into a temporary wild-flower garden with a shipping container bothy to create an alternative outdoor performance and events space. The garden hosted a series of art residencies and events until September 2013. A second permanent bothy, Sweeney's Bothy, in collaboration with artist Alec Finlay, was completed in 2014 on the Isle of Eigg. For GENERATION a new, temporary bothy developed in collaboration with Laura Aldridge, has been established in the grounds of the Scottish National Gallery of Modern Art to provide a site for performances, discussions and events with a range of groups and individuals.

The Bothy Project was first initiated by artists **Bobby Niven** and **Will Foster** in 2009. Since 2011 Niven has led the project with architect **Iain MacLeod**.

GENERATION LOCATION
Edinburgh: Scottish National Gallery of Modern Art.

BIOGRAPHY
Laura Aldridge (born 1978 in Frimley, Surrey) studied at Wimbledon School of Art, London and obtained her MFA at The Glasgow School of Art, including the Academic Exchange (MFA Programme) to CalArts, Los Angeles in 2005. Laura works with a variety of materials including photography, screenprint, ceramics, fabric and cement depending on the space she is working in. Solo exhibitions include: *THINGS HELD INSIDE//THE NEW SEA*, Kendall Koppe, Glasgow (2012); Studio Voltaire, London (2011); and *Objet D'Art*, 507 Rose, Los Angeles (2005). Group exhibitions and events include: *Openaries* with Anna Mayer, Glasgow International (2014); *Taking back our bodies (refund please)*, Infernoesque, Berlin (2013) and *Out of Doors*, Supplement, London (2013). She lives and works in Glasgow.

Inshriach Bothy, Cairngorm National Park

Studio Jamming ARTISTS' COLLABORATIONS IN SCOTLAND
COOPER GALLERY, DUNCAN OF JORDANSTONE COLLEGE OF ART & DESIGN, DUNDEE

Taking its cue from the live improvised excitement of musical jamming, Cooper Gallery at Duncan of Jordanstone College of Art & Design in Dundee presents *Studio Jamming: Artists' Collaborations in Scotland*. It is the first survey to foreground the grassroots character of artists' collaboration in this country, a phenomenon that has contributed to the remarkable achievements of contemporary art here. The programme consists of exhibitions, a month-long series of events and a Group Critical Writing Residency culminating in a 12-hour Jamming Symposium with keynote talks, gigs, performances and screenings.

Studio Jamming researches and celebrates artists' collaborations in Scotland. The key ingredient for this process is The Hub, constructed in and around Cooper Gallery and

designed by Studio Miessen led by Markus Miessen, who studied at The Glasgow School of Art. The Hub acts as a collaborative site where artists, writers, architects, educators, researchers, performers, cultural thinkers and other participants can present and reflect upon the possibilities and histories of artists' collaborations.

Among the highlights are presentations of new works from artists' collaborative groups including Graham Eatough & Graham Fagen, Full Eye, GANGHUT and Henry VIII's Wives. Offering a vital platform for presenting and disseminating new critical writing, the Group Critical Writing Residency, edited by Maria Fusco, invites emerging writers in Scotland to produce new works.

Theatre director **Graham Eatough** and visual artist **Graham Fagen**'s collaborative practice explores the ground between contemporary art installation, film and theatre. Major projects include *Killing Time* at Dundee Contemporary Arts (2007) and *The Making of Us* at Tramway, Glasgow (2012).

Full Eye, a newly formed artists' collaboration, brings together Anne-Marie Copestake, Katy Dove and Ariki Porteous. Sharing a common interest in mantra, the group explores this through writing, deep listening, extended vocal techniques and percussion.

GANGHUT is a collective bringing together artists from different parts of Scotland to create social and communal spaces where activities can happen in the spirit of co-operation and camaraderie. Formed in 2004, GANGHUT began as an assembly of graduates of Duncan of Jordanstone College of Art & Design in Dundee. They have exhibited both in the UK and internationally.

Henry VIII's Wives are a collective of artists founded in 1997, and include Rachel Dagnall, Bob Grieve, Sirko Knüpfer, Simon Polli, Per Sander and Lucy Skaer. They are based variously in Scotland, Norway, Denmark and Germany, and are all graduates of The Glasgow School of Art. Previous projects include an unsuccessful attempt to make fire by rubbing twigs and a portrait of Che Guevara in coffee beans. In 2002 the group built a 1:1 scale model of Skara Brae for their exhibition *Light Without Shadow*.

Maria Fusco writes fiction, critical and theoretical texts, edits publications, and contributes to a broad range of magazines, books and catalogues; she is also founder/editorial director of *The Happy Hypocrite*. Fusco was the inaugural Writer in Residence at Whitechapel Gallery, London in 2009–10 and Writer in Residence at the Lisbon Architecture Triennale. She is a Hawthornden Fellow at Edinburgh College of Art.

Studio Miessen was established in 2002 and is led by Markus Miessen. Studio Miessen is a collaborative agency for spatial strategy and cultural analysis, which has been involved in major art events including Manifesta, the Lyon Biennale, the Gwangju Biennale and Performa, New York.

Mood Is Made / Temperature Is Taken

GLASGOW SCULPTURE STUDIOS · CURATED BY QUINN LATIMER

Your hothouse flower your florid your lurid your leaf your car finish your finish fetish. You finish I am never finished. Your monolithic remains unpublished or publish this I ask that or this to be no not finished something—what— something unflesh. Something cast in your fervent no fervid emotional furnace. How dry it is in there. So deco. Palm purring, now clicking. What a vibe. Humid out here, you know. Wet finish.

Wet finish.

Glasgow Sculpture Studios supports a vibrant community of more than 100 professional artists who focus on innovative sculptural techniques and practices, providing studio and production facilities, alongside staff expertise. *Mood Is Made / Temperature Is Taken* considers the dual strategies of craft and appropriation among a current generation of artists working at Glasgow Sculpture Studios, and features contributions by: **Rachel Adams**; **Jennifer Bailey**; **Sarah Forrest**; **Jenny Lewis**; **Tessa Lynch**; **Lorna Macintyre**; **Niall Macdonald**; **Natalie McGowan**; **James McLardy**; **Lauren Printy Currie**; **Clara Ursitti** and **Zoe Williams**.

Quinn Latimer is an American writer and curator based in Basel, Switzerland. She is the author of *Rumored Animals* (2012) and *Sarah Lucas: Describe This Distance* (2013). Her writing also appears in *Artforum*, *Frieze*, *The Paris Review* and many artist monographs and critical anthologies. Recent curatorial projects include *Emmy Moore's Journal: An Exhibition Based on a Letter in a Short Story by Jane Bowles*, an exhibition she organised at SALTS, Basel, in 2013.

Zoe Williams, **You Consume Me VI**, 2014
C-type digital print

HOUSE WORK CASTLE MILK WOMAN HOUSE

GLASGOW WOMEN'S LIBRARY

In the past twenty-five years, women artists in Scotland have moved from the margins, to being at the forefront of Scottish contemporary art. GENERATION includes many of the women artists, art historians, curators and critics who have risen to prominence in this period.

Glasgow Women's Library is increasingly regarded as having a significant place in the modern history of art and ideas in Scotland. Launched in 1991, its history maps the period surveyed by GENERATION. Unique in Scotland, it has developed through the involvement of many women artists and writers. In 2013, it won Enterprising Museum of the Year at the Art and Business Awards sponsored by Museums Galleries Scotland.

The HOUSE WORK CASTLE MILK WOMAN HOUSE exhibition and programme for GENERATION showcases some of the pioneering work of women artists in Scotland in the early 1990s, in particular the groundbreaking collaborative public project Castlemilk Womanhouse. Instigated by Rachael Harris, Julie Roberts and Cathy Wilkes, Castlemilk Womanhouse was the most ambitious art project in the Women in Profile Festival (1990) and involved creative collaborations between women from the Castlemilk community, artists and Women in Profile co-ordinators. It was reviewed by the art critic Clare Henry as the best community project during Glasgow's year as European City of Culture. Women in Profile proved to be a crucible both for Glasgow Women's Library and for many women artists. HOUSE WORK CASTLE MILK WOMAN HOUSE will bring this innovative and historically significant episode and its legacy for women's

art in Scotland to a wide audience through screening events, discussions, online resources and an exhibition. The Library's collection team will collect and record testimonies from artists and participants who were involved in the project, and these perspectives will be shared and discussed in a series of public events.

The internationally renowned artist **Kate Davis** has been commissioned to research Castlemilk Womanhouse and make a new work in response to it. Her work will be exhibited alongside the newly catalogued Castlemilk Womanhouse collection. Davis has developed a body of work that has often involved responding to the aesthetic and political ambiguities of historical artworks and the way they have been viewed or understood. Davis revisits certain histories from a feminist perspective. In a previous collaborative project with Faith Wilding (a key figure in the original Womanhouse project in California in 1972), Davis explored how feminist artists have challenged dominant understandings of 'work' and its value.

The HOUSE WORK CASTLE MILK WOMAN HOUSE exhibition and events programme will take place in the new permanent home of Glasgow Women's Library, Bridgeton, Glasgow. The Library's role is to provide an inspiring environment where women's history is collected, contemporary work by women is showcased and its unique collections can be enjoyed by all. It is an accredited museum, an archive and a lending library and is staffed by a team specialised in working with women from diverse backgrounds.

Advertisement for Castlemilk Womanhouse,
Artists Newsletter, April 1990

HOUSEWORK

Women in Profile invite proposals from women artists working in any medium to help transform a tenement block of flats in Glasgow alongside local women.

ARTISTS WORKSHOPS & RESIDENCIES

Further information from
WOMANHOUSE PROJECT
54 Garnethill Street 2/R
Glasgow G3 6QQ
Tel. (041) 332 2378
Deadline 8th May 1990

→ Information

PAISLEY MUSEUM AND ART GALLERIES

In 1989 a group of seventeen emerging artists, a mixture of recent graduates and undergraduates from The Glasgow School of Art, staged an exhibition called *Information* at Paisley Museum. The artists were Dave Allen, Claire Barclay, Martin Boyce, Roderick Buchanan, Nathan Coley, Jacqueline Donachie, Douglas Gordon, Michael McDonough, Helen Maria Nugent, Adrian O'Donnell, Felicity Pendred, Colin Pettigrew, Craig Richardson, Ross Sinclair, Brian Smillie, Euan Sutherland and Karen Vaughan.

This little-known exhibition has been one of the best-kept secrets in the history of contemporary art in Scotland. It was the first show in a major public institution for the artists, most of whom were to become key figures in the visual arts. The title recalled the landmark 1970 show *Information* at New York's Museum of Modern Art curated by Kynaston McShine, which is widely considered to be the first survey of Conceptual art by a major American museum. The 1989 exhibition was proposed to the museum by Paisley resident Michael McDonough, then a student at The Glasgow School of Art and now an internationally renowned cinematographer. All the works were made specifically for the exhibition, and many of them responded to the museum, its collections and the wider context of the city. The accompanying catalogue declared: 'the participants intend the exhibition to be open to critical debate and that it provokes more questions than it answers.' Paisley Museum is revisiting this key moment by displaying archive exhibits, installation photographs and documentation, including the original poster, catalogue and artists' proposals.

In the spirit of the original *Information* exhibition, the students who are undertaking the MLitt course at The Glasgow School of Art in 2013–14 in Fine Art Practice (specialising in painting and drawing, sculpture, or photography) have been invited to exhibit their work alongside the archive display and respond to the theme of 'information', its relevance to the museum context and to that of Paisley. The town lent its name to the world-famous Paisley pattern, which adorned the shawls woven in the local area. Weaving technology led to information technology, as the binary-coded jacquard loom is an early precursor of the computer. In 2014 we experience and share information in a completely different way from a quarter of a century previously, which is reflected in the new work on show. The exhibition thus spans the entire twenty-five-year scope of the GENERATION project and looks both to the past and to the future legacy of contemporary art in Scotland.

Left: Michael McDonough and Nathan Coley, 1989
Right: Jasper Coppes, 2014

Discordia

PATRICIA FLEMING PROJECTS

DISCORDIA is a programme of performance and live music and a selection of limited-edition T-shirts produced by twenty contemporary artists who have been involved with Patricia Fleming Projects over the last twenty years. DISCORDIA celebrates the DIY and 'lo-fi' approach of artists, a key feature of the rise of artist-led activity in Glasgow. T-shirts are a great example of this approach: cheap to print, easy to transport and share, they are one of the simple and effective ways that artists have used to communicate ideas or images.

DISCORDIA live events include artist **David Sherry** performing *Time Based Sculptural Performance Ready Made* and in conversation with curator **James Clegg,** a screening of **Jane Topping**'s film *The Women*, music from **Danny Saunders**, **Ace City Racers** and guest DJs. Artists who have designed limited-edition T-shirts include **Martin Boyce**, **Roderick Buchanan**, **Duncan Campbell**, **Jacqueline Donachie**, **Claire Fontaine**, **Douglas Gordon**, **Jim Lambie**, **David Sherry** and **Calum Stirling.**

Artist and curator Patricia Fleming's project Fuse provided free studios across Glasgow and a stipend for over 500 artists from 1992 to 1999; it was founded as a space for artists to develop their work and also provided financial support to purchase material and helped create exhibition opportunities. The project nurtured a network of artistic collaborators and a shared DIY approach, which in turn supported artist-led institutions in the city and beyond. Artists involved in Fuse included many significant figures such as Roderick Buchanan, Martin Boyce, Raydale Dower, Michael Fullerton, Douglas Gordon, Iain Kettles, Jim Lambie, Jonathan Monk, Scott Myles, Ross Sinclair, Stephanie Smith, Calum Stirling, Simon Starling, Tony Swain, James Thornhill, Mary Redmond, Eva Rothschild and Richard Wright.

Since then Patricia Fleming has been involved in working with artists through a wide range of curatorial projects, public commissions, events and opportunities. In 2003 she curated Wales's presentation at the Venice Biennale, the exhibition *Further*. Her international projects also include *A Gathering Space* by award-winning architect Gareth Hoskins in 2008, which was Scotland's first stand-alone commission at the Venice Architecture Biennale. These days Patricia Fleming Projects is a contemporary art gallery and studio in the heart of Glasgow's arts district. The exhibition programme has evolved from twenty years' experience of working at a local and international level. In parallel with the exhibition programme, the gallery facilitates talks and events to introduce the public and new collectors to artists who are contributing to Scotland's enviable reputation for contemporary art at home and abroad.

David Sherry, **Time Based Sculptural Performance Ready Made**, 2014
Performance

→ Open Dialogues

ROYAL SCOTTISH ACADEMY

Stuart McAdam, **Lines Lost**, 2013
Performative walk with Simon Yates

The Royal Scottish Academy of Art (RSA), founded in 1826, is in a unique position in Scotland as an independent, privately funded institution led by eminent artists and architects whose sole purpose is to promote and support the creation, understanding and enjoyment of the visual arts through exhibitions and related events.

RSA New Contemporaries is a curated annual exhibition, which focuses on the finest emerging artists and architects in Scotland. It marks the RSA's commitment to presenting and supporting the best contemporary art in Scotland. In collaboration with the five Scottish art schools and six architecture schools, sixty artists are selected directly from their undergraduate degree shows and invited to make new works for the RSA galleries in the following spring. This allows the RSA to show a body of work in context, develop a continuing long-term relationship with graduates and produce a world-class exhibition, annually high-lighting the best of Scottish graduates under one roof and in an accompanying publication.

The exhibition has become one of the key events in the Scottish calendar and is attended by curators, gallerists, collectors and visitors from across Europe. Since 2009, over 360 artists have been highlighted in this exhibition and

sixty more have been selected from the 2014 degree shows.

For *OPEN DIALOGUES*, one artist from each of the *RSA New Contemporaries* displays (2009–2014) has been invited to make new work. With a range of international research and exhibitions between them, the artists have been selected for their excellence, their impact upon contemporary practice and their proven track record since *RSA New Contemporaries*.

Ade Adesina (*RSA New Contemporaries* 2013) graduated with a BA (Hons) in Printmaking from Grays School of Art in 2012. He lives and works in Aberdeen. Concerned with the environment and climate change, Ade exhibits sculptures and linocuts commenting on the planet and its natural habitat and resources.

Ernesto Cánovas (*RSA New Contemporaries* 2010) graduated with a BA (Hons) in Drawing and Painting from Edinburgh College of Art in 2009. He went on to achieve an MFA from the Slade School of Art in 2011. He lives and works in London. Using layered images and varnishes, Ernesto's presentation includes a three-metre-wide triptych painting.

Jonny Lyons (*RSA New Contemporaries* 2014) graduated with a BA (Hons) in Fine Art from Duncan of Jordanstone College of Art & Design, Dundee in 2013. He lives and works in Glasgow. He uses photographs and sculpture to capture his adventurous performances.

Stuart McAdam (*RSA New Contemporaries* 2009) graduated with a BA (Hons) in Fine Art from Duncan of Jordanstone College of Art & Design, Dundee in 2008. He lives and works in Glasgow. His presentation includes new works which focus on his journeys to areas of Europe which were significant frontiers during World War One.

Geri Loup Nolan (*RSA New Contemporaries* 2011) graduated with a BA (Hons) in Painting from Edinburgh College of Art in 2010. She lives and works in Edinburgh. A recent residency at Cill Rialaig, County Kerry, Ireland provides a rich source for new work and her presentation includes film and two new large-scale paintings.

Eva Ullrich (*RSA New Contemporaries* 2012) graduated with a BA (Hons) in Painting and Printmaking from The Glasgow School of Art in 2011. She lives and works in the Lake District. Eva exhibits new large-scale canvas paintings.

Counterpoint: An Architecture of Ideas

TALBOT RICE GALLERY

Ross Birrell, **Being and Time – The Abyss** (still), 2012
HDV

Counterpoint is a group exhibition, featuring eight contemporary artists, which aims to expand thinking about visual art in relation to other subjects of learning. The project includes a programme of interactive performances throughout August and a critical forum in October with national and international speakers.

Ross Birrell describes his work as conceptual and contextual, engaging people, politics, place, philosophy, film, writing and music. For *Counterpoint* he is showing a new chapter of the ongoing project *Envoy*, a series of site-specific actions, recorded in film, photography and text that respond to utopian literature and the logic of gift exchange.

Keith Farquhar uses the idea of the consumerist readymade, particularly clothing, to subvert our idea of what art can be. His sculptural work is provocative, humorous and audacious but it has an underlying serious endeavour that probes the essence of visual display, gender politics and art-historical conventions such as his 'reframing' of the female nude.

Alec Finlay creates poetry and art and works across a range of media and forms, from sculpture and collage, to audio-visual, neon and new technologies. For *Counterpoint*, Alec is showing *Global Oracle*, a sculptural and text work which looks at the relationship between bee behaviour and navigation, prophecy in Ancient Greece, and GPS satellite navigation systems.

Michelle Hannah explores society's obsession with technology, identity and perpetual fame through her performance and video work. In her multi-layered performances she creates ambiguous alter egos such as the artist Susan Hiller and musicians Grace Jones and David Bowie. Her new work, commissioned for *Counterpoint*, has a visual presence in the exhibition and a series of signature theatrical performances.

Ellie Harrison makes complex, provocative and politically-engaged work for gallery exhibitions and beyond. Shifting between the roles of artist, activist and administrator, she presents playful performances, installations, events and political campaigns, which aim to investigate, expose and challenge the systems that control our everyday experience and rule over our lives.

Shona Macnaughton makes filmed and animated journeys and re-enactions looking at a variety of ideas on themes including the city, the built environment, employment, power structures and the plethora of marketing in contemporary living.

Andrew Miller questions how buildings and spaces combine with objects to produce new ways of looking and thinking. He attempts to inspire curiosity in, and affection for, the discarded, worn and redundant through appropriation. From creating lunches as a platform for discussion to designing libraries, his work often creates architectural spaces and places for activity, contemplation and debate.

Craig Mulholland works in sound, performance and video and is currently focused on exploring art and instrumentalism. He is the founder of OPERA AUTONOMA, an artist collective that seeks to bring together disparate art disciplines using innovative approaches to production.

Artists' Moving Image

TRAMWAY

Tramway presents a series of curated screenings reflecting the development of artists' moving image work in Scotland.

Viewfinders
Featuring work by Johanna Billing, Cyprien Gaillard, Ben Rivers
Curated by Karen Cunningham
As a Scottish artist based in Glasgow, Karen Cunningham has selected works that have been made in Scotland by artists of her own generation who are not Scottish and who are not based in the country. Her programme draws connections between the work of artists based in Scotland and their contemporaries in other countries. The collected films and videos draw our attention towards questions of the ways in which we engage with our environment and to the act of bearing witness.

Source Material
Featuring work by Stephen Sutcliffe and Hayley Tompkins
Curated by Steven Cairns
Steven Cairns, Associate Curator of Artists' Film and Moving Image at the ICA, London, presents a screening that moves between archive and artwork, examining the research material of artists whose work often hinges on personal or existing collections of footage and imagery.

Brain Mail: Glasgow, California
Curated by George Clark
Mapping the intersection between the cities of Glasgow and Los Angeles, this programme is devised by George Clark, Assistant Curator of Film at Tate Modern, London. It explores how artists engage with international networks and the changing ways that images and ideas have circulated over the last twenty-five years. Taking its name from a mid-1990s group show by students of The Glasgow School of Art that took place at the California Institute of the Arts (CalArts), *Brain Mail* recalls the influential student exchange programme between these two colleges and marks the shift from the analogue traditions of mail art into the rapid digital exchange that defines our data-saturated present.

Trigger Tonic Compendium
By Anne-Marie Copestake
Presented by Isla Leaver-Yap
In 1999, Glasgow-based artist Anne-Marie Copestake began *Trigger Tonic*, an ongoing series of recorded interviews between artists, musicians and writers. For each recording, Copestake set simple parameters: she would introduce one Glasgow artist to one visiting artist, and then videotape their unrehearsed encounter. For this screening, Copestake has revisited her *Trigger Tonic* archive to produce a compendium of interwoven conversations and ideas, dating from 1999 to 2005. The compendium includes appearances by Ellen Cantor, Alec Empire, Bert Jansch, Mark Leckey, Le Tigre, Mary Redmond, Pipilotti Rist, Hayley and Sue Tompkins, Cathy Wilkes, Caroline Woodley and many others. It is presented by Isla Leaver-Yap, who works with artists to produce essays, books, exhibitions and events, and who is based in Glasgow and Minneapolis.

Cyprien Gaillard, **Pruitt Igoe Falls**, 2009
Video (still)

GENERATION: TG

THE TRAVELLING GALLERY

The Travelling Gallery is a mobile, contemporary art gallery custom-built in a big beautiful bus. The exhibitions are curated specifically for the unique space and are designed to travel the length and breadth of Scotland visiting schools, high streets, community centres and many other venues on the way. Touring throughout Scotland, this group exhibition includes five artists working in a range of media. The exhibition focuses on what it is like to be a contemporary visual artist in Scotland and includes a film of the artists talking about their work to pupils from Edinburgh schools in collaboration with SEE (Screen Education Edinburgh). Travelling

Gallery staff will be available to give formal and not-so-formal presentations on the exhibitions at every stop, and the exhibiting artists will give a programme of talks, workshops and performances throughout the tour. Full details of the tour are available on The Travelling Gallery's website.

Laura Aldridge was born in Frimley, lives and works in Glasgow, studied at Wimbledon School of Art in London and then obtained her MFA at The Glasgow School of Art including the Academic Exchange (MFA Programme), CalArts, Los Angeles in 2005. Laura works with a variety of materials including photography, screen-print, ceramics, fabric and cement depending on the space she is working in. For *GENERATION: TG* Laura has made new work specifically for The Travelling Gallery.

Craig Coulthard was born in Rinteln, West Germany, lives and works in Scotland, and studied to MFA at Edinburgh College of Art. From 2009 to 2012 he produced *Forest Pitch,* the Scottish commission for Artists taking the lead, part of the London 2012 Festival & Cultural Olympiad. Craig is exhibiting a number of new works including felt wall-hangings based on encaustic flooring in Edinburgh doorways and a sculptural work built from model aeroplanes.

Mandy McIntosh was born in Glasgow where she continues to live and work. She studied fashion knitwear at Trent Polytechnic and worked as a studio designer at KENZO in Paris in the early 1990s. She went on to complete a Master's in Design at The Glasgow School of Art. Mandy works across disciplines in digital film-making, socially engaged art, fine art textiles and other forms. Recent works include a 3-D animation for Random Acts on Channel 4 and a public art response to Galloway Forest Dark Sky Park (both 2013).

David Sherry was born in Northern Ireland and now lives and works in Glasgow. Since graduating with an MFA from The Glasgow School of Art in 2000, David has had solo exhibitions in Mother's Tankstation, Dublin (2011); Gallery of Modern Art, Glasgow (2011); Catalyst Arts, Belfast (2006); Villa Concordia, Germany (2006); and Tramway's Project Space, Glasgow (2001). In 2003 he was selected to represent Scotland at the 50th Venice Biennale. His work is held in many collections including the Gallery of Modern Art, Glasgow. David is performing a new work somewhere on the Travelling Gallery tour around Scotland.

Hanna Tuulikki, born in Sussex, now lives and works in Scotland, where she stayed after studying at The Glasgow School of Art. Crossing over a range of sound and visual media, she works primarily with the voice to create site-specific scores and performances. *spinning-in-stereo* is a composition for two voices, presented as a visual score and vinyl LP. The piece adopts a traditional Gaelic spinning song, *Oran Snìomhaidh,* as the basis of a circular score.

Wasps Open Studios 2014

Throughout the month of October artists within Wasps Studios from the Scottish Borders to Shetland are providing visitors with a behind-the-scenes look at how they develop and make their art by opening their doors to the public.

Wasps Open Studios first started in 2002. Since then, the event has attracted nearly 50,000 visitors. Its success shows audiences have a real appetite to learn more about how and why artists make their work. Visitors have unrivalled opportunities to meet artists in their place of work and to gain a greater understanding of studio practice – a vital aspect of the creative process. Around 400 artists will open their studio doors to showcase the broad range of creative practices that Wasps supports. *Wasps Open Studios* is a nationwide event and one that celebrates the diversity of studio communities across ages, art forms, practice and experience. It will take place in Glasgow, Edinburgh, Dundee, Aberdeen, Irvine, Selkirk, Kirkcudbright, Newburgh, Skye and Shetland.

Scotland is a nation of art lovers. Press reports on various surveys over the last few years have stated that in each year over a fifth of the population visits art galleries. Yet despite the popularity of visual arts in Scotland, the majority of the country's artists survive on very low incomes. A membership survey in September 2013 suggested that six out of ten Wasps members earn under £5,000 each year from making art. Wasps Studios exists to support these artists' careers by providing a studio for them to work in at a price they can afford. Set up in 1977, Wasps has now grown to become one of the UK's largest providers of affordable studios for artists and arts organisations. Today, it supports 850 artists and twenty-two arts organisations at sixteen buildings across Scotland.

The *Wasps Open Studios* programme begins with taster events across the country throughout August and September. These events include artist talks, exclusive behind-the-scenes tours, workshops, and visits from Wasps' curator to many of Scotland's art schools and colleges. The *Wasps Open Studios Weekend* is staggered across the month of October. The programme includes talks from visual artists, curators and fabricators, a children's trail and treasure hunt, and themed studio tours. Workshops for children and adults include life drawing, paper-making, photography, casting and printmaking. There are exhibitions and artists' performances across seven locations as well as discussion events around studio practice and sustainable careers for artists.

Moray Hillary's Studio, Wasps East Campbell Street Studios, Glasgow

Artist-run spaces in Scotland

In the last twenty-five years one of the most important features of Scotland's visual arts scene has been artist-led culture. Across the country artists have set up galleries, studios, temporary or itinerant projects, publications, festivals, events, gigs and exhibitions. A fluctuating network of individual artists, loose collectives, membership groups and charitable organisations are the building blocks of artistic practice in Scotland. Some have become established galleries with permanent homes and some public funding, some are temporary and exist thanks only to the goodwill and hard work of their founders. All of them rely on the labour and commitment of the artists who volunteer to run them. You will find that most of the artists in GENERATION will have been actively involved in, or shown their work with, artist-run initiatives. The GENERATION *Reader* includes more information about the story of artist-run initiatives in Scotland. If you are visiting GENERATION and want to know more about Scotland's artist-led culture we have listed below some of the places where you could find out more.

DUNDEE

Generator is a membership organisation founded in 1996 and run by a rolling committee of volunteers. It hosts a project and exhibition space, Generator Projects. generatorprojects.co.uk

EDINBURGH

Embassy Gallery is an artist-run gallery founded in 2004. It holds exhibitions, events and off-site projects and co-ordinates *Annuale*, a festival of grassroots artistic activity in Edinburgh. www.embassygallery.org

Rhubaba Gallery and Studio is an artist-run organisation founded in 2009 that provides studio space for artists and an annual programme of exhibitions and events. www.rhubaba.org

GLASGOW

David Dale Gallery and Studios is a non-profit organisation based in the east end of Glasgow. Established in 2009, it is run by a dedicated team of volunteers, promotes international contemporary art and provides artist studio spaces. www.daviddalegallery.co.uk

Market Gallery is a visual arts organisation run by volunteers based in Glasgow's East End. It was established in 2000 and presents contemporary exhibitions, projects and events. It is taking part in the GENERATION project. www.marketgallery.org

Southside Studios was founded in 2005 to provide studios and support for artists in part of the city where provision was sparse. It also hosts exhibitions and events. www.southsidestudios.org

SWG3 is an arts facility providing studio space to a community of over 120 creative practitioners from many disciplines. The building also produces a visual art exhibition programme, live music and electronic events. www.swg3.tv

The Glue Factory is a venue for exhibitions and events run by a committee of volunteers. Since 2010 it has showcased bold and ambitious projects from visual art and design to contemporary performance and film. www.thegluefactory.org

The Pipe Factory runs a public visual arts and learning programme, which includes exhibitions, workshops, residencies, events and publications. It also provides affordable spaces for artists to work. www.thepipefactory.co.uk

Transmission Gallery was set up by artists in 1983. It is run by a committee of volunteers and provides a place where artists can meet, exhibit and see the work of their peers and influences. www.transmissiongallery.org

Glossary

ABSTRACT ART

Art in which there is no attempt to depict things existing in the world. The word is particularly used from the twentieth century onwards.

ABSURDISM

A term first used in the 1960s, for a strand of theatre and literature, which emphasised the nonsensical, illogical or irrational. It is sometimes associated with dark humour or satire. Absurdist ideas were a recurring feature of radical culture of the twentieth century but the term is particularly associated with post-war theatre and with the playwright Samuel Beckett.

ART DECO

Taking its name from the major exhibition of decorative arts held in Paris in 1925, art deco was a design style of the 1920s and 1930s, using geometric or stylised shapes and bright colours.

ART NOUVEAU

Decorative art style popular in Europe and North America in the late nineteenth and early twentieth centuries. It is characterised by flowing lines based on plant forms.

AVANT-GARDE

A term for culture that challenges tradition through experimentation and innovation. Originally a military term, in the arts it is particularly associated with radical movements in visual art, literature and music of the late nineteenth and early twentieth centuries.

BAROQUE

A general term for European art, music and architecture from the seventeenth to the mid-eighteenth centuries. In art it particularly refers to works with a sense of movement and theatricality.

BAUHAUS

An influential German school of art and design founded in the German city of Weimar in 1919 under the architect Walter Gropius. It was based on workshop training rather than academic studios and is a celebrated attempt to bring diverse arts and craft into unity and for functional design. The school moved to Dessau in 1925, housed in a famous building designed by Gropius. It moved to Berlin in 1930 before closing in 1933 due to pressure from the Nazis.

CAST

The production of a sculpture by use of a mould to make a copy, usually in a more durable material, of the original work. The term is used to describe both the process and the resulting object.

CLASSICAL

A broad term used to describe the history and culture of Ancient Rome, Ancient Greece and associated civilisations in the area of the Mediterranean during the period from the eighth century BC to the fifth century AD.

COLLABORATIVE

A term to describe artists who work in groups or pairs to produce a single body of work, for example the Canadian artists General Idea who began working together in the 1960s or the British artists Gilbert & George. Collaborative working might be temporary between artists with individual careers, or a long-standing group of artists often working under a collective identity or name.

COLLAGE

An image made from found materials, such as photographs, paper or fabric, glued to a surface, sometimes with additional painted or drawn elements. It is an art form particularly associated with the early twentieth-century art movements Dada and Surrealism.

CONCEPTUAL ART

Art in which the idea is more important than the finished product or visual form. It emerged in the 1960s and was often concerned with the nature of art itself and the use of language.

CONSTRUCTIVISM

A geometric, abstract style founded in the early twentieth century in Russia by Vladimir Tatlin. The movement reflected the machine age through its use of new technology and materials and applied its theories to architecture and design as well as fine art. Exiled artists such as Naum Gabo helped to spread the constructivist ideas.

CUBISM

A movement in painting first developed by Georges Braque and Pablo Picasso in the first two decades of the twentieth century. Instead of painting a figure or object from a fixed position, they represented it from multiple viewpoints.

DADA

A radical artistic and literary movement that was a reaction against the cultural and political climate that supported the First World War. The Dadaists took an anti-establishment attitude, questioning art's status and favouring performance and collage over traditional art techniques. Many Dadaists went on to become involved with Surrealism.

FIGURATIVE

A general term for art that refers to the real, visible world, used more specifically for the representation of the human figure.

FLUXUS

A collective of international artists formed in 1960 by the artist George Maciunas. Their name means 'flowing' in Latin, and they aimed to break down barriers between art and life by staging avant-garde musical performances and anti-art events which closely involved the public. Among the

various group members were Nam June Paik, John Cage and Yoko Ono.

GOTHIC
The art and architectural style that dominated Western Europe during the medieval period. Its buildings are characterised by pointed arches, strong vertical lines and elaborate window structures.

IMPROVISATION
A term used for the composition or performance of a passage of music without preparation or musical text. Improvisation is a key characteristic of jazz, and in the second half of the twentieth century was used by many avant-garde composers in performance. It had a big impact on several abstract painters.

INSTALLATION
An art practice developed in the second half of the twentieth century that broke away from the view of a sculpture as a singular object to be looked at. Instead, artists create groups of objects or an environment that may surround the viewer. Many are temporary or created for a particular location.

JESMONITE®
A water-based material used in sculpture and casting which combines a gypsum powder compound with acrylic resin.

LAND ART
A movement beginning in the 1960s that sought a direct engagement with nature, creating artworks in and with the landscape.

LIFE MODEL
A model for 'life drawing', the drawing of a human figure, usually nude, from observation.

LINOCUT
A print produced in a similar way to a woodcut, but using a layer of linoleum, sometimes mounted on wood. As a cheap and easy way of producing prints, linocuts are often used by amateur artists, but the method was also used by artists like Picasso.

MINIMALISM
This term was first used in relation to twentieth-century paintings, which were notable for their austerity or simple geometric forms. From the 1960s onwards it was used to describe an art movement, mainly of American sculptors such as Donald Judd and Robert Morris, who worked with simple, often repeated, forms and industrial materials.

MODERNISM
A broad term used to describe the various movements in art, architecture, literature and music from the late nineteenth century to the 1960s. Modernism in visual art involved a break from traditional values and styles, and the development of new forms in art and society believed to be more suitable to the industrial age.

MONOCHROME
An image made with a single colour.

MONTAGE
A combination of images from different sources brought together to create one new whole. The term can be used in relation to film, photography, or handmade images, or any combination of these.

MONUMENTAL SCULPTURE
A term to describe all kinds of large-scale sculptures from ancient civilisations to modern times. Most recently it is understood to mean the kind of large sculpture that is found in public places to commemorate important people or events.

MOTIF
A distinctive element in a work of art or design.

PERFORMANCE/PERFORMANCE ART

Works in which the actions of the artist, or a performer, constitute the art. Artists have used performance techniques throughout the twentieth century, but the term 'performance art' is usually applied to works from the 1960s onwards.

PHOTOREALISM

An extremely detailed form of naturalistic art, often based on photographs. The style is particularly associated with a type of North American painting of the 1970s.

POP ART

An art movement of the 1950s to the 1970s that was primarily based in Britain and the United States. Pop artists are so called because of their use of imagery from popular culture, such as comics, advertising or commercial packaging. They also introduced techniques and materials from the commercial world, such as screenprinting, to fine art practice.

PSYCHOANALYSIS

A set of psychological ideas and therapies developed in the closing years of the nineteenth century and most closely associated with the work of the Austrian neurologist Sigmund Freud. Psychoanalysis places an emphasis on childhood experiences and on conflicts between conscious and unconscious drives. Its ideas have had a significant impact on art, including the importance placed on dreams and the unconscious and techniques such as free association.

READYMADE

A term coined by the artist Marcel Duchamp to describe an existing object that is taken from its original context and regarded as a work of art.

RELIEF

A form of sculpture where the image or design projects from a flat surface.

RENAISSANCE

A period in European culture from the fourteenth to the sixteenth centuries in which the visual arts flourished. It is particularly associated with Italy, where it began, though the term applies elsewhere. It is noted for a revival of interest in the cultures of ancient Greece and Rome.

REPRESENTATION

The depiction of a person or object in a work of art.

RESIDENCY/ARTIST'S RESIDENCY

A term used to describe the opportunity for artists to work away from their usual location or circumstances. An associated idea is that of the Artist-in-Residence, placing artists in a particular location such as an institution or workplace.

ROMANTIC

Relating to Romanticism, a movement in art, literature and music in the eighteenth and nineteenth centuries that rejected restraint in favour of emotion and individual expression.

SCREENPRINTING

A method of making prints by forcing ink through a screen on which a stencil is placed. Traditionally used for commercial printing, it has been taken up by artists since the 1960s when it was used extensively in Pop Art.

SITE-SPECIFIC

A term used particularly since the 1960s to describe art made with a particular location in mind, whether inside our outside. The work may be made at that location or made for it. Site-specific art may be an intervention in a specific place, environment or landscape.

STIJL, DE (DUTCH FOR 'THE STYLE')

De Stijl was the title of a Dutch art and design journal edited by Theo van Doesburg from 1917 to 1932 that gave its name to the movement

associated with it, which included the artist Piet Mondrian. It was concerned with finding a harmonious balance in life and art, and the associated visual style is simple abstraction, characterised by strong horizontal and vertical lines and primary colours.

STILL LIFE
A painting, drawing or photograph depicting inanimate objects.

STUDIO CERAMICS
A term for ceramics or pottery that is handmade by artists or artisans in the studio rather than mass-produced in a factory. Studio ceramics can include tableware or small sculptures where all, or most, of the stages of making are undertaken by an individual artist.

SUBCULTURE
A group that understands its own culture as different from, or sometimes against, the mainstream culture of a larger group. Subcultures often define their membership through music, distinctive dress or speech.

SUBJECTIVE
Based on personal feeling, emotion or taste.

SUBLIME
An aesthetic concept often applied to landscape painting since the eighteenth century. It describes scenes that excite a sense of awe by evoking the overwhelming vastness of the world.

SURREALISM
A literary and artistic movement founded by the poet André Breton in 1924. Many of the associated artists, such as Max Ernst and Jean Arp, had previously been involved with Dadaism. The movement sought to challenge conventions through the exploration of the subconscious mind, invoking the power of dreams and elements of chance. Traditional artistic values were challenged by the combination of diverse elements in collages and sculptural assemblages. The movement is also notable for the collaborations between artists and writers evident in the Surrealists' many publications.

TROMPE-L'OEIL
This term, from the French meaning 'to deceive the eye', is used to describe a form of illusionism used by artists to trick the viewer. It often involves the extremely realistic representation of an object in three dimensions.

UTOPIAN
Relating to an imaginary state or place where everything is perfect. The term was invented by Sir Thomas More in the book *Utopia* (1516).

GENERATION

ABERDEEN
1. Aberdeen Art Gallery
2. Wasps Studios

ARBROATH
3. Hospitalfield Arts

ARGYLL & BUTE
4. Cove Park

AYR
5. Maclaurin Art Gallery

BANFF
6. Duff House

BERWICK-UPON-TWEED
7. Paxton House

DUMFRIES
8. Gracefield Arts Centre

DUNDEE
9. Cooper Gallery, Duncan of Jordanstone College
10. Dundee Contemporary Arts
11. The McManus: Dundee's Art Gallery & Museum
12. Wasps Studios

EDINBURGH
13. City Art Centre
14. Collective
15. Dovecot Studios
16. Edinburgh Art Festival
17. Edinburgh Sculpture Workshop
18. The Fruitmarket Gallery
19. Ingleby Gallery
20. Inverleith House
21. Jupiter Artland
22. Royal Scottish Academy
23. Scottish National Gallery
24. Scottish National Gallery of Modern Art
25. Scottish National Portrait Gallery
26. Stills
27. Talbot Rice Gallery, University of Edinburgh
28. Travelling Gallery*
29. Wasps Studios

*Touring throughout Scotland: see website for daily locations.

FALKIRK
30. The Park Gallery

GLASGOW
31. CCA
32. The Common Guild
33. Glasgow Print Studio Gallery
34. The Glasgow School of Art
35. Glasgow Sculpture Studios
36. Glasgow Women's Library
37. Gallery of Modern Art
38. House for an Art Lover
39. The Hunterian
40. Kelvingrove Art Gallery and Museum
41. Market Gallery
42. The Modern Institute
43. Patricia Fleming Projects
44. People's Palace
45. Platform
46. Project Ability
47. Riverside Museum
48. Street Level Photoworks
49. Tramway
50. Wasps Studios

HELMSDALE
51. Timespan

INVERNESS
52. Inverness Museum and Art Gallery

IRVINE
53. Wasps Studios

ISLE OF BUTE
54. Mount Stuart

ISLE OF MULL
55. An Tobar

ISLE OF NORTH UIST
56. Taigh Chearsabhagh Museum & Arts Centre

ISLE OF SKYE
57. ATLAS
58. Wasps Studios

KILMARNOCK
59. Dick Institute

KIRKCALDY
60. Fife Contemporary Art & Craft
 @ Kirkcaldy Galleries

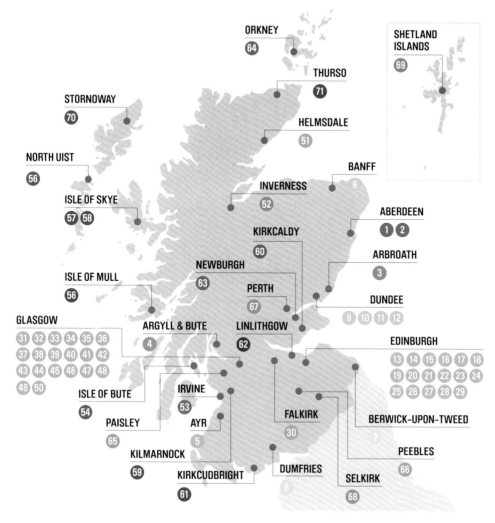

ORKNEY
64

THURSO
71

SHETLAND ISLANDS
69

STORNOWAY
70

HELMSDALE
51

NORTH UIST
56

BANFF
6

ISLE OF SKYE
57 58

INVERNESS
52

ABERDEEN
1 2

KIRKCALDY
60

ARBROATH
3

NEWBURGH
63

PERTH
67

DUNDEE
9 10 11 12

ISLE OF MULL
56

GLASGOW
31 32 33 34 35 36
37 38 39 40 41 42
43 44 45 46 47 48
49 50

ARGYLL & BUTE
4

LINLITHGOW
62

EDINBURGH
13 14 15 16 17 18
19 20 21 22 23 24
25 26 27 28 29

ISLE OF BUTE
54

IRVINE
53

FALKIRK
30

BERWICK-UPON-TWEED
7

PAISLEY
65

AYR
5

PEEBLES
66

KILMARNOCK
59

KIRKCUDBRIGHT
61

DUMFRIES
8

SELKIRK
68

KIRKCUDBRIGHT
61 Wasps Studios

LINLITHGOW
62 Linlithgow Burgh Halls

NEWBURGH
63 Wasps Studios

ORKNEY
64 Pier Arts Centre

PAISLEY
65 Paisley Museum

PEEBLES
66 The Gallery, Tweeddale Museum

PERTH
67 Perth Museum & Art Gallery

SELKIRK
68 Wasps Studios

SHETLAND ISLANDS
69 Wasps Studios

STORNOWAY
70 An Lanntair

THURSO
71 Caithness Horizons

Confirmed partners at time of printing

GENERATION Programme Listings

All information correct at time of printing. Please check individual venue websites for confirmed opening times.

ABERDEEN ART GALLERY

Schoolhill, Aberdeen, AB10 1FQ
www.aagm.co.uk

Anthony Schrag
Playtime / Placetime: Public Project:
22 March to 21 June 2014
Exhibition: 19 July to 16 August 2014

AN LANNTAIR

Kenneth Street, Stornoway, SC, HS1 2DS
www.lanntair.com

Dalziel + Scullion
Tumadh – Immersion: 6 July to 31 August 2014

AN TOBAR

Argyll Terrace, Tobermory, Isle of Mull, PA75 6PB
www.antobar.co.uk

Ilana Halperin
Learning To Read Rocks: 30 May to 26 July 2014

ATLAS

Skye Gathering Hall, Fancy Hill, Portree,
Isle of Skye IV51 9BX
www.atlasarts.org.uk

Joanne Tatham and Tom O'Sullivan
'An experience being an experience like an experience you just had': 6 August to 31 October 2014

CAITHNESS HORIZONS

Old Town Hall, High Street, Thurso, Caithness, KW14 8AJ
caithnesshorizons.wordpress.com

Douglas Gordon
ARTIST ROOMS: Douglas Gordon:
9 May to 11 October 2014

CCA

350 Sauchiehall Street, Glasgow, G2 3JD
www.cca-glasgow.com

Rachel Maclean
Happy & Glorious: 31 May to 13 July 2014

CITY ART CENTRE

2 Market Street, Edinburgh, EH1 1DE
www.edinburghmuseums.org.uk/
Venues/City-Art-Centre.aspx

Charles Avery, Christine Borland, Martin Boyce, Nathan Coley, Graham Fagen, Kate Gray, Kenny Hunter, Chad McCail, Jonathan Owen, Toby Paterson and Carol Rhodes
Urban/Suburban: 1 August to 19 October 2014

COLLECTIVE

City Observatory & City Dome
38 Calton Hill, Edinburgh, EH7 5AA
www.collectivegallery.net

Ruth Ewan in collaboration with Astrid Johnston
Memorialmania: ongoing

Ross Sinclair
20 Years of Real Life: 28 June to 31 August 2014

THE COMMON GUILD

21 Woodlands Terrace, Glasgow, G3 6DF
www.thecommonguild.org.uk

Hayley Tompkins
21 June to 2 August 2014

Corin Sworn
9 August to 13 September 2014

Duncan Campbell
20 September to 25 October 2014

COOPER GALLERY, DUNCAN OF JORDANSTONE COLLEGE OF ART & DESIGN

13 Perth Road, Dundee, Angus, DD1 4HT
www.exhibitions.dundee.ac.uk/

Graham Eatough & Graham Fagen, Full Eye, Ganghut, and Henry VIII's Wives
Studio Jamming: Artists' Collaborations in Scotland: 30 June to 2 August 2014

COVE PARK

Peaton Hill, Cove, Argyll & Bute, G84 0PE
www.covepark.org

Alex Frost
The Patrons: 21 June to 26 September 2014

DUNDEE CONTEMPORARY ARTS (DCA)

152 Nethergate, Dundee, DD1 4DY
www.dca.org.uk

Rob Churm, Raydale Dower and Tony Swain
Continue Without Losing Consciousness:
28 June to 24 August 2014

DICK INSTITUTE

Elmbank Avenue, Kilmarnock, KA1 3BU
www.eastayrshireleisure.com

Christine Borland, Graham Fagen and Dalziel + Scullion
GENERATION – SXSW 2014: 3 May to 16 August 2014

DOVECOT STUDIOS

Dovecot Studios, 10 Infirmary Street, Edinburgh, EH1 1LT
www.dovecotstudios.com

Dalziel + Scullion
Tumadh: Immersion: 1 August to 13 September 2014

DUFF HOUSE

Duff House, Banff, AB45 3SX
www.duffhouse.org.uk

Katy Dove
26 July to 23 August 2014

EDINBURGH ART FESTIVAL

www.edinburghartfestival.com

Various Artists / Exhibitions / Events

Commissions include: Craig Coulthard and Jacqueline Donachie
31 July to 31 August 2014

EDINBURGH SCULPTURE WORKSHOP

Bill Scott Sculpture Centre, 21 Hawthornvale,
Edinburgh, EH6 4JT
www.edinburghsculpture.org

Paul Carter
Icaro Menippus [x2]: 2 August to 31 August 2014

FIFE CONTEMPORARY ART & CRAFT @ KIRKCALDY GALLERIES

War Memorial Gardens, Kirkcaldy, KY1 1YG
www.fcac.co.uk ; www.kircaldygalleries.org.uk

Toby Paterson
26 April to 22 June 2014 (touring: Dumfries, Inverness
and Peebles)

THE FRUITMARKET GALLERY

45 Market Street, Edinburgh, EH1 1DF
www.fruitmarket.co.uk

Jim Lambie
Jim Lambie: 27 June to 19 October 2014

THE GALLERY, TWEEDDALE MUSEUM

Chambers Institution, High Street, Peebles, EH45 8AG
www.scotborders.gov.uk/museums

Toby Paterson
6 September to 25 October 2014 (touring:
Kirkcaldy, Dumfries and Inverness)

GENERATION PUBLIC COMMISSIONS

Various locations
www.generationartscotland.org

Jacqueline Donachie, Nicolas Party
see website for further details

GLASGOW PRINT STUDIO GALLERY

Trongate 103, Glasgow, G1 5HD
www.glasgowprintstudio.co.uk

Michael Fullerton
Meaning, Inc.: 28 June to 15 August 2014

THE GLASGOW SCHOOL OF ART

Mackintosh Museum, The Glasgow School of Art,
167 Renfrew Street, Glasgow, G3 6RQ
www.gsa.ac.uk

Graham Fagen
Cabbages in an Orchard; The formers and forms
of Charles Rennie Mackintosh and Graham
Fagen: 28 June to 27 September 2014

GLASGOW SCULPTURE STUDIOS

2 Dawson Road, Glasgow, G4 9SS
www.glasgowsculpturestudios.org

Rachel Adams, Jennifer Bailey, Sarah Forrest, Jenny
Lewis, Tessa Lynch, Lorna Macintyre, Niall Macdonald,
Natalie McGowan, James McLardy, Lauren Printy
Currie, Clara Ursitti and Zoe Williams
Mood is Made / Temperature is Taken:
4 July to 6 September 2014

GLASGOW WOMEN'S LIBRARY

23 Landressy Street, Glasgow, G40 1BP
www.womenslibrary.org.uk

Kate Davis
HOUSE WORK CASTLE MILK WOMAN
HOUSE: 18 October to 18 December 2014

GALLERY OF MODERN ART (GoMA)

Royal Exchange Square, Glasgow, G1 3AH
www.glasgowlife.org.uk/museums/GoMA

Nathan Coley
15 May 2014 to 1 March 2015

Moyna Flannigan
29 May to 2 November 2014

Sara Barker
27 June to 5 October 2014

Douglas Gordon
27 June to 28 September 2014

GENERATION: 25 Years of Contemporary Art in Scotland

GRACEFIELD ARTS CENTRE

28 Edinburgh Road, Dumfries, DG1 1JQ
www.dumgal.gov.uk

Christine Borland, Graham Fagen and Dalziel + Scullion
GENERATION – SXSW 2014: 10 May to 5 July 2014

Toby Paterson
22 November 2014 to 17 January 2015 (touring: Kirkcaldy, Inverness and Peebles)

HOSPITALFIELD ARTS

Hospitalfield House, Arbroath, Angus, DD11 2NH
www.hospitalfield.org.uk

Fiona Jardine and Sue Tompkins
Let the Day Perish: 4 July to 6 July 2014

Claire Barclay
4 July to 6 July 2014

HOUSE FOR AN ART LOVER

Bellahouston Park, 10 Dumbreck Road, Glasgow, G41 5BW
www.houseforanartlover.co.uk

Kenny Hunter
Kontrapunkt: 4 July to 4 September 2014

THE HUNTERIAN

University of Glasgow, 82 Hillhead Street, Glasgow, G12 8QQ
www.gla.ac.uk/hunterian

Lucy Skaer
6 June to 4 January 2015

INGLEBY GALLERY

15 Calton Road, Edinburgh, EH8 8DL
www.inglebygallery.com

Katie Paterson
Ideas: 28 June to 27 September 2014

INVERLEITH HOUSE

Royal Botanic Garden Edinburgh, Inverleith Place / Row, Edinburgh, EH3 5LR
www.rbge.org.uk/the-gardens/edinburgh/inverleith-house

Corin Sworn
12 April to 29 June 2014

Sue Tompkins
You, Me and the Plants: 26 July to 31 December 2014

INVERNESS MUSEUM AND ART GALLERY

Castle Wynd, Inverness, IV2 3EB

Toby Paterson
26 July to 23 August 2014 (touring: Kirkcaldy, Dumfries and Peebles)

JUPITER ARTLAND

Bonnington House Steadings, Wilkieston, Edinburgh, EH27 8BB
www.jupiterartland.org

Tessa Lynch
Raising: 17 July to 28 September 2014

Katie Paterson
Earth-Moon-Earth (Moonlight Sonata Reflected from the Surface of the Moon): 17 July to 28 September 2014

Mick Peter
Popcorn Plaza: 31 July to 28 September 2014

KELVINGROVE ART GALLERY AND MUSEUM

Argyle Street, Glasgow, G3 8AG
www.glasgowmuseums.com

David Sherry
GENERATION: 25 Years of Contemporary Art in Scotland – Works from Glasgow Museums Collection

LINLITHGOW BURGH HALLS

The Cross, Linlithgow, West Lothian, EH49 7AH

Louise Hopkins
Black Sea, White Sea: 15 August to 2 November 2014

MACLAURIN ART GALLERY

Rozelle Park, Monument Road, Ayr, KA7 4NQ
www.themaclaurin.org.uk

Christine Borland, Graham Fagen and Dalziel + Scullion
GENERATION – SXSW 2014: 17 May to 13 July 2014

THE McMANUS: DUNDEE'S ART GALLERY & MUSEUM

1 Albert Square, Meadowside, Dundee, DD1 1DA
www.mcmanus.co.uk

Nick Evans
The White Whale: 20 June to 31 August 2014

MARKET GALLERY

334 Duke Street, Glasgow, G31 1QZ
www.marketgallery.org
28 June to 1 August 2014

THE MODERN INSTITUTE

3 Aird's Lane, Glasgow, G1 5HU
www.themoderninstitute.com

Richard Wright
25 June to 30 August 2014

14–20 Osborne Street, Glasgow, G1 5QN
www.themoderninstitute.com
Scott Myles
28 June to 30 August 2014

MOUNT STUART

Isle of Bute, Argyll and Bute, PA20 9LR
www.mountstuart.com

Lorna Macintyre
6 July to 31 August 2014 (by appointment only
31 August to 31 October 2014)

PAISLEY MUSEUM

Paisley Museum, High Street, Paisley,
Renfrewshire, PA1 2BA
www.renfrewshire.gov.uk

Various Artists
Information: 11 July to 5 October 2014

THE PARK GALLERY

Callendar Park, Falkirk, Stirlingshire, FK1 1YR
www.falkirkcommunitytrust.org/venues/park-gallery/

John Shankie
Refractory and Refrigeration:
2 August to 26 October 2014

PATRICIA FLEMING PROJECTS

South Block 60 Osborne Street, Glasgow, G15 5QH
www.patriciaflemingprojects.co.uk

Over 20 artists including: Martin Boyce, Roderick
Buchanan, Duncan Campbell, Justin Carter, Jacqueline
Donachie, Jim Lambie, Douglas Gordon, Kenny Hunter,
Kevin Hutcheson, Iain Kettles, Danny Saunders, David
Sherry, Calum Stirling
DISCORDIA: 14 June to 4 July 2014

PAXTON HOUSE

Berwick-upon-Tweed, TD15 1SZ
www.paxtonhouse.co.uk

Kenny Hunter
The Singing of Swans: 21 June to 31 October 2014

PEOPLE'S PALACE

People's Palace and Winter Gardens, Glasgow Green,
Glasgow, G40 1AT
www.glasgowlife.org.uk/museums/peoples-palace

Beagles & Ramsay
GENERATION: 25 Years of Contemporary Art
in Scotland: Works from Glasgow Museums
Collection: 27 June to 29 September 2014

PERTH MUSEUM & ART GALLERY

78 George Street, Perth, PH1 5LB
www.pkc.gov.uk/museums

Alison Watt
7 June to 28 September 2014

PIER ARTS CENTRE

28–30 Victoria Street, Stromness, Orkney Islands, KW16 3AA
www.pierartscentre.com

Zoë Walker & Neil Bromwich
Orcadia & Other Stories: 21 June to 23 August 2014

PLATFORM

The Bridge, 1000 Westerhouse Road, Glasgow, G34 9JW
www.platform-online.co.uk

Mary Redmond
Cross Block Split: 20 June to 3 August 2014

PROJECT ABILITY

103 Trongate, Glasgow, G1 5HD
www.project-ability.co.uk

Cameron Morgan
Cameron's Way: Coast to Coast
Open Studio: 2 June to 27 June 2014
Exhibition: 3 July to 23 August 2014

RIVERSIDE MUSEUM

100 Pointhouse Place, Glasgow, G3 8RS
www.glasgowmuseums.com

Alan Currall
GENERATION: 25 Years of Contemporary Art in Scotland – Works from Glasgow Museums Collection: 27 June to 29 September 2014

ROYAL SCOTTISH ACADEMY

The Mound, Edinburgh, EH2 2EL
www.royalscottishacademy.org

Ade Adesina, Ernesto Cánovas, Geri Loup Nolan, Stuart McAdam, Eva Ullrich and Jonny Lyons
OPEN DIALOGUES: 28 June to 31 August 2014

SCOTTISH NATIONAL GALLERY

The Mound, Edinburgh, EH2 2EL
www.nationalgalleries.org

Karla Black, Christine Borland, Martin Boyce, Steven Campbell, Callum Innes, Rosalind Nashashibi, David Shrigley and Sue Tompkins
GENERATION: 25 Years of Contemporary Art in Scotland: 28 June to 2 November 2014

SCOTTISH NATIONAL GALLERY OF MODERN ART MODERN ONE

75 Belford Road, Edinburgh, EH4 3DR
www.nationalgalleries.org

Charles Avery, Claire Barclay, Roderick Buchanan, Henry Coombes, Kate Davis, Alex Dordoy, Graham Fagen, Douglas Gordon, Torsten Lauschmann, Lucy McKenzie, Jonathan Monk, Victoria Morton, Jonathan Owen, Toby Paterson, Ciara Phillips, Julie Roberts, Ross Sinclair, Smith/Stewart, Simon Starling, Alison Watt, Richard Wright, The Bothy Project
GENERATION: 25 Years of Contemporary Art in Scotland: 28 June to 25 January 2015

SCOTTISH NATIONAL PORTRAIT GALLERY

1 Queen Street, Edinburgh EH2 1JD
www.nationalgalleries.org

Luke Fowler
GENERATION: 25 Years of Contemporary Art in Scotland: 28 June to 2 November 2014

STILLS

23 Cockburn Street, Edinburgh, EH1 1BP
www.stills.org

Owen Logan
The King's Peace – Realism and War:
1 August to 26 October 2014

STREET LEVEL PHOTOWORKS

103 Trongate, Glasgow, G1 5HD
www.streetlevelphotoworks.org

Wendy McMurdo
Digital Play – Wendy McMurdo, Collected Works
(1995–2012): 27 June to 17 August 2014

TAIGH CHEARSABHAGH MUSEUM & ARTS CENTRE

Lochmaddy, North Uist, H56 5AA
www.taig-chearsabhagh.org

Joanne Tatham and Tom O'Sullivan
'an experience being an experience like an experience
you just had':
1 August to 30 September 2014

TALBOT RICE GALLERY

University of Edinburgh, Old College, South Bridge,
Edinburgh, EH8 9YL
www.ed.ac.uk/about/museums-galleries/talbot-rice

Ross Birrell, Alec Finlay, Andrew Miller, Ellie Harrison,
Keith Farquhar, Shona Macnaughton, Michelle Hannah
and Craig Mulholland and performances by Alex Hare,
Jeans & MacDonald and Ortonandon
Counterpoint: 1 August to 18 October 2014

TIMESPAN

Dunrobin Street, Helmsdale, Sutherland, KW8 6JA
www.timespan.org.uk

Stephen Hurrel
North Sea Hitch: 8 June to 3 August 2014

TRAMWAY

25 Albert Drive, Glasgow, G41 2PE
www.tramway.org

Mick Peter
15 May to 1 October 2014

Cathy Wilkes
28 June to 5 October 2014

Artists' Moving Image: Various Artists
28 June to 31 August 2014

Joanne Tatham and Tom O'Sullivan
28 June to 27 July 2014

Charlie Hammond, Iain Hetherington and Alex Pollard
9 August to 14 September 2014

Alan Michael
20 September to 19 October 2014

Performance Programme: Sue Tompkins, Cara Tolmie,
Clare Stephenson and Sophie Macpherson, Charlotte
Prodger, Raydale Dower
See website for further details
GENERATION: 25 Years of Contemporary Art in Scotland

TRAVELLING GALLERY

Various locations
see www.travellinggallery.com for daily location

Laura Aldridge, Craig Coulthard, Mandy McIntosh,
David Sherry, Hanna Tuulikki
GENERATION-TG: 23 July to 15 November 2014

WASPS STUDIOS

Various locations
www.waspsstudios.org.uk

2014 Open Studio Event
Wasps Open Studios: throughout October 2014

GENERATION Project Management

Executive Steering Group
Iain Munro, *Deputy Chief Executive, Creative Scotland (chair)*
Sir John Leighton, *Director-General, National Galleries of Scotland*
Bridget McConnell, *Chief Executive, Glasgow Life*

Advisory Board
Glasgow Life: Jill Miller, *Director of Cultural Services*
British Council Scotland: Lloyd Anderson, *Chief Executive;*
Juliet Dean, *Visual Arts Advisor*
BBC Scotland: Sharon Mair, *Project Executive – Commonwealth Games;*
Andrew Lockyer, *Project Producer – BBC @ the Quay*
Creative Scotland: Leonie Bell, *Director of Arts and Engagement*
Event Scotland: Marie Christie, *International Events Director – Culture*
Museums Galleries Scotland: Joanne Orr, *Chief Executive;*
Lori Anderson, *Relationships and Partnerships Manager*
Visit Scotland: Malcolm Roughead, *Chief Executive*

Curatorial Board
Amanda Catto, *Portfolio Manager, Creative Scotland (chair)*
Katrina Brown, *Associate Curator, GENERATION*
Simon Groom, *Director, Scottish National Gallery of Modern Art*
Sarah Munro, *Head of Arts, Glasgow Life, Director, Tramway*
Keith Hartley, *Chief Curator, Scottish National Gallery of Modern Art*
Victoria Hollows, *Museum Manager for Socially Engaged Practice and Research, Glasgow Life*
Lucy Askew, *Senior Curator (Exhibitions), Scottish National Gallery of Modern Art*

GENERATION Project Team
Jenny Crowe, *Project Manager*
Iona McCann, *Public Engagement Coordinator*
Moira Jeffrey, *Publications Editor*
Chloe Shipman, *Digital Project Manager*
Lesley Young, *Public Commissions Project Manager*

Thanks

The Curatorial Board would like to thank the many individuals who have contributed to the development and realisation of this publication: the artists, without whom there would be no project, for lending their time and attention to the collation of the texts and images with authors and the Publications team; the various galleries and other representatives of artists who have supplied information and images; and to our colleagues working across the network of museums, galleries and venues participating in GENERATION who have shared documentation about their projects so that the breadth of the GENERATION programme can be expressed.

The format and scope of the publications supporting the project were conceived by an Editorial Board and we are grateful to those who gave so freely of their time and expertise to this: Steven Cairns; Dr Sarah Lowndes, Lecturer, The Glasgow School of Art; Professor Neil Mulholland, ECA, the University of Edinburgh; Dr Dominic Paterson, the University of Glasgow; and Professor Andrew Patrizio, ECA, the University of Edinburgh, as well as Moira Jeffrey (editor) and Katrina Brown (associate curator, GENERATION). We thank the Publishing team at National Galleries of Scotland who have managed the complex production with support from colleagues at NGS and Glasgow Life along with the project team for GENERATION.

We are indebted to the diligence of Moira Jeffrey, who not only helped to define the publication strategy at the outset in her role as moderator of the GENERATION Editorial Board but who has brought integrity, energy and attention to detail in her role as editor of the resulting book you now hold in your hand.

The contributors of the artists' entries are indicated by their initials:
Lucy Askew LA
Katrina Brown KB
Shona Cameron ShC
Steven Cairns StC
Julie-Ann Delaney J-AD
Ben Harman BH
Keith Hartley KH
Claire Jackson CJ
Moira Jeffrey MJ
Sean McGlashan SMcG
Sarah Munro SM
Dominic Paterson DP
Andrew Patrizio AP
Linsey Young LY

Acknowledgements and Credits

IMAGE COPYRIGHT CREDITS

p. 13 © Charles Avery; p. 15 courtesy of the artist and Stephen Friedman Gallery; p. 17 courtesy of the artist and Mary Mary, Glasgow; p. 19 © the artists; p. 21 © Karla Black, courtesy Gisela Capitain; p. 23 © the artist; p. 25 © the artist, courtesy the Modern Institute/Toby Webster Ltd, Glasgow; p. 27 © the artist; p. 29 courtesy of the artist; p. 31© the artist's estate; p. 33 © Paul Carter and Paul Gray; p. 35 © the artist; p. 37 © Nathan Coley; p. 39 © Henry Coombes; p. 41 © the artist; p. 43 © the artist; p. 45 © Dalziel + Scullion; p. 47 courtesy of the artist and Galerie Kamm; p. 49 courtesy of the artist and Patricia Fleming Projects; p. 51 © the artist, courtesy the Modern Institute/Toby Webster Ltd, Glasgow; p. 53 courtesy of the artist and DCA editions; p. 55 © Raydale Dower, Tony Swain and Rob Churm; p. 57 courtesy the artist and Mary Mary, Glasgow; p. 59 © Ruth Ewan and Astrid Johnston, Memorialmania, 2013; p. 61 courtesy of the artist and Matt's Gallery, London; p. 63 courtesy of the artist; p. 65 © the artist, courtesy the Modern Institute/ Toby Webster Ltd, Glasgow; p. 67 courtesy of Alex Frost; p. 69 © the artist, courtesy of Carl Freedman Gallery, London; p. 71 © Douglas Gordon / Studio lost but found / VG Bildkunst, Bonn 2014; p. 73 courtesy of the artist; p. 75 courtesy of the artist & Galerie Kamm, Berlin; p. 77 © of the artist; p. 79 © Louise Hopkins; p. 81 © the artist; p. 83 courtesy of the artist; p. 85 © Callum Innes, courtesy Frith St Gallery , London , Sean Kelly New York, and Ingleby Edinburgh; p. 87 courtesy of F.Jardine/ Hospitalfield; p. 89 © the artist, courtesy the Modern Institute/Toby Webster Ltd, Glasgow; p. 91 courtesy of the artist; p. 93 courtesy of the artist; p. 95 courtesy of the artist; p. 97 courtesy of the artist and Mary Mary, Glasgow; p. 99 courtesy of the artist; p. 101 courtesy of the artist; p. 103 © Chad McCail, courtesy of Laurent Delaye Gallery; p. 105 © Lucy McKenzie; p. 107 © Wendy McMurdo. All Rights Reserved, DACS 2014; p. 109 courtesy of the artist and Vilma Gold, London; p. 111 courtesy the artist and Galleri Nicolai Wallner, Copenhagen; p. 113 © the artist; p. 115 courtesy of the artist and the Modern Institute/Toby Webster Ltd, Glasgow; p. 117 © the artist, courtesy the Modern Institute/Toby Webster Ltd, Glasgow; p. 119 © Rosalind Nashashibi; p. 121 copyright the artist; p. 123 © the artist, courtesy the Modern Institute/Toby Webster Ltd, Glasgow; p. 125 courtesy the artist and Ingleby Gallery, Edinburgh; p. 127 © the artist, courtesy the Modern Institute/Toby Webster Ltd, Glasgow; p. 129 courtesy the artist; p. 131 courtesy of the artist; p. 133 courtesy of the artist; p. 135 courtesy of the artist; p. 137 © the artist, courtesy the Modern Institute/Toby Webster Ltd, Glasgow; p. 139 © the artist; p. 141 © Julie Roberts; p. 143 courtesy the artist; p. 145 courtesy of the artist and Galleri Nicolai Wallner, Copenhagen; p. 147 © the artist; p. 149 © the artist, courtesy the artist and Galleri Nicolai Wallner, Copenhagen; p. 151 courtesy of the artist; p. 153 courtesy of the artist; p. 155 © Smith/Stewart; p. 157 courtesy of the artist and Neugerriemschneider, Berlin; p. 159 courtesy of the artist; p. 161 © the artist, courtesy the Modern Institute/Toby Webster Ltd, Glasgow; p. 163 courtesy of the artist

and Kendall Koppe, Glasgow; p. 165 © the artists, courtesy the Modern Institute/Toby Webster Ltd, Glasgow; p. 167 © the artist; p. 169 © the artist, courtesy the Modern Institute/Toby Webster Ltd, Glasgow; p. 171 © the artist, courtesy the Modern Institute/Toby Webster Ltd, Glasgow; p. 173 courtesy of the artists; p. 175 courtesy the artist and Ingleby Gallery, Edinburgh; p. 177 © the artist, courtesy the Modern Institute/Toby Webster Ltd, Glasgow; p. 179 © the artist, courtesy the Modern Institute/Toby Webster Ltd, Glasgow; p. 182 © Cooper Gallery, Exhibitions DJCAD; p. 185 © Zoe Williams; p. 186 Castlemilk Womanhouse archive collection, Glasgow Women's Library; p. 189 © Michael McDonough and Nathan Coley, 1989 © Jasper Coppes, 2014; p. 191 © the artist courtesy of the artist and Patricia Fleming Projects; p. 192 © Stuart McAdam; p. 194 courtesy the artist & Ellen de Bruijne Projects, Amsterdam; p. 197 © Cyprien Gaillard, courtesy Sprüth Magers Berlin London/ Bugada & Cargnel, Paris/ Laura Bartlett Gallery, London.